"Dance baby
romance ..."
oh wait! That's
Prince!
♡+

LADY GAGA

CRITICAL MASS FASHION

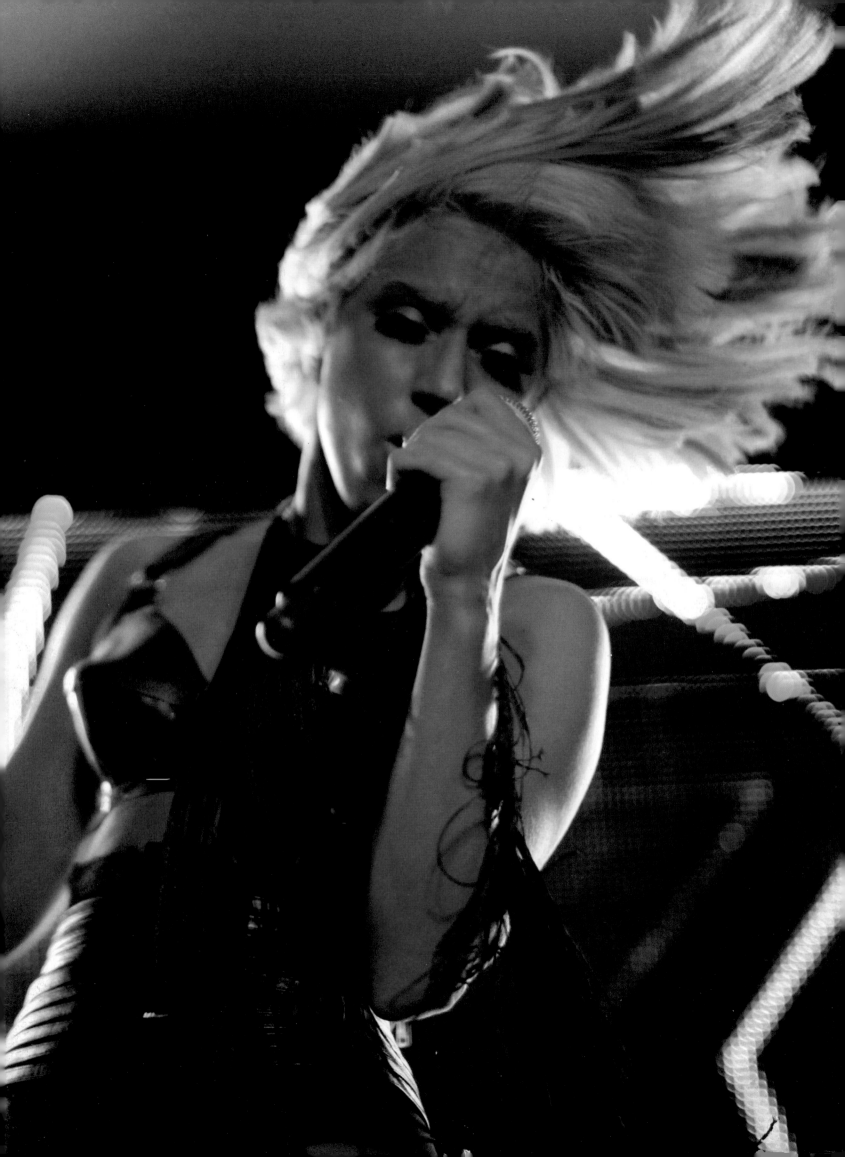

LADY GAGA

BY LIZZY GOODMAN

CRITICAL MASS FASHION

 St. Martin's Griffin New York

www.stmartins.com

Book Design: Samantha Caplan

Editorial: Kjersti Egerdahl

Image Research: Shayna Ian

Production Coordination: Tom Miller

Library of Congress Cataloging-in-Publication Data is available upon request.

ISBN 978-0-312-66840-2

First Edition: September 2010

10 9 8 7 6 5 4 3 2 1

Lady Gaga: Critical Mass Fashion is produced by becker&mayer!, Bellevue, Washington.

www.beckermayer.com

TABLE OF CONTENTS

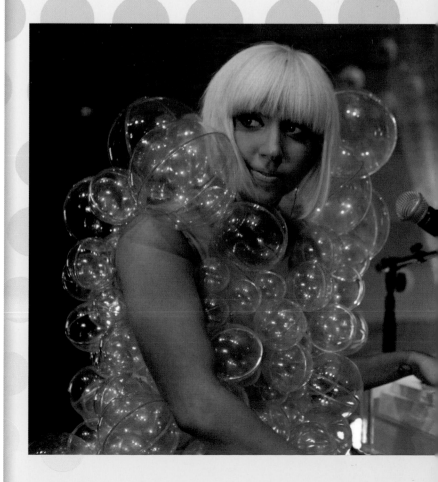

INTRO

Lying on her belly on a Las Vegas stage in 2010, feet kicked up delicately behind her, Lady Gaga likened herself to the world's most famous fairy. "I'm like Tinker Bell," Lady Gaga said, comparing herself to the fairy from *Peter Pan* whose survival depends on other people's faith in her existence. "You know how she dies if you don't clap for her? Scream for me! Do you want me to die?!" It's hard to know where this sort of manic lust for adulation comes from. Do chart-dominating, culture-altering pop stars chase fame because they are tormented as kids or are they tormented as kids because the freaky qualities that will make them famous are already on full display? For Lady Gaga the answer is: both.

Born Stefani Joanne Angelina Germanotta in New York City in 1986, the singer was a musical prodigy from the beginning. Gaga learned piano at age four and by the time she was eleven she was writing her own songs. By fourteen she was performing at open mic nights in the city. Equally obsessed as a young teenager with Judy Garland and Led Zeppelin, the singer's inner creative identity was already highly developed; but on the outside she still looked like a lost little girl. "I had a very big nose, very curly brown hair, and I was overweight," she told *Cosmopolitan.* "I got made fun of." Gaga went to high school at Convent of the Sacred Heart, a private Roman Catholic school in Manhattan, and it was There that she began the physical transformation from dutiful

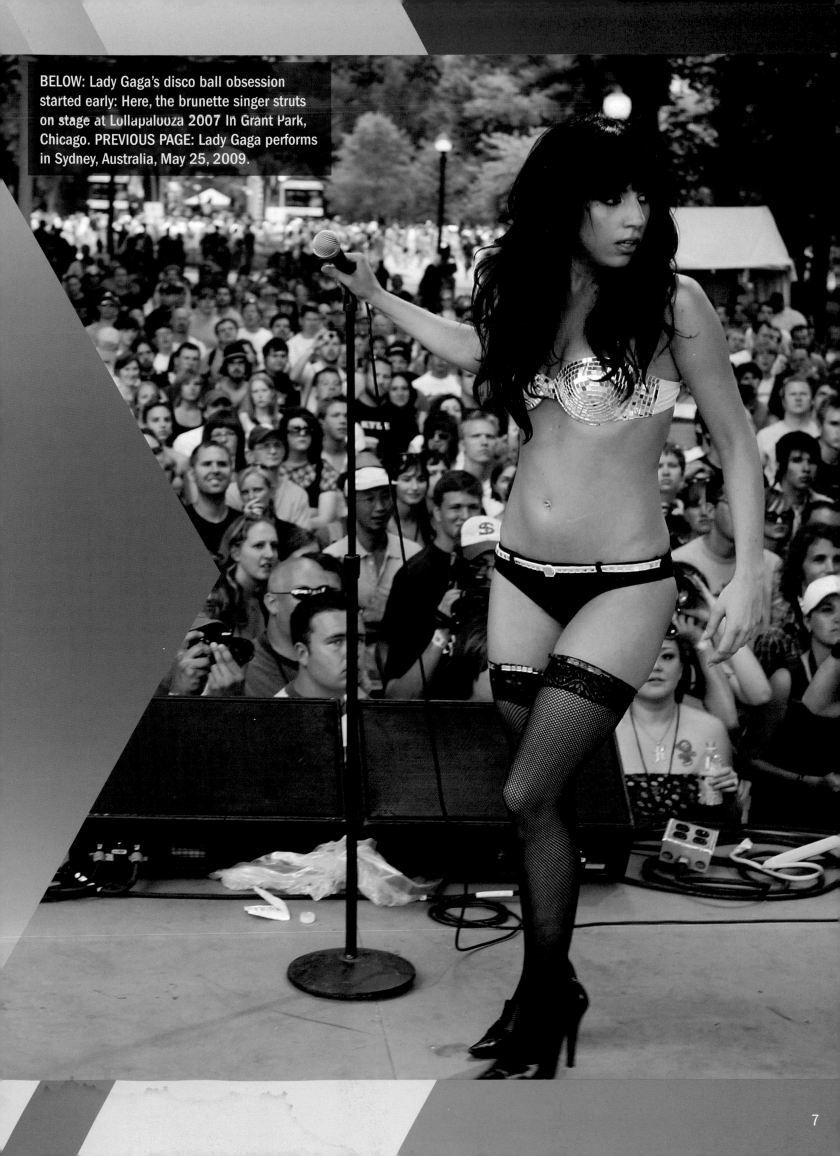

BELOW: Lady Gaga's disco ball obsession started early: Here, the brunette singer struts on stage at Lollapalooza 2007 in Grant Park, Chicago. PREVIOUS PAGE: Lady Gaga performs in Sydney, Australia, May 25, 2009.

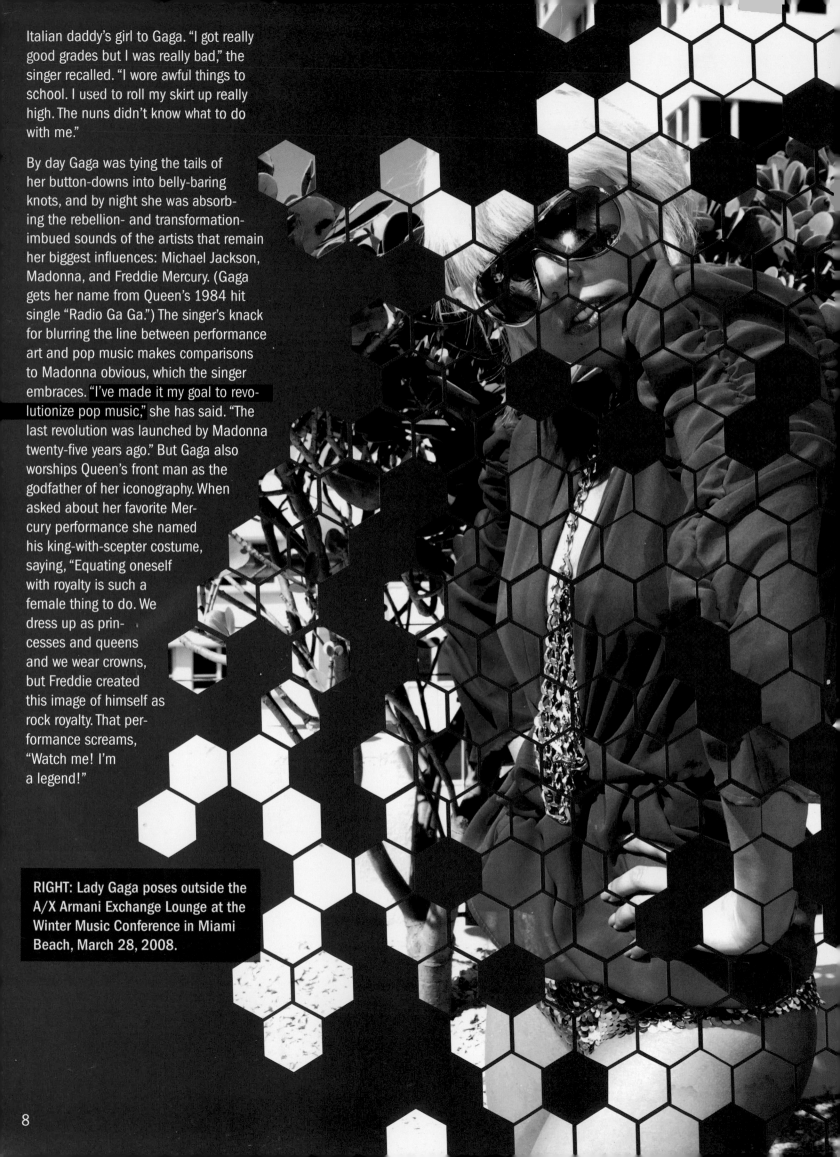

Italian daddy's girl to Gaga. "I got really good grades but I was really bad," the singer recalled. "I wore awful things to school. I used to roll my skirt up really high. The nuns didn't know what to do with me."

By day Gaga was tying the tails of her button-downs into belly-baring knots, and by night she was absorbing the rebellion- and transformation-imbued sounds of the artists that remain her biggest influences: Michael Jackson, Madonna, and Freddie Mercury. (Gaga gets her name from Queen's 1984 hit single "Radio Ga Ga.") The singer's knack for blurring the line between performance art and pop music makes comparisons to Madonna obvious, which the singer embraces. "I've made it my goal to revolutionize pop music," she has said. "The last revolution was launched by Madonna twenty-five years ago." But Gaga also worships Queen's front man as the godfather of her iconography. When asked about her favorite Mercury performance she named his king-with-scepter costume, saying, "Equating oneself with royalty is such a female thing to do. We dress up as princesses and queens and we wear crowns, but Freddie created this image of himself as rock royalty. That performance screams, "Watch me! I'm a legend!"

RIGHT: Lady Gaga poses outside the A/X Armani Exchange Lounge at the Winter Music Conference in Miami Beach, March 28, 2008.

8

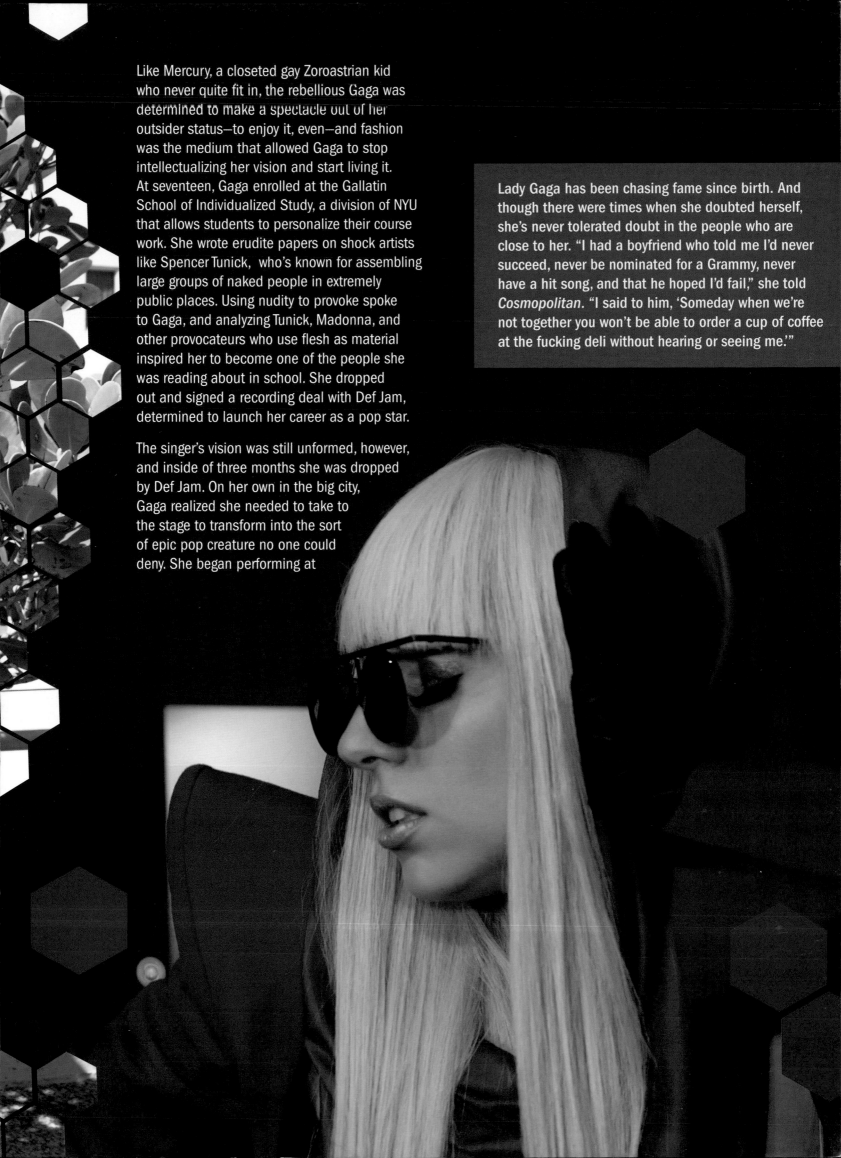

Like Mercury, a closeted gay Zoroastrian kid who never quite fit in, the rebellious Gaga was determined to make a spectacle out of her outsider status—to enjoy it, even—and fashion was the medium that allowed Gaga to stop intellectualizing her vision and start living it. At seventeen, Gaga enrolled at the Gallatin School of Individualized Study, a division of NYU that allows students to personalize their course work. She wrote erudite papers on shock artists like Spencer Tunick, who's known for assembling large groups of naked people in extremely public places. Using nudity to provoke spoke to Gaga, and analyzing Tunick, Madonna, and other provocateurs who use flesh as material inspired her to become one of the people she was reading about in school. She dropped out and signed a recording deal with Def Jam, determined to launch her career as a pop star.

The singer's vision was still unformed, however, and inside of three months she was dropped by Def Jam. On her own in the big city, Gaga realized she needed to take to the stage to transform into the sort of epic pop creature no one could deny. She began performing at

Lady Gaga has been chasing fame since birth. And though there were times when she doubted herself, she's never tolerated doubt in the people who are close to her. "I had a boyfriend who told me I'd never succeed, never be nominated for a Grammy, never have a hit song, and that he hoped I'd fail," she told *Cosmopolitan*. "I said to him, 'Someday when we're not together you won't be able to order a cup of coffee at the fucking deli without hearing or seeing me.'"

clubs on the Lower East Side, go-go dancing and doing burlesque at the Slipper Room, Pianos, and the Knitting Room, among others. Taking off her clothes on stage alienated her family—her father was horrified and completely stopped talking to her—but creatively it was inspiring. She became so interested in the art of undressing that she began to go out into the streets wearing nothing but leotards and platforms. "I just feel freer without pants," the singer has said. In a breakthrough performance at Lollapalooza in 2007, she wore a mirror-encrusted bikini inspired by T. Rex front man and glam rock icon Marc Bolan, whose pansexual approach to life and unabashedly sensationalized onstage persona make him a major Gaga progenitor. The Lollapalooza moment served as a sort of coming-of-age for the merging of Gaga's intellectual vision with her outward appearance. "The audience must've thought, 'Who is she? Why is she here? And is this even music?'" the singer remembered. "I loved that. I inspire shock in people, and it's fascinating to me. I want people to be entertained in a way that they're not used to."

Gaga's debut album *The Fame* (2008) and the eight-song bonus disc that followed it, *The Fame Monster* (2009), have sold a combined 8 million copies worldwide. She's won two Grammy awards and was the first artist in the history of the *Billboard* pop song charts to have her first *five* singles reach number one. And that's just her musical accomplishments. Always pushing creativity over commerce, she's put most of the proceeds from her rapid rise to fame back into the art, assembling the Haus of Gaga, a team of stylists, makeup artists, hairdressers, and assistants who manage the giant performance art piece that is her celebrity. In addition to working with an impressive list of bold-name collaborators like Beyoncé, photographer David LaChapelle, and Dior Homme designer and photographer Hedi Slimane, the Haus of Gaga has put together one of the most ambitious, outlandish tours in history (the Fame Ball) and has revolutionized the music video, reinstating it as a dominant force in pop art. But, in the end, it's Gaga's connection with the millions of people she calls her "beautiful fans" that fuels the pop cultural tidal wave that has become her career. Every track, every performance, every hair bow, every flaming bra, every walk to the local bar is meant to inspire the attention she needs to live. Just like Tinker Bell, Gaga will follow you until you love her. If you don't, she's dead.

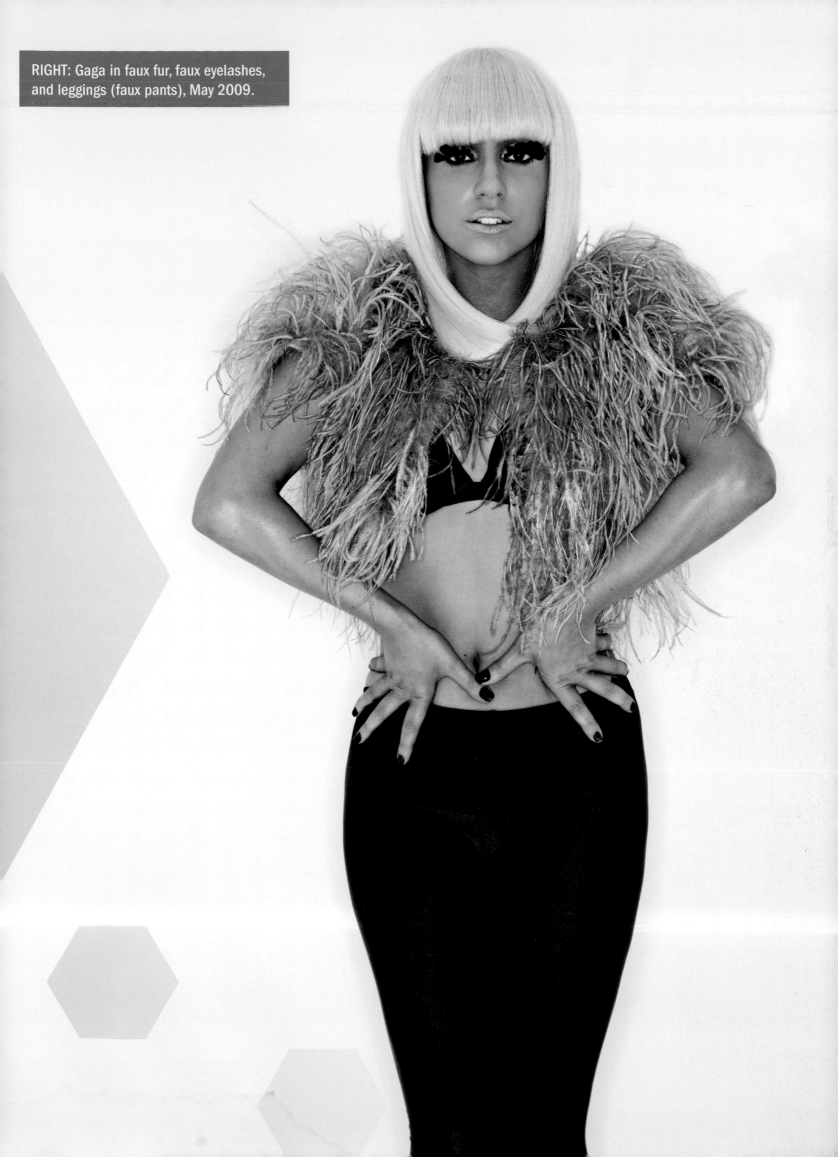

*L*ady Gaga really likes to get naked. Whether she's cavorting around London in a transparent catsuit or grocery shopping back in New York wearing a see-through bodysuit, bra, and G-string, she's rarely spotted on or off stage in an outfit that doesn't expose something we're not supposed to see. But for Gaga, undressing in public is not just about the shock value of the bare breast or the exposed ass cheek; it's about the larger story. "'Persona' is the first word people think of when they're trying to figure out how to describe what it is that I do because we're not used to artists that live and breathe their work," the singer has said. "But this is truly who I am. Gaga is not a character. There's the fashion, the music, the films, and the videos. Everything that you see is an extension of me. It's not a character that I play on television."

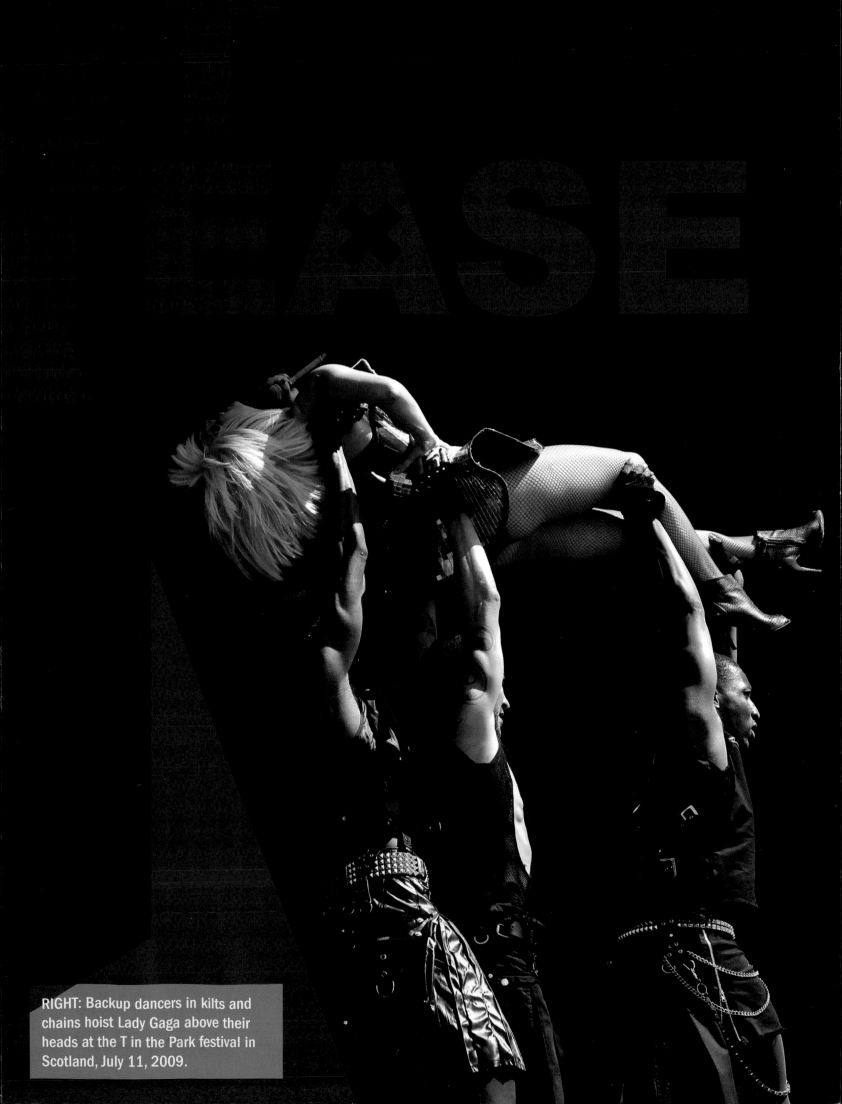

RIGHT: Backup dancers in kilts and chains hoist Lady Gaga above their heads at the T in the Park festival in Scotland, July 11, 2009.

BELOW: Lady Gaga lights up the stage in Hanover, Germany, February 20, 2009.

From the outside, the transformation from Queens-born Catholic schoolgirl Stefani Germanotta to international pop icon Lady Gaga appears seamless: The star's hair is immaculately blonde, her makeup perfectly applied, her body taut, her manner serene as she speaks earnestly about her "beautiful fans" like she's Norma Desmond. But there was a time when this preternaturally composed young artist was just another self-described "delusionally ambitious" kid from New York with a head full of dreams that contrasted starkly with her reality. She was living in a grimy rental on the Lower East Side, supporting herself the way struggling artists do, by working several crap jobs. To earn extra cash, Gaga started go-go dancing. After a long day spent waiting tables, then shaking her ass for tips, Gaga would go home, call her coke dealer, and spend hours doing blow and making herself up like her androgynous idols, David Bowie, Grace Jones, and New Wave performer Klaus Nomi. "It was just like this very special moment that I had with myself where I could feel confident and feel like a star," the singer told *Rolling Stone*. "Sometimes I look back on it and I miss it in a way."

Gaga was also rehearsing for fame in less destructive ways. In 2007 she met DJ and performer Lady Starlight, and the two formed an instant creative bond. Starlight had been performing on the downtown scene since the early 2000s, working a combination of multimedia art projects, radio gigs, fashion events, rock writing, and onstage work into a distinctly DIY sensibility. Her willingness to wear, say, and do absolutely anything on stage was like the skeleton key that unlocked Gaga's own creative identity. "She was in the commercial pop world," Starlight told *Q*, "but she has a rock 'n' roll mentality. So I encouraged her: If you have an idea, however ridiculous, do it. All the way. Rock 'n' roll is supposed to stun. And appall. She wanted to shake up the industry, and I'd compare her to Bowie way before Madonna in terms of bringing alternative culture into the mainstream. She is anarcho-punk!"

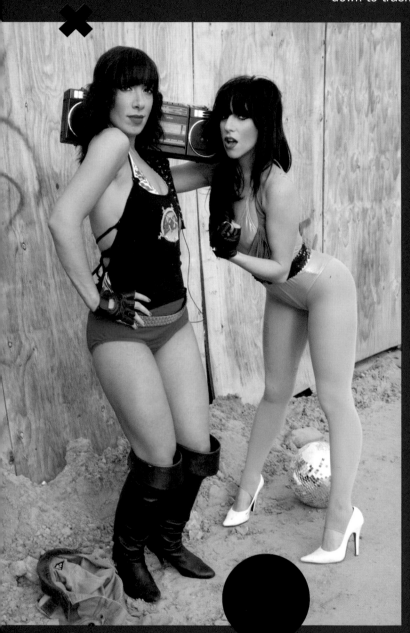

The pair merged Gaga's pop sheen and Starlight's metal edge into Lady Gaga and the Starlight Revue and started playing shows around lower Manhattan. Billed as "The Ultimate Pop Burlesque Rockshow" they would strip down to trashy bikinis, showgirl-worthy feathered headdresses, and hot pants, and light cans of hairspray on fire while playing covers. Even if they hadn't mentioned "burlesque" in their show description, it would have been hard not to see the influence of that art form on their performances. Born out of the vaudeville theater tradition, burlesque uses striptease as a form of storytelling. It's not just girls in pasties, it's girls in pasties with something to say! But seriously, the idea that you can deliver a complex narrative using pyro and tits was a revelation for Lady Gaga, one that's influenced every aspect of her performance style. Each mini piece of Gaga performance art—from her videos to her television performances to her interviews, every single reenactment of every single song on stage night after night, each appearance at each club in each city, each new outfit—is itself a burlesque performance. She's telling a story every time. "Eh Eh" romanticizes the all-American boy-meets-girl trope. "Paparazzi" is about the quest for fame at any cost. "Poker Face" is about fantasizing about a woman while having sex with a man, but they're all narrative statements that when reenacted live in sexually suggestive, cerebral ways become pieces of pop art.

ABOVE: Lady Starlight and Lady Gaga, who founded Lady Gaga and the Starlight Revue out of a shared love for rock excess, cheap bikinis, and choppy layers.

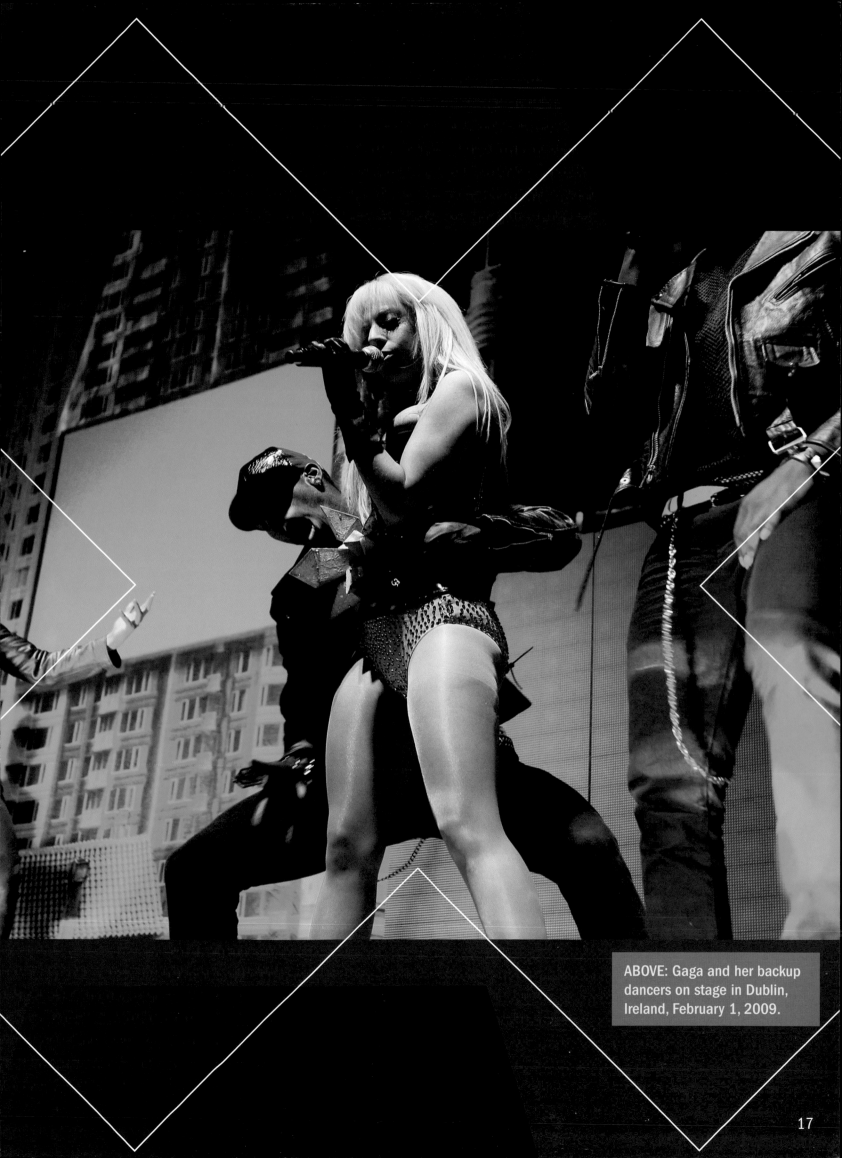

ABOVE: Gaga and her backup dancers on stage in Dublin, Ireland, February 1, 2009.

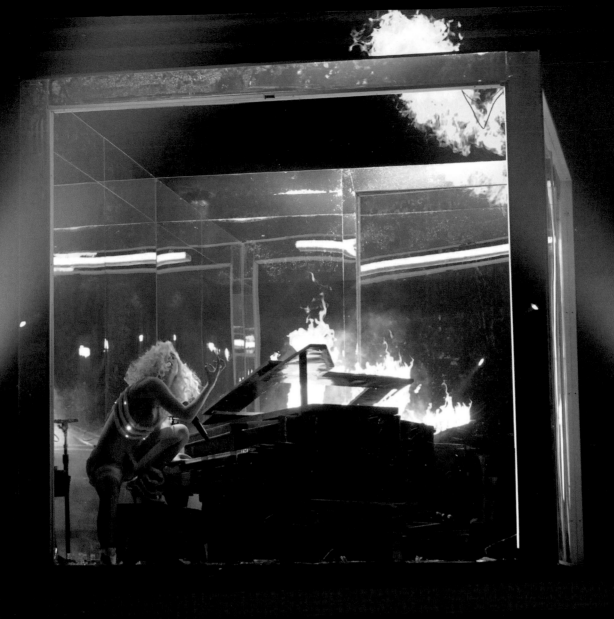

What distinguishes Lady Gaga from someone like Britney Spears is not only that Gaga is self-invented while Britney is reinvented by others, but also that Gaga never turns it off. Britney's off-camera antics are hilarious, tragic, deeply compelling, and totally key to her larger celebrity, but they're not contrived. When we see her running into a gas station bathroom, barefoot, with Cheetos dust all over her cutoffs, we're witnessing the "real Britney." And it thrills us to witness the "Stars! They're Just Like Us!" scene behind the coquettish fantasy of "Oops (I Did It Again)."

Lady Gaga is not like us. She goes to the grocery store in McQueen platforms. She spends her downtime on the road practicing new material in a silk dressing gown on the all-white piano she requests for her hotel room. She goes for a drink in a fetish policewoman's outfit. She's not playing Gaga; she *is* Gaga . . . at least that's the concept. "We always laugh when we get to some major magazines and they're like, so, the art direction of the shoot is: We want the world to see the real you. And I'm sitting there thinking, 'these fucking people don't get it at all. At all.'" the singer told *Q*. "It's mind-blowing to me. That's like saying, we know you're full of shit, but it's fine, we get it. So let's just cut out the bullshit for one shoot. You don't really want to get to know me or photograph my soul, you want to do some version of what you already think I am and then expose something that you believe is hidden. When the truth is, me and my big fucking dick are all out there for you." Unlike other pop stars, who tease us with a nip-slip here, a panty line there, Lady Gaga is a sure thing. She's going to take it all off. And all she asks for in exchange is that we watch.

"I look at my work in three components. Part pop show, part performance art, and part fashion installation," Lady Gaga has said. "Those three components come together anytime you see my work." The singer's capacity to blend high art influences, pop art instincts, and transcendent live performances wasn't always so evolved. She learned to merge the three while go-go dancing and performing at small clubs, and to this day, she's proud of even the most minor skills she picked up. "When I was nineteen I did burlesque in New York," the singer recalled to *Blender*. "So I can dance on just one foot of stage."

BODILY FASHION

Though the horror genre has lately been reduced to a cheesy farce (see *Saw IV*), there's a long tradition of being terrified for fun by people who know how to do it right. If you lived in Paris in the 1890s and were feeling a little dark, you could skip the Moulin Rouge and spend an evening at Le Théâtre du Grand-Guignol. Born out of the idea that to provoke is to connect, shows at the Grand-Guignol were thrilling, gory affairs featuring unsavory characters enduring cartoonish acts of violence including beheadings, hangings, stabbings, and rapes. The success of a piece was judged by how many people passed out from shock while watching it.

So far, we've seen Gaga die only once, at the 2009 Video Music Awards when she performed a career-defining version of "Paparazzi" that she called "my first truly original moment." She started off decked out in white lace with a demure crown, in apparent homage to Madonna's infamous performance of "Like A Virgin" at the 1984 inaugural VMAs, where she humped the stage in a poufy wedding dress. But Gaga took her MTV moment to a much darker place than the original Material Girl. As the song escalated, she began to shed clothing until there was nothing but a stomach-baring white leotard between her and the cameras. And she didn't stop there. For those truly committed to their fame, being nearly naked on national TV is not enough. You must cripple yourself for fame, and so she did, hobbling around on one crutch. You must bleed for it, and so she did,

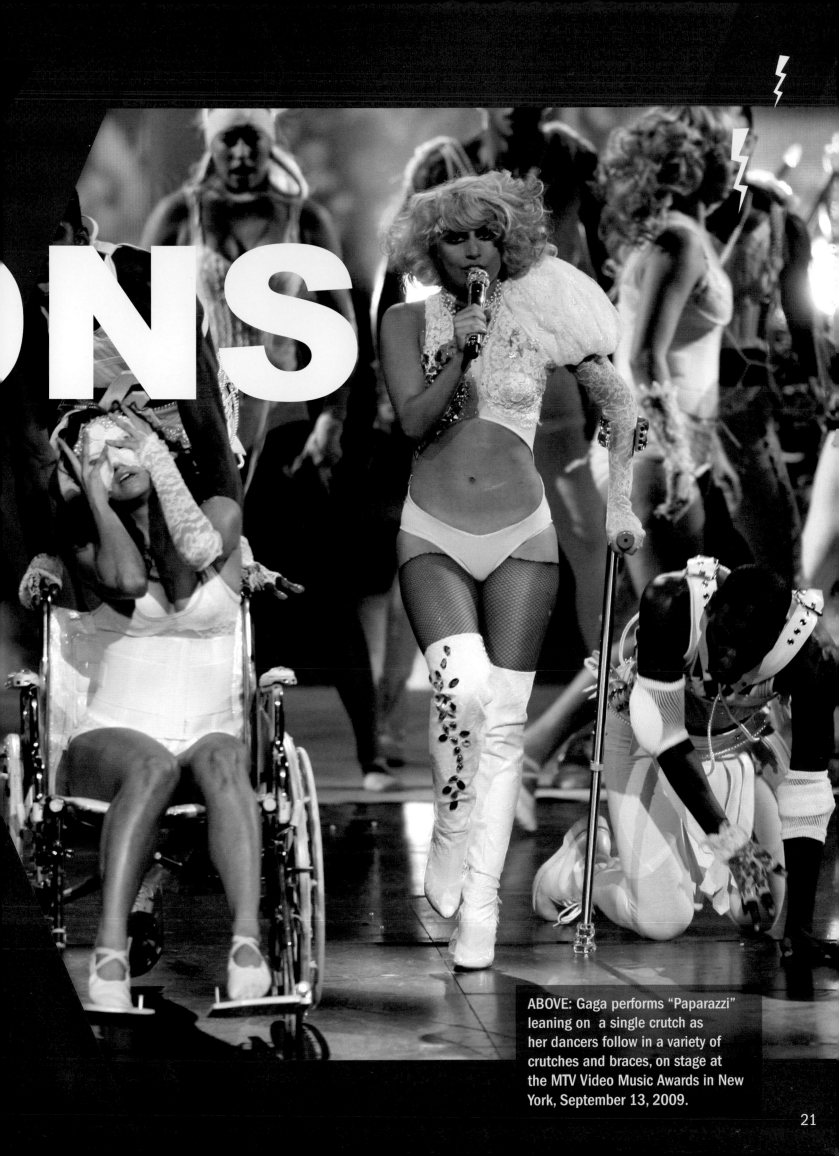

ONS

ABOVE: Gaga performs "Paparazzi" leaning on a single crutch as her dancers follow in a variety of crutches and braces, on stage at the MTV Video Music Awards in New York, September 13, 2009.

staggering as blood gushed from her torso. And you must die for it, and so she did, hanging glassy-eyed and dripping blood from a rope suspended high above the Radio City stage. The narrative was so stark, its execution so dramatic, that Gaga turned hundreds of her more famous peers into stunned fans. As the cameras panned across the audience it captured, among others, Diddy, mouth agape, totally riveted.

Gaga is not the first pop star to use horror as a form of provocative entertainment. (The graphic Nine Inch Nails video for "Closer" was banned from MTV, Flaming Lips front man Wayne Coyne regularly smears his white suits with fake blood, and Kiss has been spitting blood on stage for more than thirty years, just to name a few other examples.) But the scale, scope, and inventiveness with which Gaga pursues the grotesque as entertainment is new. She uses blood, exposed bones, and gore to represent both what she's willing to give to be famous and what the pop world expects from its icons. It's not enough to see their sex tape on YouTube or read about their drug problems in the tabloids or see photos of their cellulite on blogs. We also want to view their inner lives—literally. We want to see the throbbing contractions as their hearts pump blood through their veins, we want to see their organs pulsating with life, we want to see their tendons flexing as they dance for us on stage. And in exchange for our adoration, they are happy to give us what we demand.

LEFT: Gaga's bloodstained grand finale at the 2009 MTV Video Music Awards.

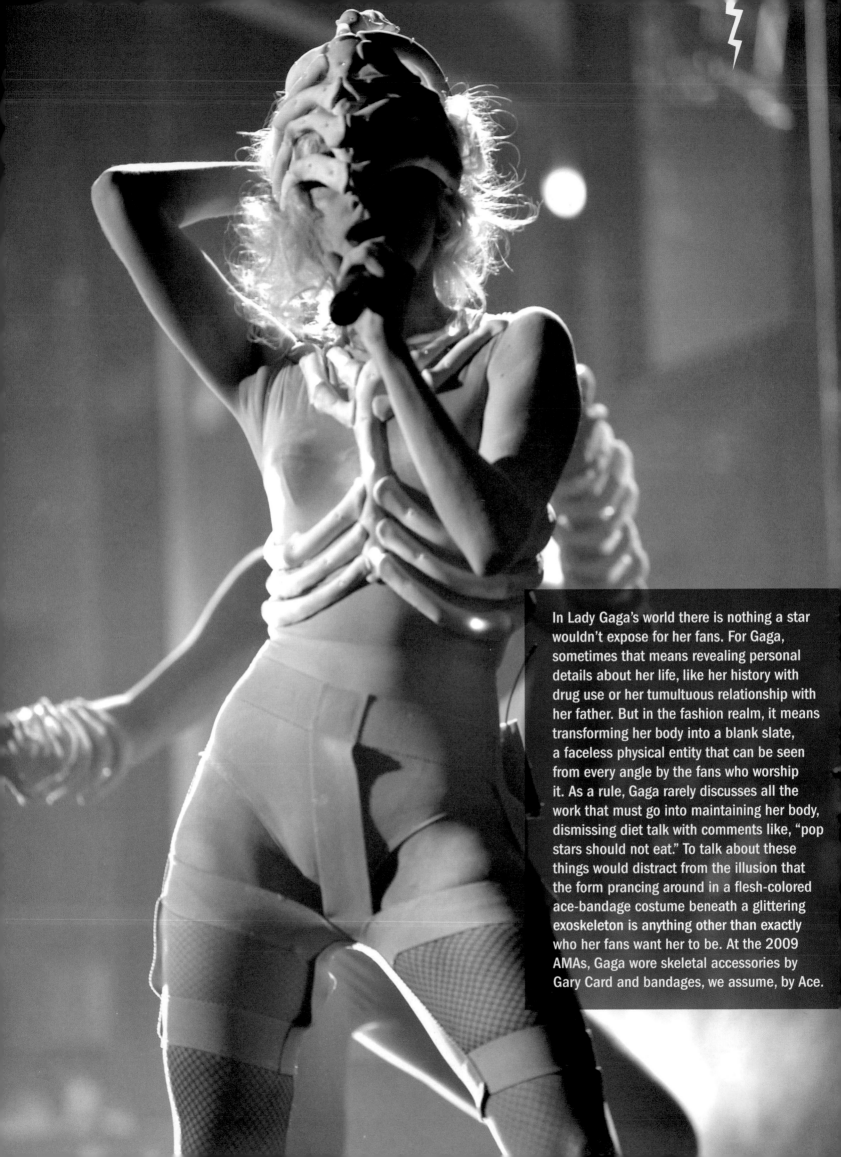

In Lady Gaga's world there is nothing a star wouldn't expose for her fans. For Gaga, sometimes that means revealing personal details about her life, like her history with drug use or her tumultuous relationship with her father. But in the fashion realm, it means transforming her body into a blank slate, a faceless physical entity that can be seen from every angle by the fans who worship it. As a rule, Gaga rarely discusses all the work that must go into maintaining her body, dismissing diet talk with comments like, "pop stars should not eat." To talk about these things would distract from the illusion that the form prancing around in a flesh-colored ace-bandage costume beneath a glittering exoskeleton is anything other than exactly who her fans want her to be. At the 2009 AMAs, Gaga wore skeletal accessories by Gary Card and bandages, we assume, by Ace.

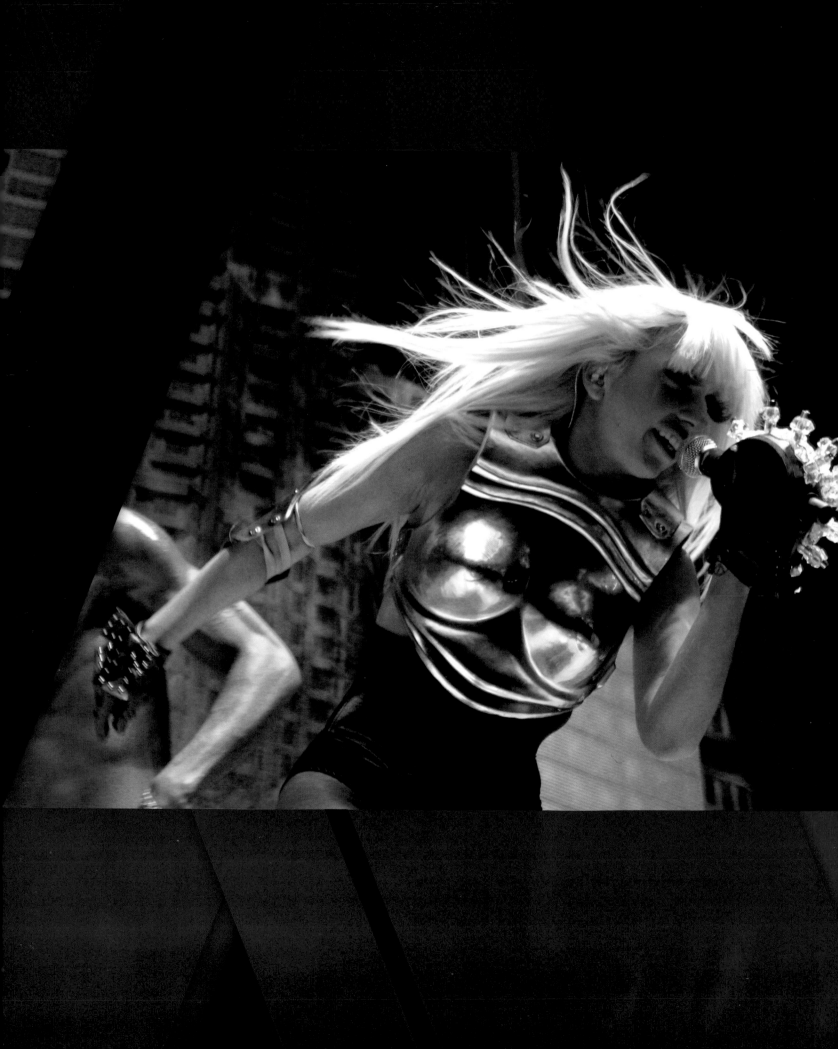

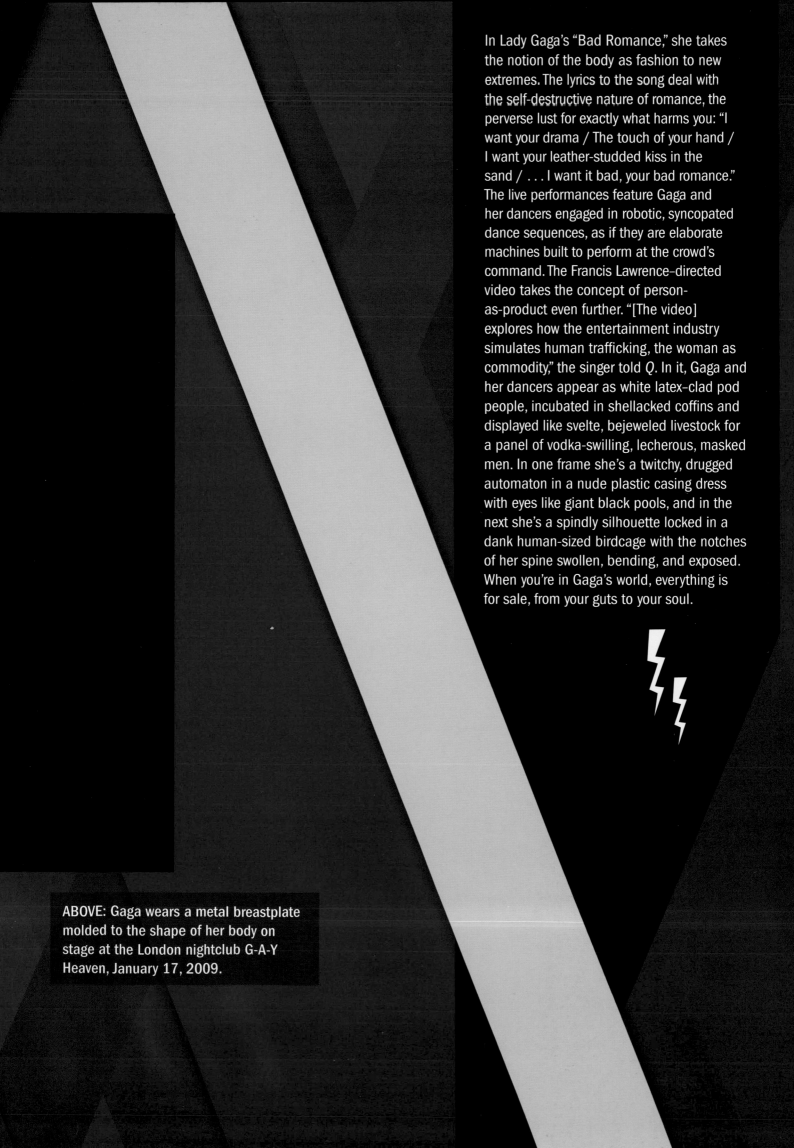

In Lady Gaga's "Bad Romance," she takes the notion of the body as fashion to new extremes. The lyrics to the song deal with the self-destructive nature of romance, the perverse lust for exactly what harms you: "I want your drama / The touch of your hand / I want your leather-studded kiss in the sand / . . . I want it bad, your bad romance." The live performances feature Gaga and her dancers engaged in robotic, syncopated dance sequences, as if they are elaborate machines built to perform at the crowd's command. The Francis Lawrence–directed video takes the concept of person-as-product even further. "[The video] explores how the entertainment industry simulates human trafficking, the woman as commodity," the singer told Q. In it, Gaga and her dancers appear as white latex–clad pod people, incubated in shellacked coffins and displayed like svelte, bejeweled livestock for a panel of vodka-swilling, lecherous, masked men. In one frame she's a twitchy, drugged automaton in a nude plastic casing dress with eyes like giant black pools, and in the next she's a spindly silhouette locked in a dank human-sized birdcage with the notches of her spine swollen, bending, and exposed. When you're in Gaga's world, everything is for sale, from your guts to your soul.

ABOVE: Gaga wears a metal breastplate molded to the shape of her body on stage at the London nightclub G-A-Y Heaven, January 17, 2009.

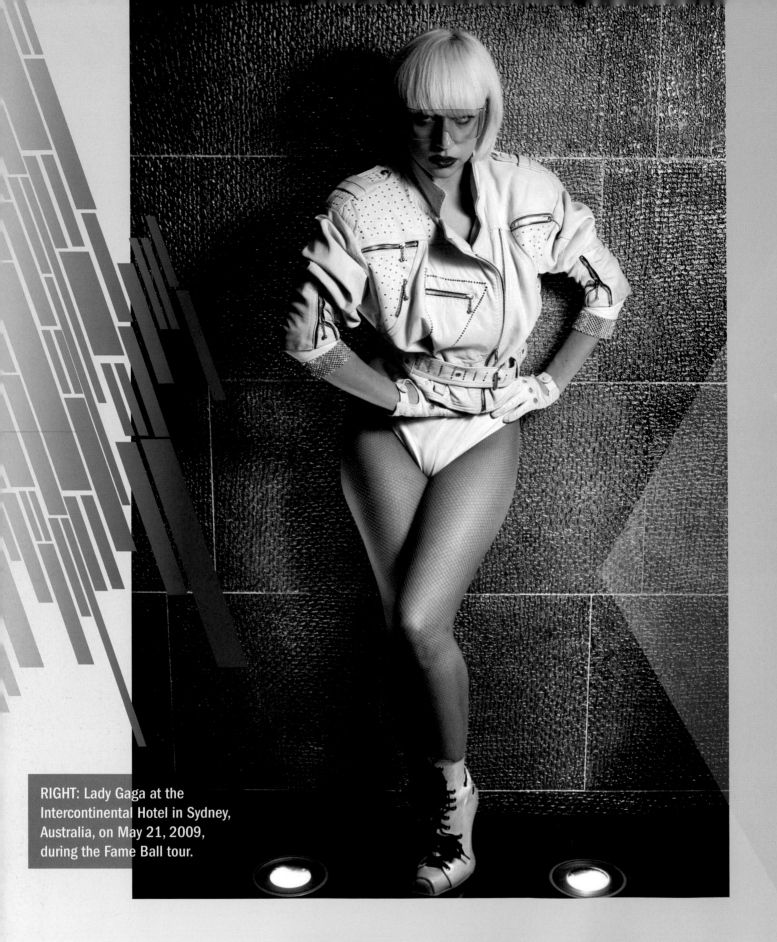

RIGHT: Lady Gaga at the Intercontinental Hotel in Sydney, Australia, on May 21, 2009, during the Fame Ball tour.

PANT

The first time Lady Gaga stripped on stage was during a small club gig at the Bitter End in New York City. "The bar was packed, and the crowd was full of fratty, drunk NYU students," she has recalled. "They wouldn't shut up, and I couldn't play until everybody got quiet. So I took my clothes off. Then everybody shut up." The moment was career defining, even if no one but Gaga knew it at the time. "I felt a spontaneity and nerve in myself that I think had been in a coffin for a very long time," she told *Out*. "At that moment I rose up from the dead. And I made a real decision about the kind of pop artist I wanted to be."

Before she started getting naked on stage, Lady Gaga didn't really know who she was, creatively. She'd been an attention-obsessed, obscenely ambitious, preternaturally talented kid from an early age, but her mind was still a kaleidoscope of ideas with no unifying theme or direction. In truth, she had something in common with all those Abercrombie-clad bros ignoring her as she tried to play; they were bored and disconnected from her performance, and so was she. But after she stripped to her underwear, fishnets, and white pumps—in that moment of stunned silence, as the air hit her newly bare skin, before the catcalling started—Lady Gaga found something that she was looking for: freedom. And she's been pantsless ever since.

GOING
PANTSLESS

During Madonna's reign as the queen of pop, boobs were the zeitgeist-defining body part, and the Material Girl promoted her spectacular pair with characteristic dedication, aiming them at audiences like weapons in her infamous Gaultier cone bra. In Britney Spears's era, it was all about the bare midriff: flat, bronzed, and coquettishly peeking out above a schoolgirl skirt or hip-slung Seven jeans. But in the last few years, it's been all about the legs: long, sleek, and exposed to the maximum in whatever way possible, whether that involves scandalously short miniskirts or Lindsay Lohan–endorsed skintight leggings. Gaga, ever seeking to push the limits of trend, has taken it one step further and dropped any pretense of covering her lower half at all.

Especially for women, being sexy is directly tied to being famous. When labels are assembling paper-doll pop stars in boardrooms in Los Angeles and New York, sex appeal is discussed with the same level of cool-headed practicality as whether or not the kid can sing, dance, or speak coherently. In fact, it's sometimes even more important; we have Auto-Tune and choreographers and media trainers to deal with the rest of that stuff, but if you're not cute, you're not marketable. Unattractive people can be pop stars but it's rare, and when it happens, their substandard looks are usually a key element of their story. (The beauty of *Britain's Got Talent* sensation Susan Boyle's voice seems all the more extreme when contrasted with her ugly duckling looks.)

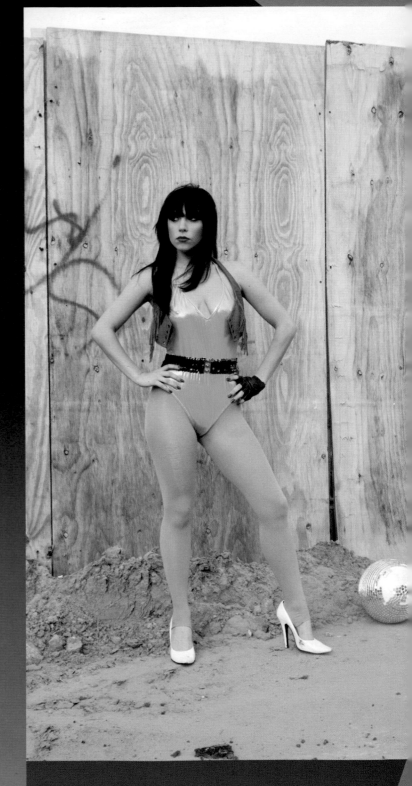

Lady Gaga has given us a lot to look at. But of all the images she's presented, the one we immediately associate with her is the one where she's not wearing any pants. It's the only constant we expect from this compulsively chameleon-like figure, and no matter what incarnation she adopts in the future, this is the look that will define her rise because it's the look that helped her find her identity as an artist. Even before she had an army of posh costume designers sewing sequins on her hot pants Gaga knew how to rock her signature look in a cheap teal one-piece and a child-sized suede cowboy vest.

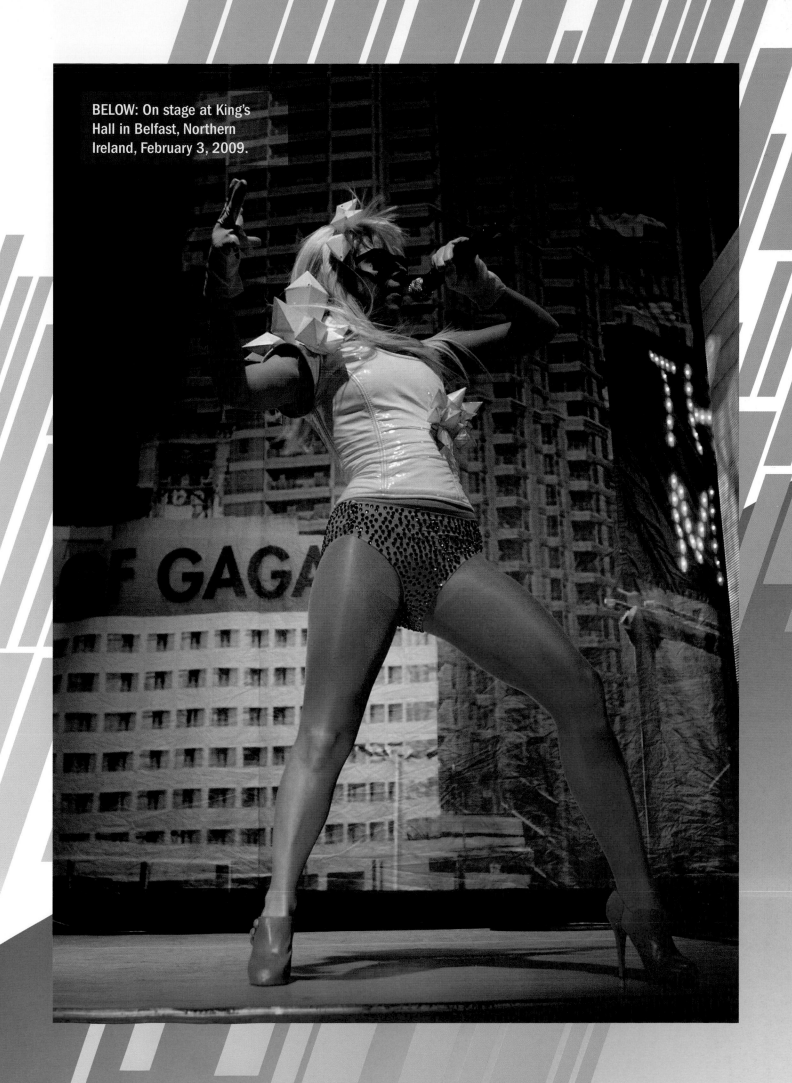

BELOW: On stage at King's Hall in Belfast, Northern Ireland, February 3, 2009.

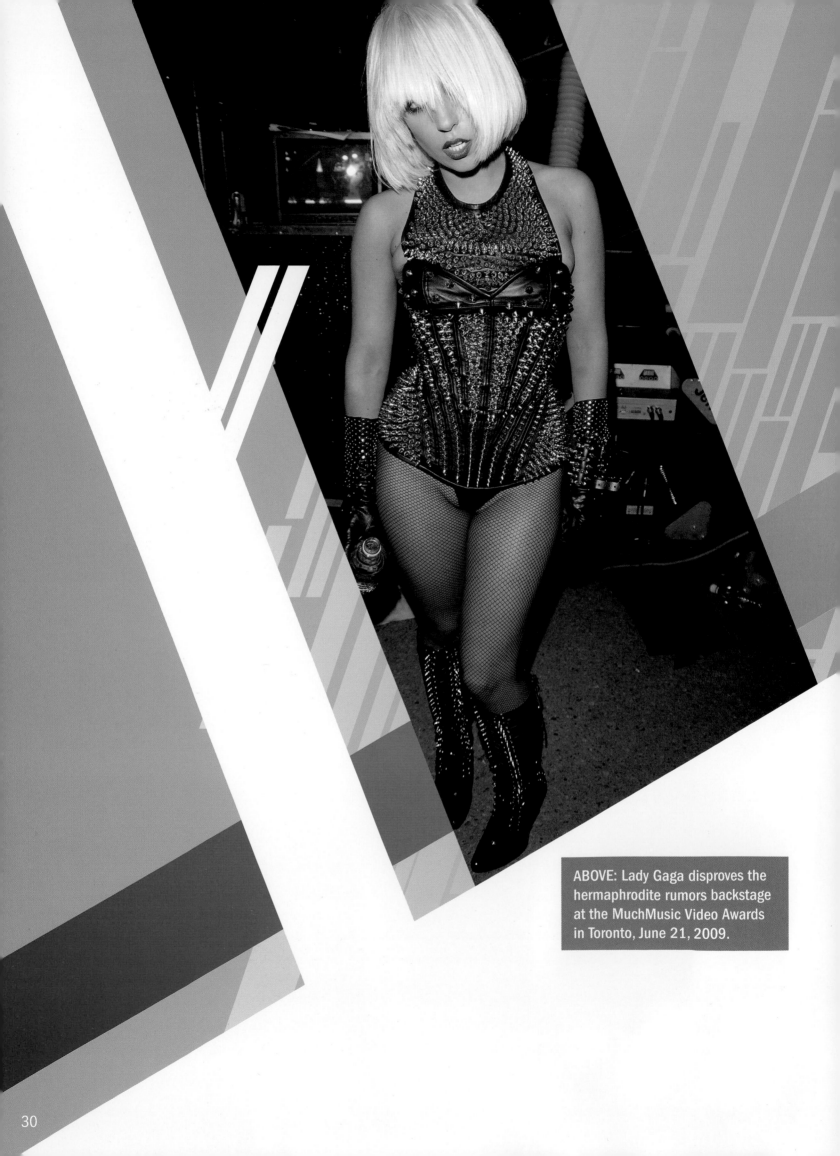

ABOVE: Lady Gaga disproves the hermaphrodite rumors backstage at the MuchMusic Video Awards in Toronto, June 21, 2009.

This system, in and of itself, isn't really a problem: We all like to look at attractive people. We want to be like them. And aspiration is what fame's all about. Lady Gaga gets that sex appeal is part of her job, and she revels in displaying it, but she doesn't want it to become just another line on her résumé. She wants to control it. Sometimes literally: "I don't know if this is too much for your magazine, but I can actually mentally give myself an orgasm," she confided to *New York* magazine. "You know, sense memory is quite powerful."

Even before she had any stage to strip on, Lady Gaga was researching the power of sexual assertiveness while waiting tables at upscale Sicilian bistro Palma in Manhattan's West Village. "The other waiters got so mad," the singer recalled. "Because they had full careers at the restaurant, and then I came in my little heels [because] you always make more money in heels." By the winter of 2008, Gaga's interest in the interplay between power and sex had become much more explicit; she decided to make a "feminist" statement with a pair of sparkly underwear. "I wore them so often and so frequently and so repetitively and consistently and diligently and punctually that it became a true statement about my freedom," the singer told *Q*, with comical earnestness. "I believe in the power of propaganda, of repetition." And in the power of exploiting yourself before anyone else has the chance. Getting naked on stage that night at the Bitter End, strapping on crippling four-inch platforms to earn a few extra bucks at Palma, prancing around the Lower East Side in the dead of winter in disco ball panties, declaring to the world her passion for sex but insisting she's married to her work: These are the behaviors of a woman who wants to be a sex object—but only on her own terms.

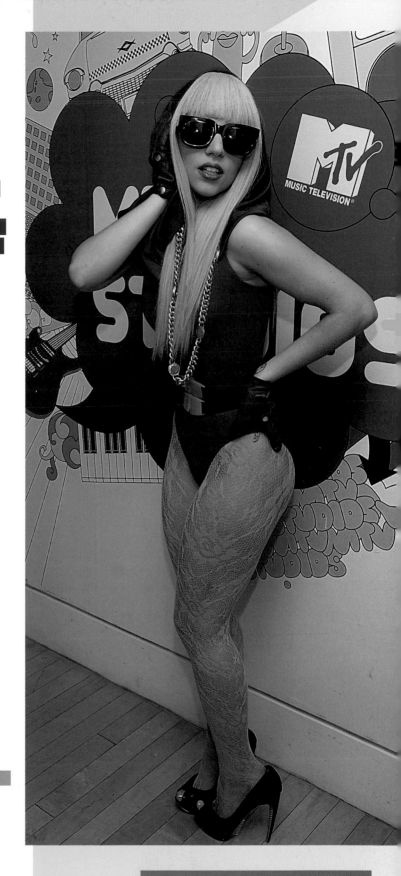

Above: Looking a little hip-hop and a little glam while visiting *TRL* at the MTV studios in New York, August 12, 2008.

And she's not the only one who feels that way. Not since the '60s have young women been so obsessed with balancing ambition and creative achievement with a rocking sex life. Madonna invented it, *Sex and the City* broadcast it on television, Angelina Jolie personified it, and now you have an entirely new generation eager to use sexual provocation as a means of self-empowerment. (See as evidence the success of *Secret Diary of A Call Girl*, a naughty, intelligent TV series based on the blogs of Belle de Jour, a medical researcher by day and high-class London call girl by night, or the emergence of pole dancing as exercise.) "People think if you're strong about your sexuality, you must have a dick," Lady Gaga has said with characteristic bluntness. "[But] you can be strong about your sexuality and be a smart woman who wears lipstick and high heels and looks pretty."

BELOW: A promotional shot for Lady Gaga's appearance at the Open A.I.R. Summer Concert Series in New York, May 15, 2008.

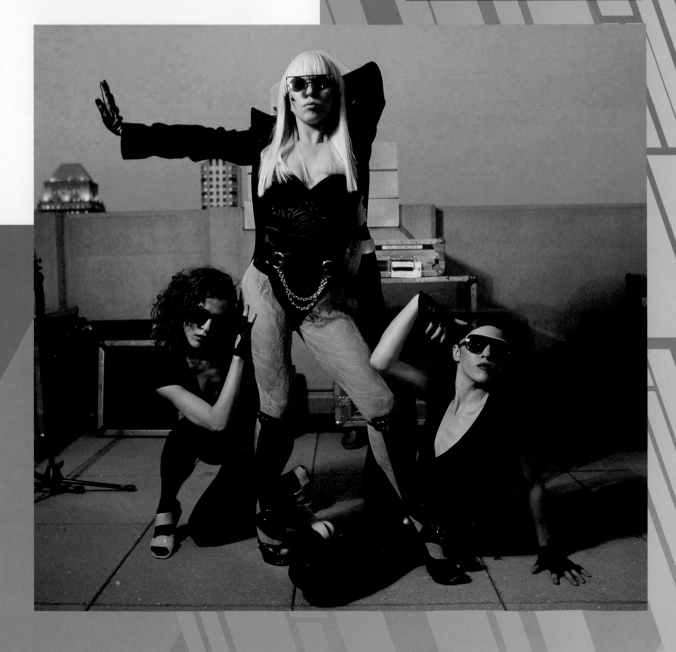

ABOVE: At the VIP Room Theatre in Paris, February 25, 2009.

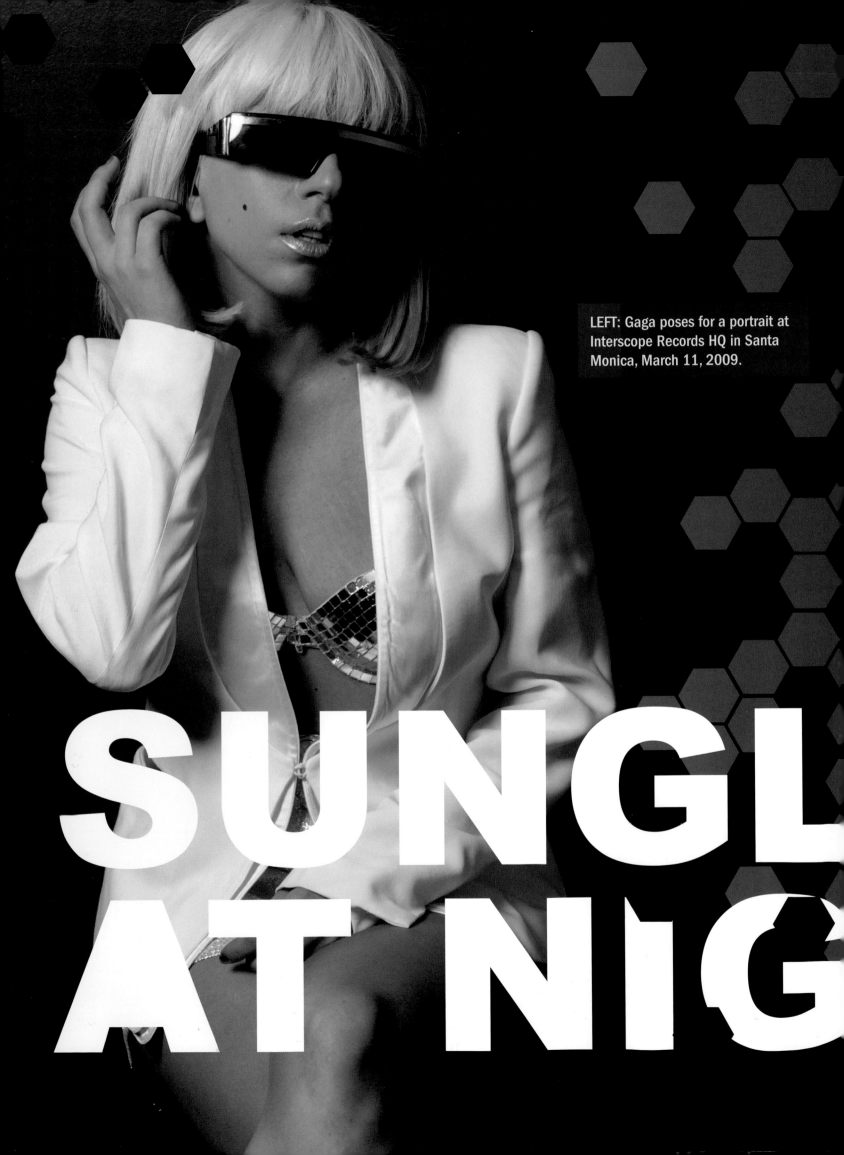

LEFT: Gaga poses for a portrait at Interscope Records HQ in Santa Monica, March 11, 2009.

SUNGL AT NIG

"I really have nothing to say, but I want to say it all the same," says Guido Anselmi, the famous Italian film director whose creative crisis is the plot of Federico Fellini's *8 ½*. The film portrays success as divorced from inspiration and rife with frivolous distraction—agitated studio honchos, melodramatic actresses, and various wives and mistresses all gather around Anselmi conveying their various displeasures, which he receives imperiously from behind a pair of giant black shades not unlike the Versace 676s Lady Gaga often wears. But Fellini, like Gaga, was as interested in celebrating the vapidity of Hollywood as he was in criticizing it. When Fellini began shooting the film in the spring of 1962, he taped a little piece of paper next to the viewfinder of the camera. It read: "Remember, this is a comedy." As decadent and silly as they all are, Fellini conveyed great affection for his characters and retained a deep sense of humor about the absurdity of their lives and, by extension, his own. And to do that, you need a great pair of shades.

ASSES
HT

Maybe you're a professional chemist and you wear goggles in case something explodes in the lab, or you're a fighter pilot (awesome) and you wear Aviators without irony, or maybe you are actually outside on a sunny day. Whatever the context in which you reach for them, when you put on a pair of shades, you're looking for protection. In Gaga's world, she needs protection from being seen as anything other than whatever walking, talking art installation she's turned herself into. In order to pull off what she's going for creatively, Gaga can't run the risk that the windows to her soul might betray her aesthetic, so she keeps them covered. "She has a thing about showing her eyes," architect Frank Gehry, who designed the singer's giant crumpled hat for the Museum of Contemporary Art anniversary gala, has said. "She doesn't like to."

BELOW: Lady Gaga chews up the stage wearing the crystal-encrusted glasses from the cover of *The Fame*, Mannheim, Germany, August 29, 2008.

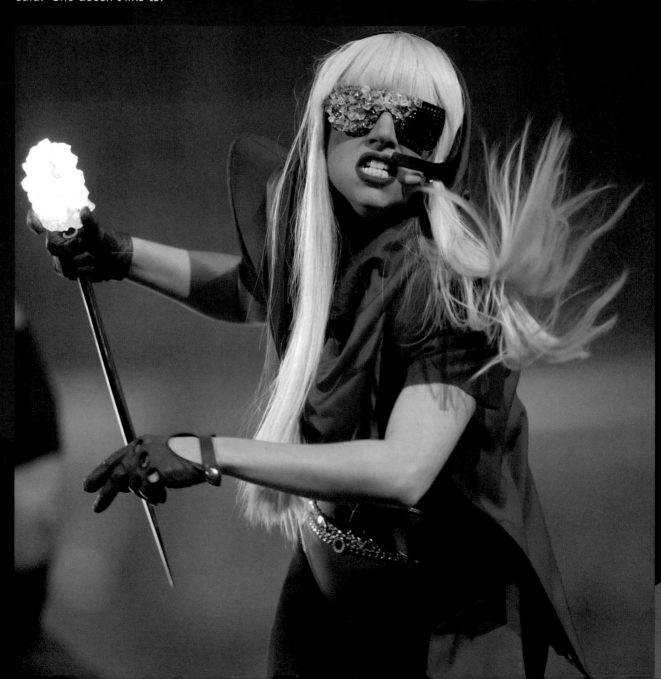

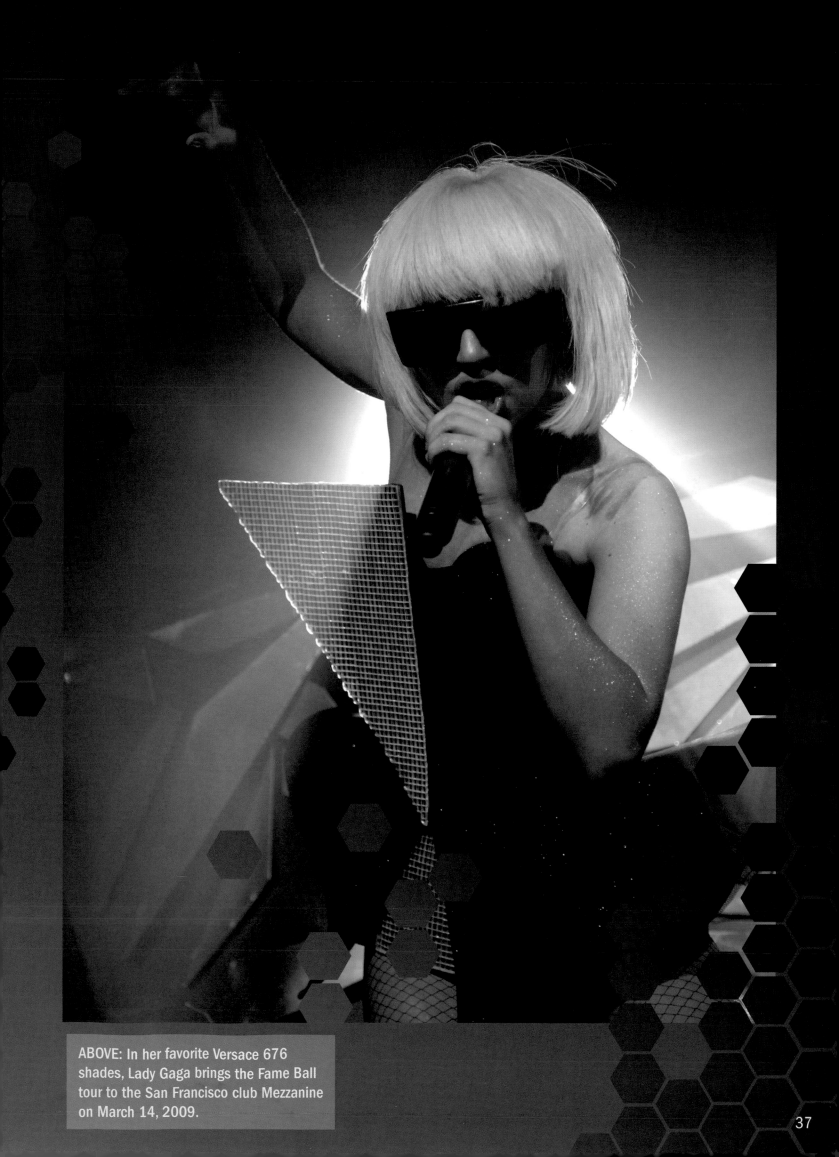

ABOVE: In her favorite Versace 676 shades, Lady Gaga brings the Fame Ball tour to the San Francisco club Mezzanine on March 14, 2009.

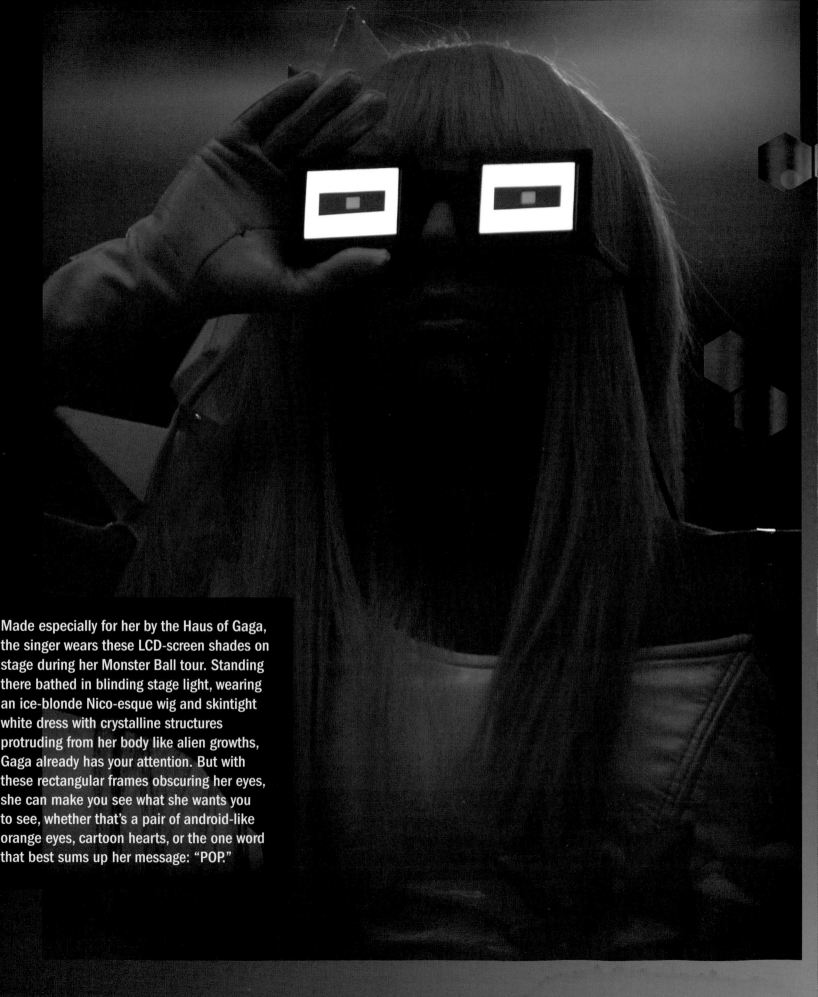

Made especially for her by the Haus of Gaga, the singer wears these LCD-screen shades on stage during her Monster Ball tour. Standing there bathed in blinding stage light, wearing an ice-blonde Nico-esque wig and skintight white dress with crystalline structures protruding from her body like alien growths, Gaga already has your attention. But with these rectangular frames obscuring her eyes, she can make you see what she wants you to see, whether that's a pair of android-like orange eyes, cartoon hearts, or the one word that best sums up her message: "POP."

In her short career, Lady Gaga has assembled an impressive collection of bizarre eyewear. There are the decadent, slightly odd but always glamorous designer pieces: the flip-up Minnie Mouse shades by Jeremy Scott for Linda Farrow, the Dolce & Gabbana butterfly glasses, and the Scott Wilson for Hussein Chalayan lens-less fluorescent wraparounds. And then there are the truly nutty works of eyewear art, many of which she can't even see out of: the chain-link fence shades from the "LoveGame" video, the lit-cigarette glasses from the "Telephone" video. "Gaga doesn't care so much about the technical part, but she's involved in every creative aspect," "Telephone" director Jonas Åkerlund told *New York* magazine. "We just allow ourselves to be very stupid with each other, and then you get ideas like sunglasses made of cigarettes." The Haus of Gaga worked with her on a pair of rectangular projector specs, which show images of everything from the singer herself to cartoonish hearts to the word "pop." The singer even wore a pair made of razor blades in the "Bad Romance" video, which she considers super feminist. "I wanted to design a pair for some of the toughest chicks and some of my girlfriends," the singer has said of these infamous shades. "They used to keep razor blades in the side of their mouths," she explained. "That tough female spirit is something that I want to project. It's meant to be, 'This is my shield, this is my weapon, this is my inner sense of fame, this is my monster.'"

ABOVE: The glasses go classic as Gaga arrives in Melbourne, Australia, on September 26, 2008, to promote her newly released single "Just Dance."

f French philosopher Michel Foucault were still alive, he could probably get a spot on Lady Gaga's guest list. Dubbed the "bondage philosopher," Foucault theorized that what's considered normal and abnormal sexual behavior is completely determined by social context. If you think respectable missionary sex is tasteful and appropriate, take note: You're actually in the middle of a really twisted sex game with society in which you submit to its rules and it convinces you that you like it. Try being blindfolded and bound to the bed. That's real freedom.

Freedom is big with Lady Gaga. "I'm a free bitch," she sings in "Bad Romance," repeating it like a mantra on stage when she's reveling in her moment, getting her minions to scream it when she wants to pump them up. And like the naughty, nerdy Foucault, Gaga finds freedom in bondage. The most literal example of this is in fashion; the singer regularly wears outfits that reference different roles in BDSM sex play. Sometimes she's the sadist, an imperious vinyl-coated dominatrix in thigh-high boots; sometimes she's the masochist, collared and constrained by yards of chain worn as a necklace or dresses so tight they look like they'd bruise.

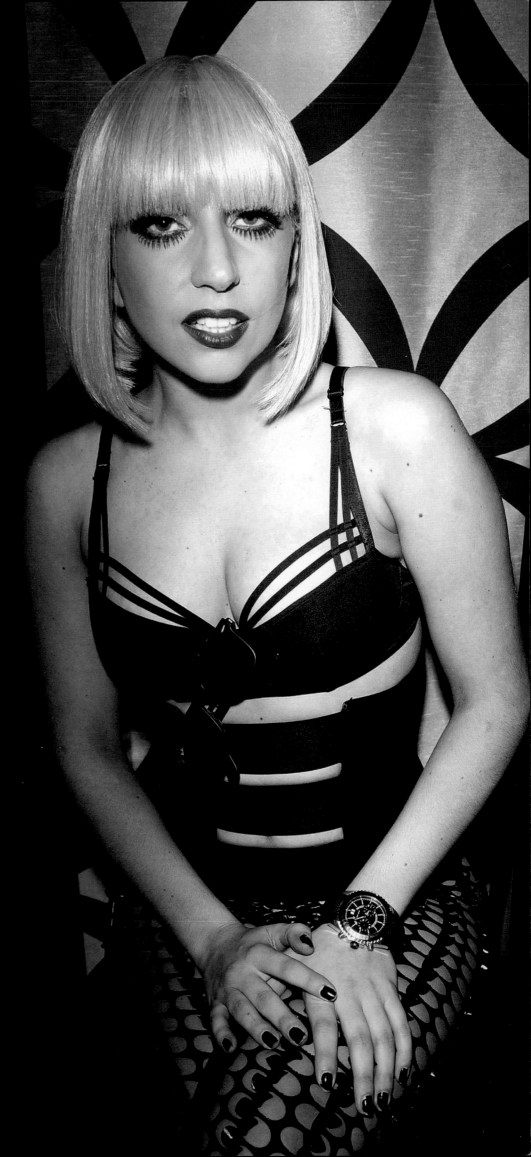

Right: Lady Gaga refuses to relax in the lounge at the MuchMusic Video Awards in Toronto, June 21, 2009.

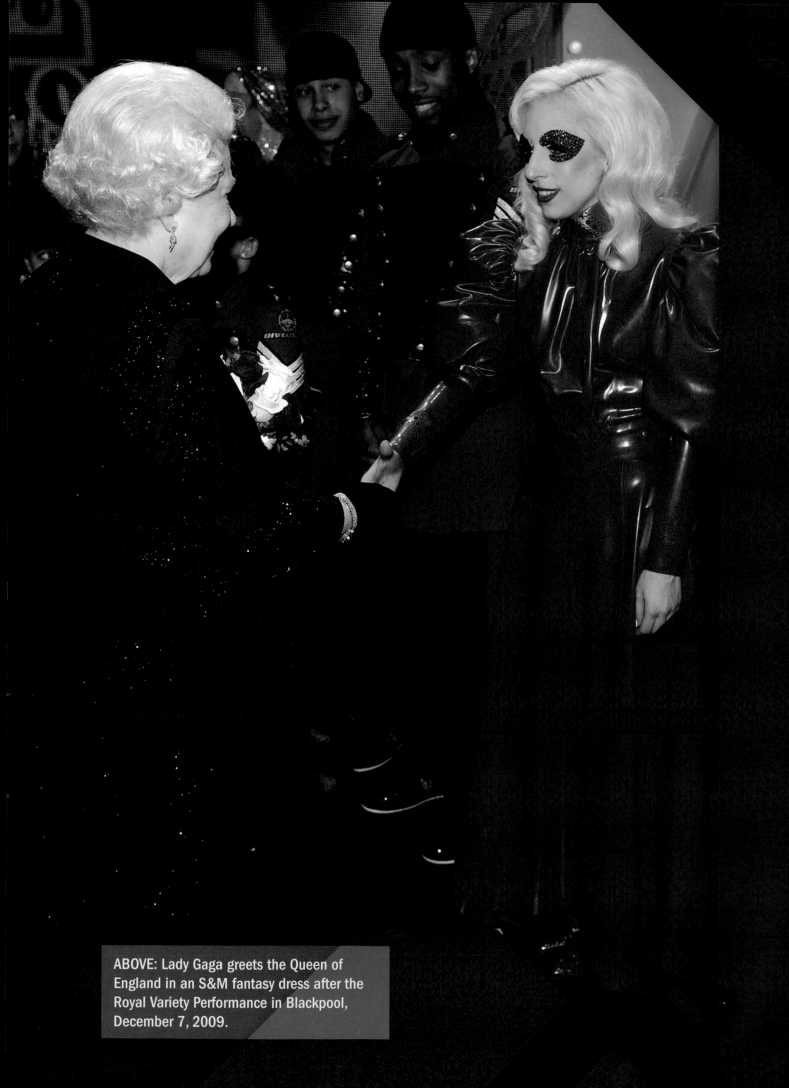

ABOVE: Lady Gaga greets the Queen of England in an S&M fantasy dress after the Royal Variety Performance in Blackpool, December 7, 2009.

Sometimes she plays the demure subject, bowing to her queen in a bloodred PVC gown with a tall, suffocating Elizabethan collar around her neck. And sometimes Gaga blurs the line between sartorial pleasure and pain to such a degree that it's life-threatening. On a flight between London and New York in the spring of 2010, a team of flight attendants had to cut the pop singer out of an Alexander McQueen dress made of black and yellow tape. Her limbs had begun to swell, signaling the onset of vein thrombosis, which can be deadly.

"I don't feel that I look like the other perfect little pop singers," Lady Gaga told *Rolling Stone*. "I think I look new. I think I'm changing what people think is sexy." Lady Gaga is not conventionally pretty. She has a distinctive nose and prominent teeth—two features most aspiring pop stars get sanded down and molded into generic, appealing shapes before their first single comes out. And yet Gaga is arrestingly attractive. Just as she's used her outsider status to forge a psychological connection with her fans, she's used her unconventional looks to promote a new kind of beauty. The singer actually distracts from her flawless skin and large, expressive eyes to present the weirder aspects of her appearance as what's beautiful about her.

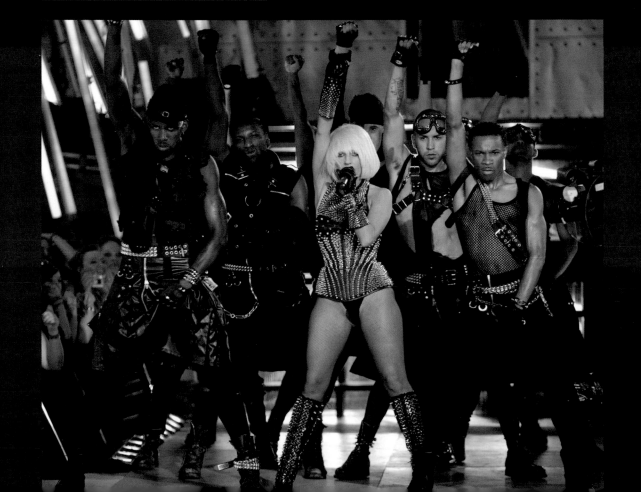

BELOW: Lady Gaga and her backup boys get aggressive in studded leather during the 2009 MuchMusic Video Awards.

"I want women—and men—to feel empowered by a deeper and more psychotic part of themselves," Gaga told the *Los Angeles Times*. "The part they're always trying desperately to hide. I want that to become something they cherish." For Lady Gaga, freedom is all about subverting traditional values. She expresses this partially through bondage dress—the more punitive her clothing, the more unleashed she feels. And she expresses it through extreme makeup, by transforming herself into a glamorous but grotesque pop object, not beautiful exactly but totally mesmerizing. And finally, Gaga expresses her freedom through sexual provocation. In a world where women are taught to fear their own sexual appetites and seek stability and confidence through partnership with men, Gaga is a sometimes-promiscuous, sometimes-celibate, but always wilfully unattached beacon. As a teenager on the Upper West Side, going to school every day in her demure uniform, practicing her classical piano like a good little girl, and making straight As, she was also having as much sex as possible. "I wanted to sleep with as many rock n' roll guys as I could," the singer told *Cosmo*, "and I've certainly had my fun." Even when she has a boyfriend, she doesn't really, saving her deepest fidelity for her work and her fans. "Some women choose to follow men, and some women choose to follow their dreams," she has said. "If you're wondering which way to go, remember that your career will never wake up and tell you that it doesn't love you anymore." She might be lying twisted and contorted in a mock coffin, sewn into a rib-bruising corset, or poured into a suffocating body casing, but no matter what, Lady Gaga always holds the keys to her own handcuffs.

Lady Gaga is passionate about sex. And she's passionate about power. And super passionate about promoting the connection between sex and power, especially to her female fans. "We are really looking forward to seeing that lip color on condoms all over the world," the singer told *Women's Wear Daily* while promoting her M.A.C. lipstick. But for Gaga, sexual power doesn't come from sexual abandon alone: Sometimes it comes from restraint. "I come across in all my videos and all my music as this sexually empowered woman, but even I say no," she continued. "Just because you are a sexual woman doesn't mean you are dumb."

ABOVE: Wearing a tight vinyl pencil skirt and veil at the launch of her Heartbeats headphones in Berlin, September 7, 2009.

"I would rather die than have my fans not see me in a pair of high heels," Lady Gaga told British TV presenter Jonathan Ross in the spring of 2010 while wearing an old-fashioned black telephone on her head. "You see legendary people taking out their trash, I think it's destroying show business."

It's hard to pinpoint exactly when it happened, but at some point it became desirable for celebrities to be normal. Instead of seeing a grainy photo of Leonardo DiCaprio gassing up his Prius in flip-flops, or Madonna without makeup, our contact with famous people used to be limited to whatever they did to become famous. But with the entire globe online twenty-four hours a day, there is an insatiable desire for new information about our idols, and a vast network of blogs, Web sites, and magazines in place to meet demand. And yet, as manically as we devour images of Jessica Simpson in line for security at LAX in dirty sweats or Ben Affleck getting a parking ticket, a little part of our enthusiasm for stars is dampened when we see them this way.

These glittery space platforms look like they defy gravity, as if Gaga is walking around on her own personalized jeweled clouds, but they have to hurt. As every woman knows, the narrower the platform the more unstable the shoe, and the actual soles of these decadent creations are the size of a baby bootie. Perhaps it's all those years spent dancing on stages the size of two-by-fours, but Lady Gaga has serious skills in the walking-in-heels department. Every time she straps her feet into another pair of stilt-like contraptions, she's giving another mini performance just by walking down the red carpet. And that's what we love about Lady Gaga: She doesn't get out of bed without putting on a show.

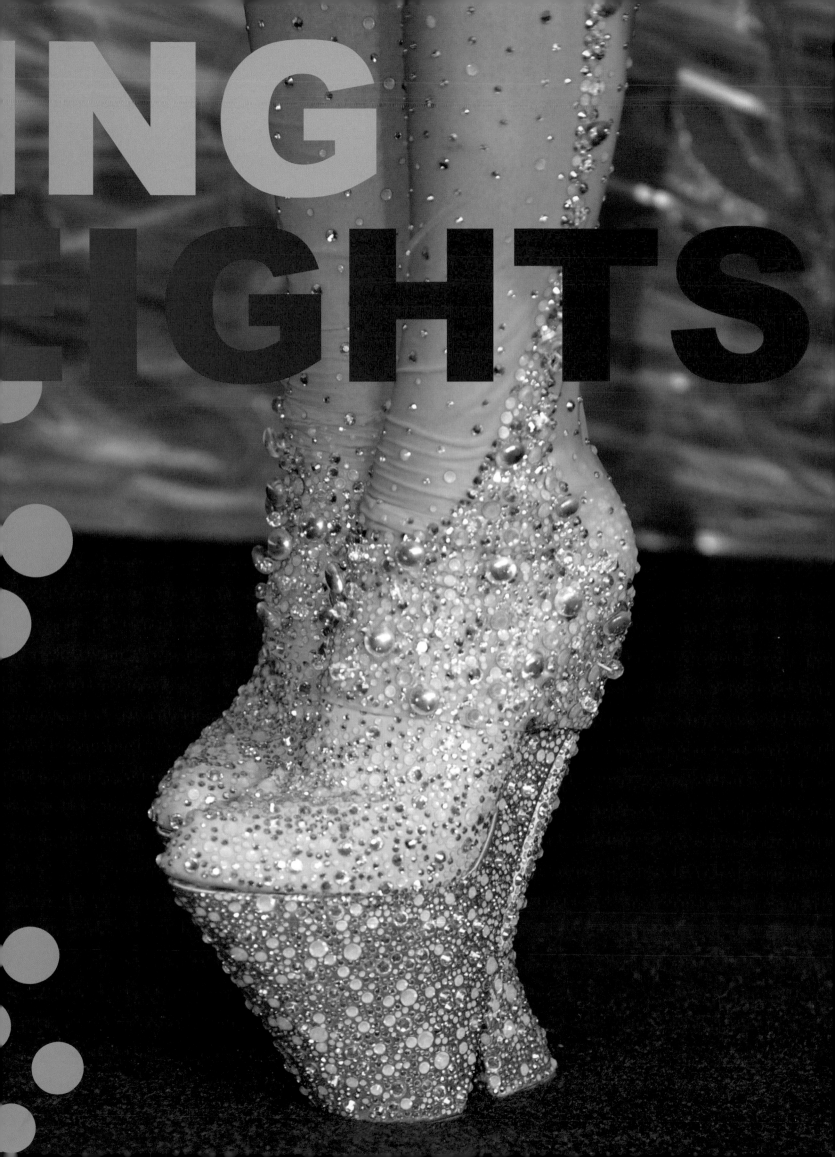

Famous people are not supposed to be just like us. We are already just like us. Fame is supposed to be about perpetuating a fantasy the rest of us can't possibly live up to, so that we have someone happier, more beautiful, more talented, and richer to obsess over. "It's not really rocket science," Gaga has said of the fame equation. "The music is intended to inspire people to feel a certain way about themselves, so they'll be able to encompass, in their own lives, a sense of inner fame that they can project to the world." And in order to accomplish this, the singer needs to be in character at all times. The wigs, the tan, the fake fingernails, the rhinestones, the hats, they're all part of the elaborate, relentless process of keeping Gaga away from the realm of the ordinary.

Nothing projects the power of femininity like a woman in towering heels. Like most women, Gaga has as many pairs as she can get her hands on. She has her outrageously sexy footwear: neon yellow stripper sandals with clear plastic binding, messily laced thigh-high nude boots, and skintight black PVC platform hooker boots. Then she has her truly bizarre works of footwear sculpture, which are often so constricting and difficult to walk in that they become another example of the singer's ongoing obsession with bondage: sea green serpent platforms, Ziggy Stardust-esque glittering space boots, the infamous Alexander McQueen armadillo shoes, and an outfit featuring stilettos on the shoulders. Even when Gaga is dressed down, in a demure evening gown or a simple pencil skirt, she doesn't just wear a pair of nondescript black pumps. They have to be architectural heel-less wedges or stilettos with a hidden platform so extreme they're practically stilts.

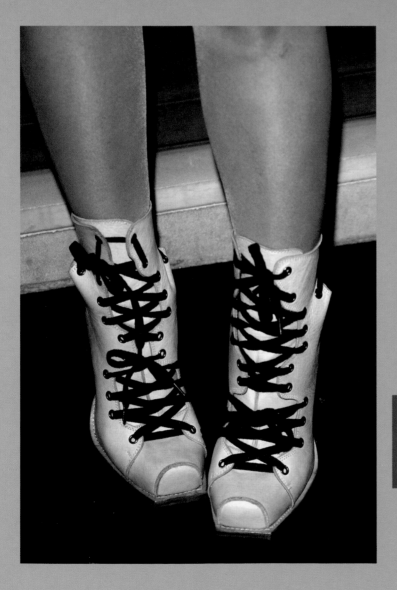

LEFT: Knotted laces and heavy seams adorn the boots Gaga wore to a benefit in Paris on April 23, 2009, which she paired with gold Christian Dior.

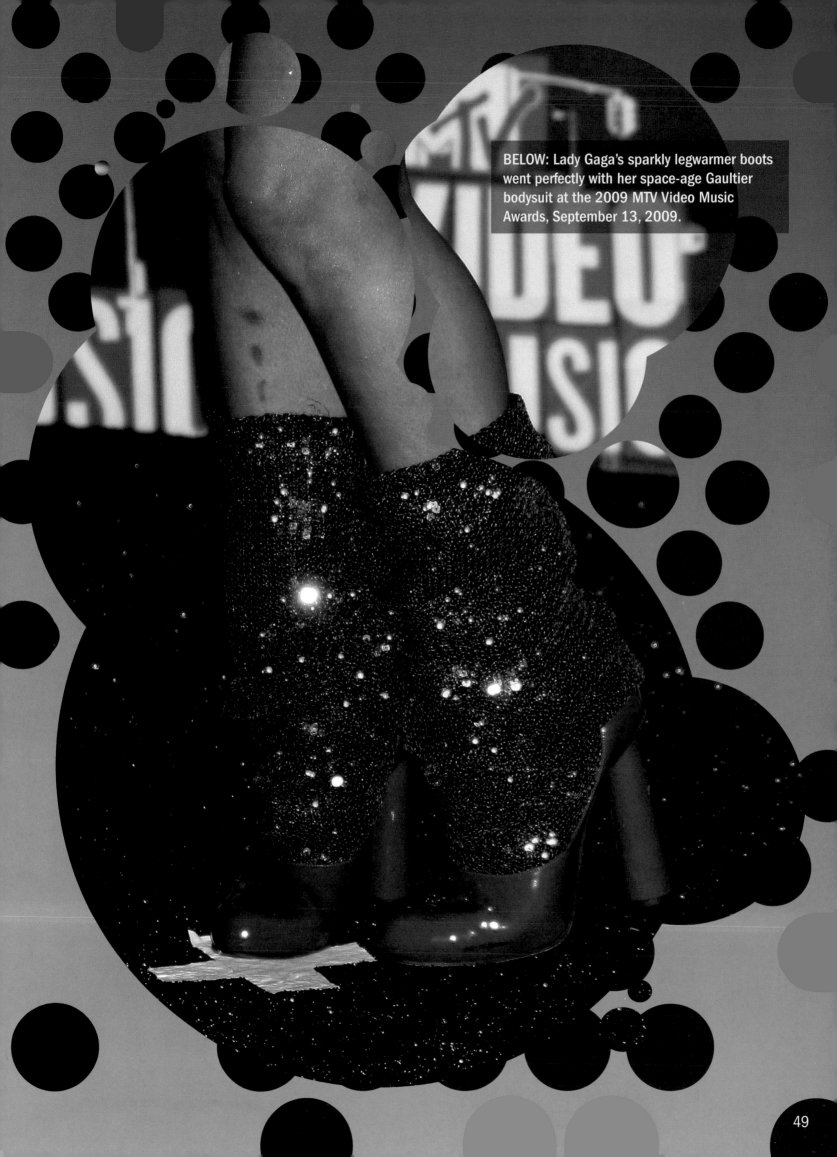

BELOW: Lady Gaga's sparkly legwarmer boots went perfectly with her space-age Gaultier bodysuit at the 2009 MTV Video Music Awards, September 13, 2009.

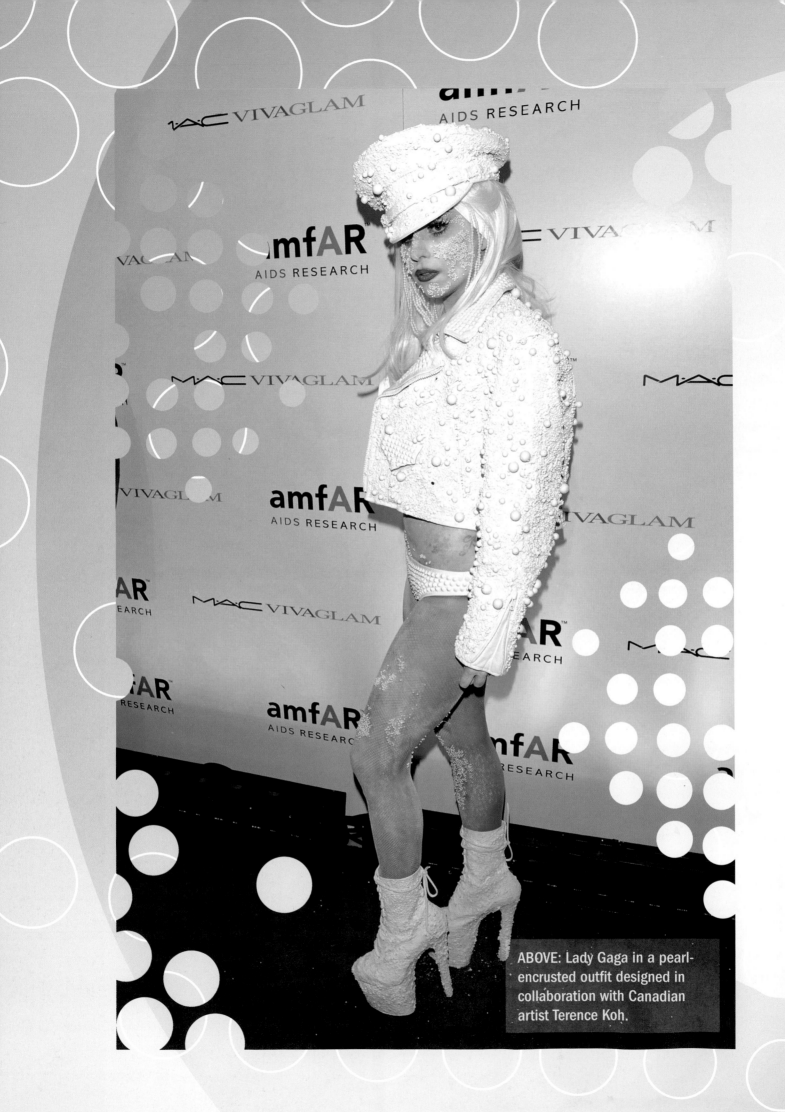

ABOVE: Lady Gaga in a pearl-encrusted outfit designed in collaboration with Canadian artist Terence Koh.

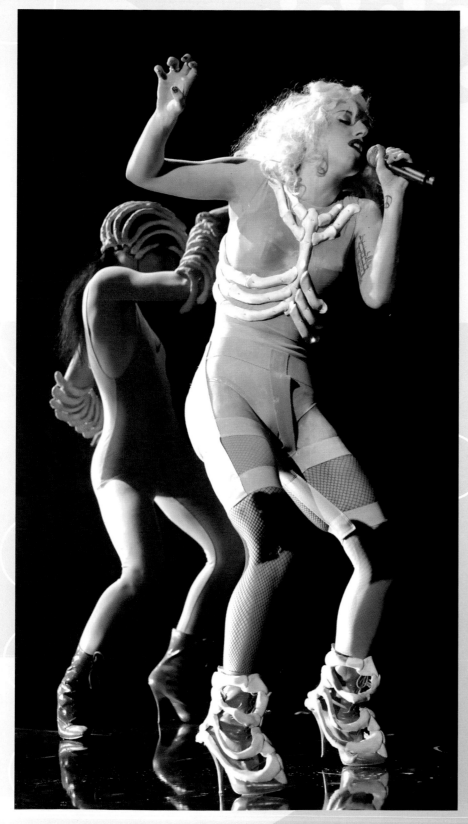

Gaga's shoes are difficult to walk in, nearly impossible to dance in, expensive, and physically painful to wear; but without them, Lady Gaga finds it hard to go on, literally. After discovering that the pair of custom Christian Louboutins she was supposed to wear on *The Tonight Show with Jay Leno* had been stolen, Gaga held up production for more than an hour while a massive shoe hunt was conducted. In the end, she had to perform barefoot, but not before breaking down in tears. It wasn't quite as bad as being seen taking out the trash, but for Gaga it was close.

*W*hen Lady Gaga was six years old she used to watch her mother get ready every morning. "I'd sit on the toilet and watch her set her hair," the singer told *Women's Wear Daily.* "She'd put in a curler and hand one to me, and I'd be trying to pin them in and they would be falling everywhere. Next, she'd hand me the lipstick and I'd put it on. That was my first relationship with beauty." The ritual not only instilled in Gaga a deep love of dress up, it showed her that makeup has the power of transformation. Without makeup, Cindy Germanotta was an average Italian housewife who'd just rolled out of bed, but after she put on her face she was the glamorous mother of Lady Gaga.

Gaga's transformation, however, took a little time. The singer's high school yearbook photos show a glossy-haired, all-American blonde, the kind of girl who is everybody's favorite babysitter. But behind that Colgate smile, the aspiring singer felt like a complete outcast. She was drawn to artists like Grace Jones and David Bowie, people who reveled in their

EX
MAK

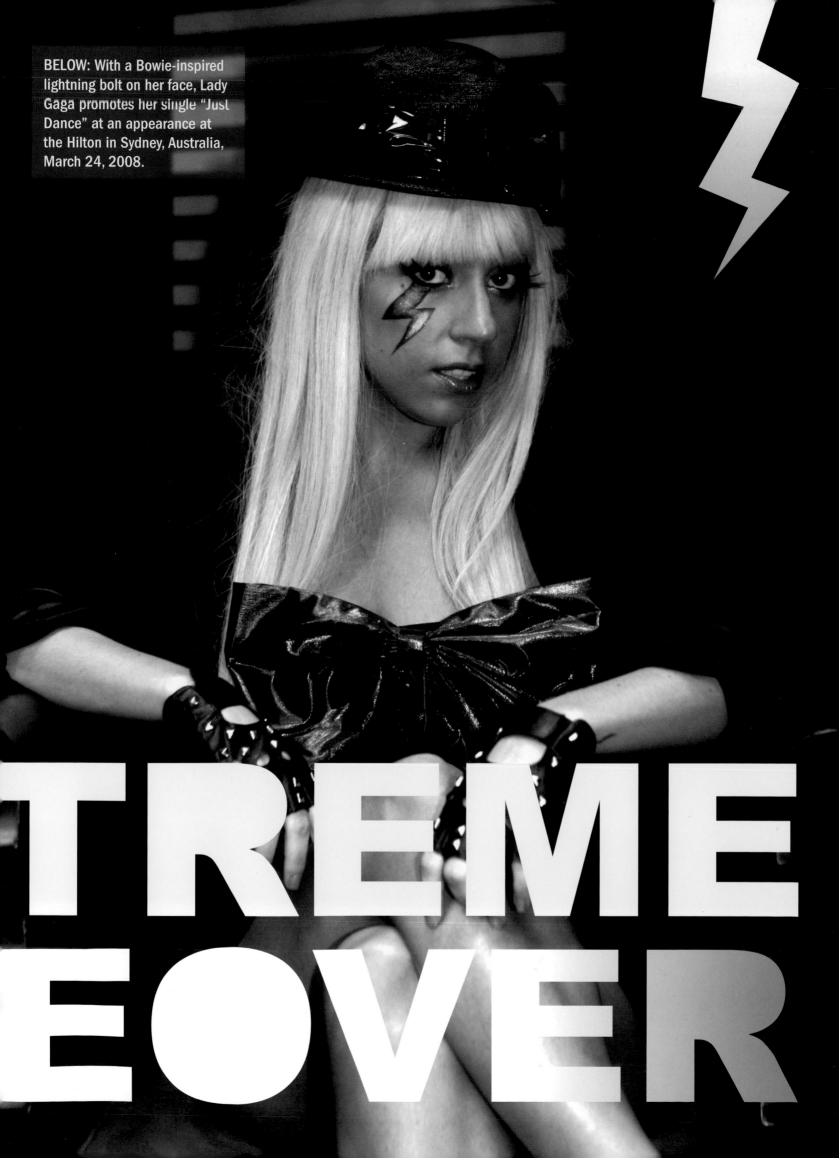

BELOW: With a Bowie-inspired lightning bolt on her face, Lady Gaga promotes her single "Just Dance" at an appearance at the Hilton in Sydney, Australia, March 24, 2008.

TREME
EOVER

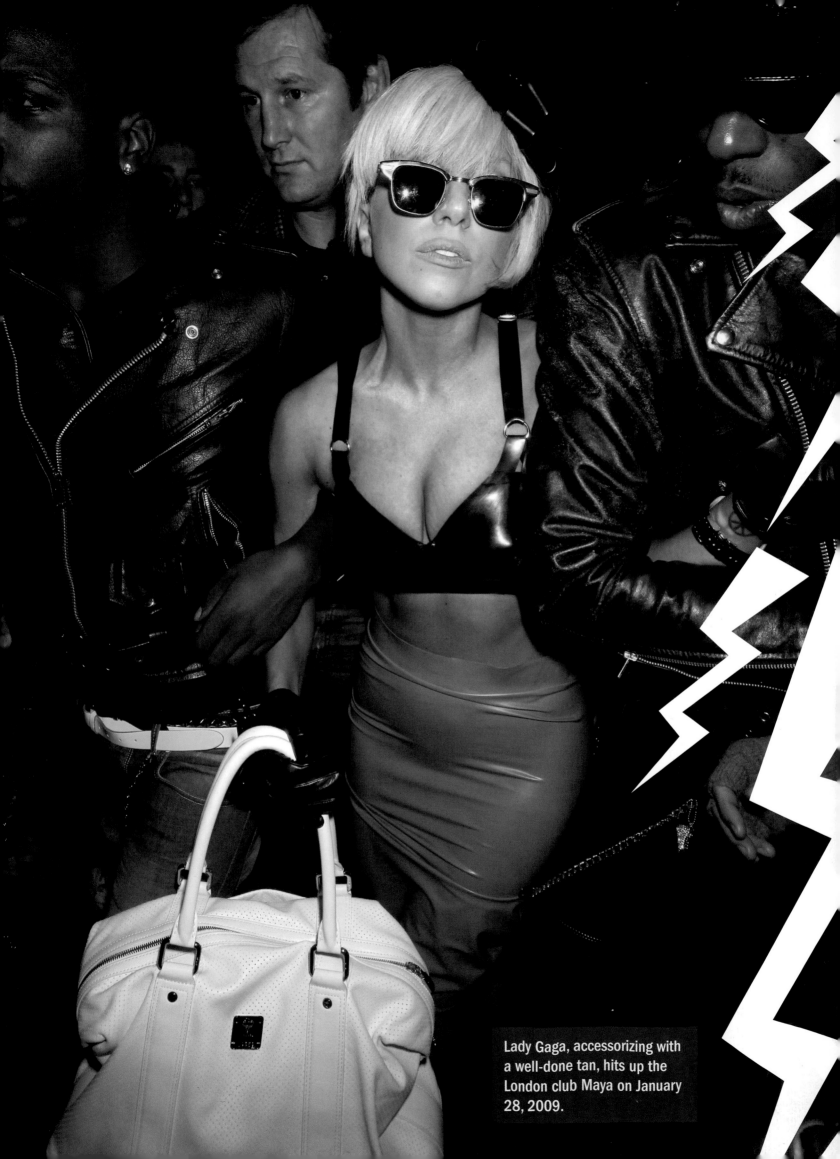

Lady Gaga, accessorizing with a well-done tan, hits up the London club Maya on January 28, 2009.

RIGHT: In 2007, Lady Gaga spent a lot of her time holed up in her apartment experimenting with different makeup looks, imitating idols like David Bowie and Marc Bolan of T. Rex.

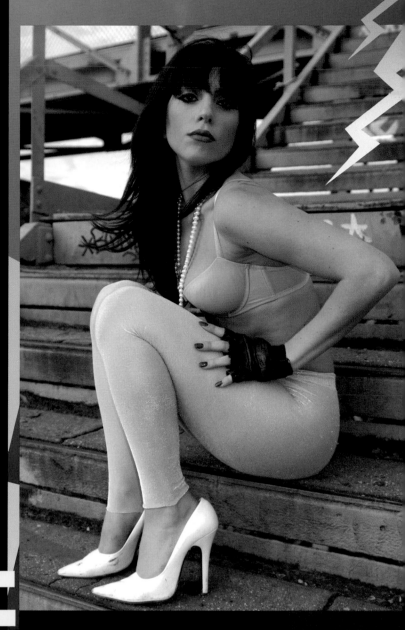

own freakishness, and she longed to do the same. But as a good student from a tight-knit family, Gaga had to make do with small rebellions: illegally short schoolgirl skirts, rock music, and lots of makeup. "I had to put my makeup on when I got home before I went to bed because I wasn't allowed to wear makeup in school," the singer has said. "When I walked around the corner and saw Boy George in the window [of a M.A.C. store], I said, 'I feel just like that!' Why is that attitude nowhere else? And RuPaul, and Pamela Anderson . . . I said, 'Gosh, I feel just like that.'"

Well before Lady Gaga had anyone around to take her picture, she was making herself up for the cameras; in high school, then at NYU, and after she dropped out to pursue her music career, in her crap apartment on the Lower East Side with nothing but her mirror, her makeup bag, and her cocaine to keep her company. Fueled by line after line, the aspiring star played The Cure's "Never Enough" on repeat and made herself up in one style after another. "I wanted to be the artists I loved, like Mick Jagger and Andy Warhol," she said. The singer eventually realized that the drugs held her back creatively, but the versions of herself she saw staring back at her from that

powder-covered mirror night after night stuck with her. Armed with a few Wet N Wild products and a vision, she could become whoever she wanted to be. And this is the message the singer aims to deliver with her chameleon-like looks. Today she might be a ghost-pale vampire vixen in a velvet gown with red lips, fat blonde curls, and fangs. Tomorrow she might be an orange-tinted Eurotrash diva in a nude latex skirt and black patent bustier with frosted pink lips, blonde bob, and dark shades. Yesterday she might have been a provocative but classy garden party guest in a white cleavage-exposing suit, blue-and-white striped sun hat, and berry-colored Clara Bow lips. She changed the shape of her eyes to become a mental patient in the "Bad Romance" video; she changed the shape of her lips to become a ghoulish ingénue for her performance at the Museum of Contemporary Art.

Gaga started making herself up because she wanted to be somebody else—her mother, David Bowie, Boy George, London club promoter/performance artist Leigh Bowery—but now she is the style icon behind millions of her fans' private and not-so-private dress-up sessions. Online there are countless fashion guides instructing Gaga fans on how to dress like the star . . . for Halloween or just for fun. YouTube clips show you how to replicate the icy, space-age makeup from Gaga's "Poker Face" video. Clubs host Gaga nights, with prizes for the most outrageous outfits. Not since Madonna mania—when an entire generation of teenage girls wore dirty blonde perms and circulation-threatening armfuls of plastic wristbands—has the impact of one pop icon's look been so pronounced. During her rise, Madonna changed her look every album: Gaga changes several times a day, and yet her fans keep up, embracing every new wig, makeup trick, and oversized shoulder pad.

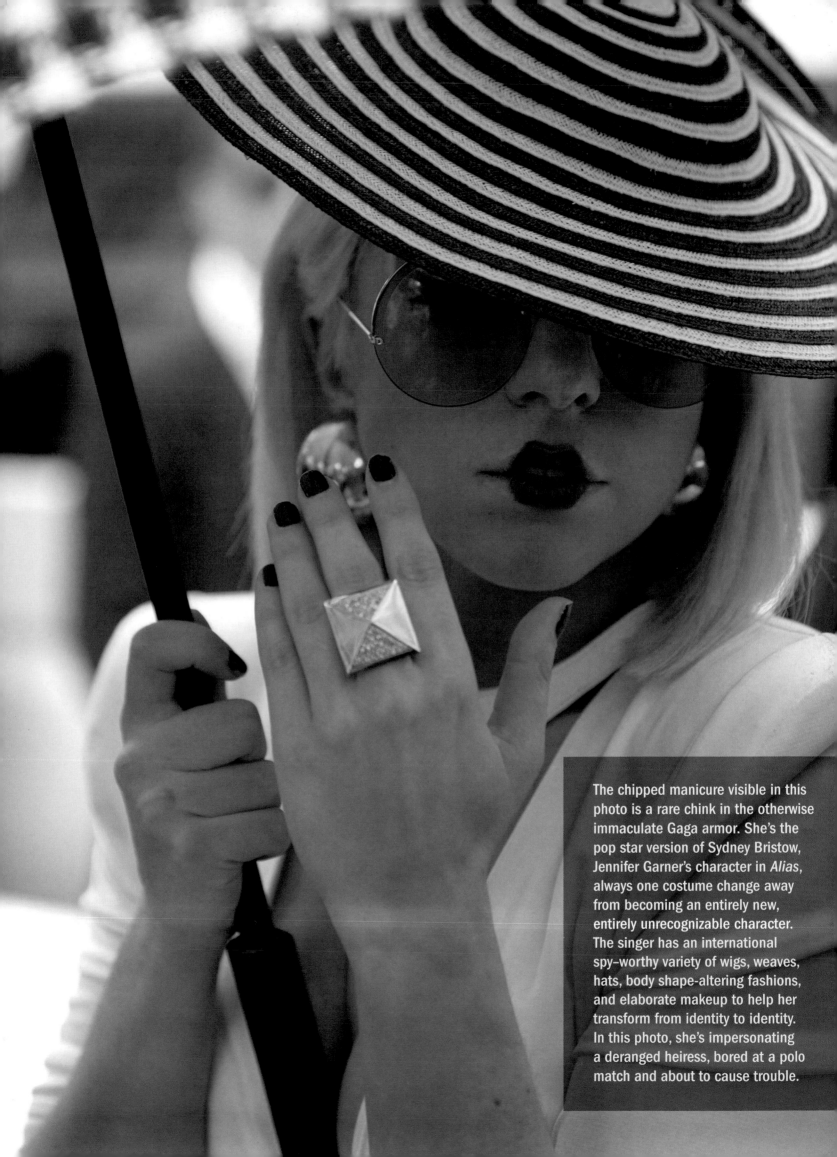

The chipped manicure visible in this photo is a rare chink in the otherwise immaculate Gaga armor. She's the pop star version of Sydney Bristow, Jennifer Garner's character in *Alias*, always one costume change away from becoming an entirely new, entirely unrecognizable character. The singer has an international spy-worthy variety of wigs, weaves, hats, body shape-altering fashions, and elaborate makeup to help her transform from identity to identity. In this photo, she's impersonating a deranged heiress, bored at a polo match and about to cause trouble.

*I*n November 2009 Lady Gaga debuted her new single "Speechless" on stage at the 30th anniversary of the Museum of Contemporary Art (MOCA) in Los Angeles. If her performance at the VMAs earlier that summer was the apex of the artist's pop art—a gruesome commemoration of all the tragic blondes who've martyred themselves for fame— then the event at MOCA was the apex of her high art—an epic, elegant, mind-bogglingly pretentious but totally riveting display of pop theater. And it took an army of bold-name artists to pull it off.

Frank Gehry designed the sculptural hat Gaga wore; Miuccia Prada took care of Gaga's corpse bride dress and all the Bolshoi Ballet dancers' costumes; film director Baz Luhrmann and his wife, Catherine Martin, created the masks worn by Gaga and the event's mastermind, Italian artist Francesco Vezzoli; and the piano Gaga played was a bubblegum pink Steinway covered in blue butterflies painted by Damien Hirst. Gaga played "Speechless," a ballad she wrote for her father, crying tears of blood, surrounded by impossibly graceful dancers soundlessly pirouetting amidst a dewy mist of stage smoke, while Vezzoli sat with his back to the singer, quietly needlepointing in front of a crowd that included Hollywood actors, New York fashion editors, socialites, and art world power players. It was simultaneously an absurd spectacle of staged decadence and eccentricity and a sincere, moving enactment of living art.

LEFT: Replacing eyeshadow with tiny pink crystals, Gaga performs at the 2010 Grammy Awards.

HOW T

DAZZL

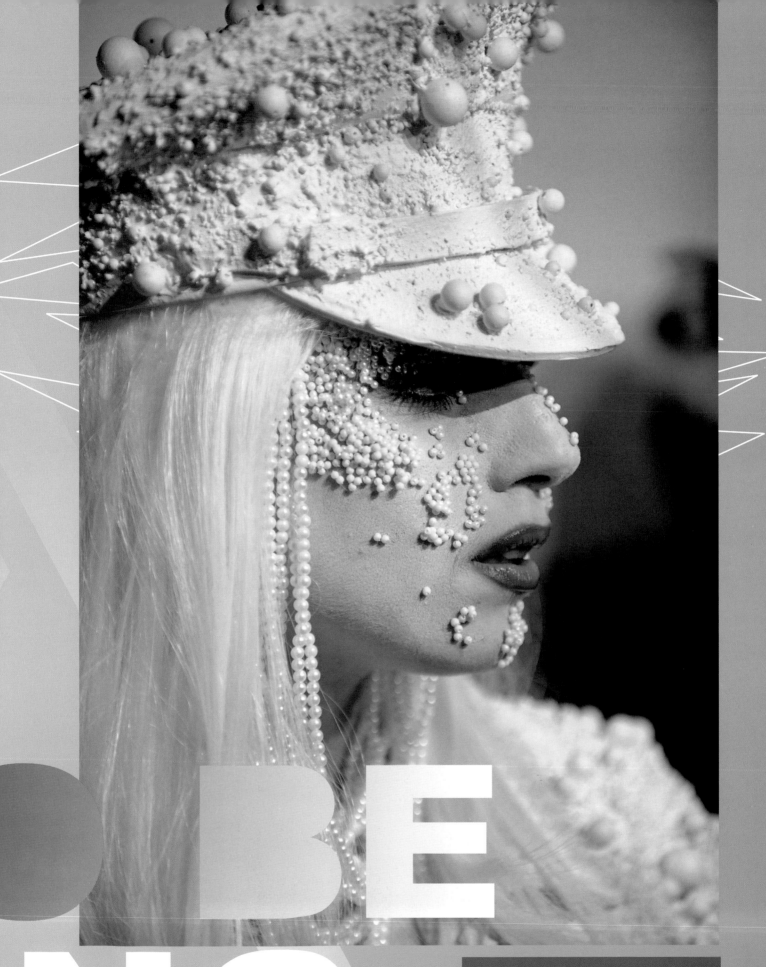

BE

NG

ABOVE: Lady Gaga, encrusted with pearls and wearing her new shade of M.A.C. lipstick, attends the amfAR New York benefit cosponsored by M.A.C., February 10, 2010.

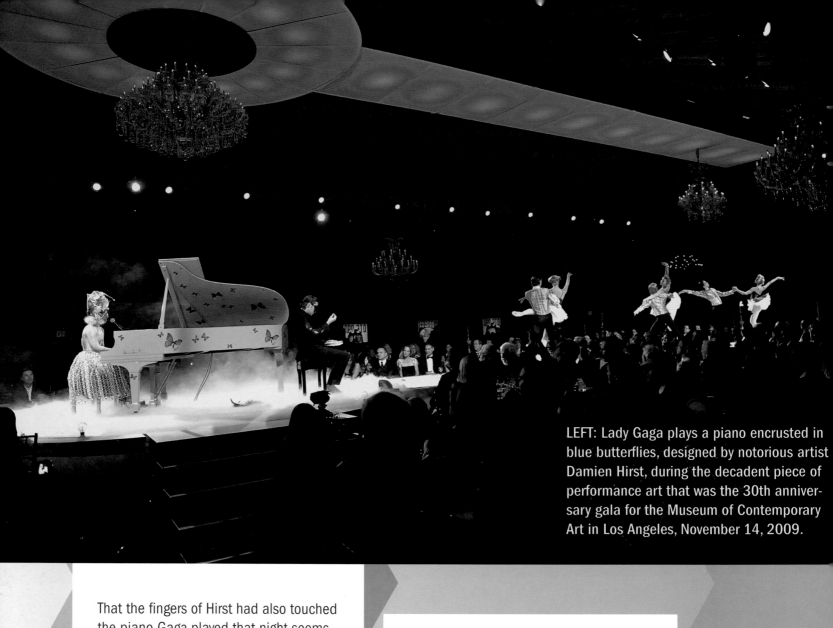

LEFT: Lady Gaga plays a piano encrusted in blue butterflies, designed by notorious artist Damien Hirst, during the decadent piece of performance art that was the 30th anniversary gala for the Museum of Contemporary Art in Los Angeles, November 14, 2009.

That the fingers of Hirst had also touched the piano Gaga played that night seems somehow symbolic. The highbrow artsy side of Gaga's work owes a tremendous debt to Hirst and his brotherhood of wild, egomaniacal, impetuous geniuses. In 2007, while Lady Gaga was lighting cans of hairspray on fire in leopard bikinis and wondering if she'd ever get out of the downtown performance art ghetto, Hirst produced his most controversial work yet. *For the Love of God* is a diamond-covered platinum cast of a skull featuring real human teeth—and it works as a blueprint for Lady Gaga's whole career.

Like the glittering skull, Gaga herself is an organic form decorated with elaborate adornments and sold for an insane amount of money to a populace filled with ardent supporters and vitriolic detractors, all of whom, love her or hate her, are talking about her—which is, of course, the point. The more elaborate and extreme Gaga's accoutrements, the more successfully the point gets made. And that's where the Thierry Mugler robot armor, and the silver glitter-covered iceberg hood, and the reams of chain worn as a body necklace, and the Dolce & Gabbana metal corset, and the chain mail hood come in. She's decorating herself like a living doll: You can't make a comment about the absurdity of excess without being really excessive. But for Gaga, merely wearing elaborate, high-concept accessories is not enough.

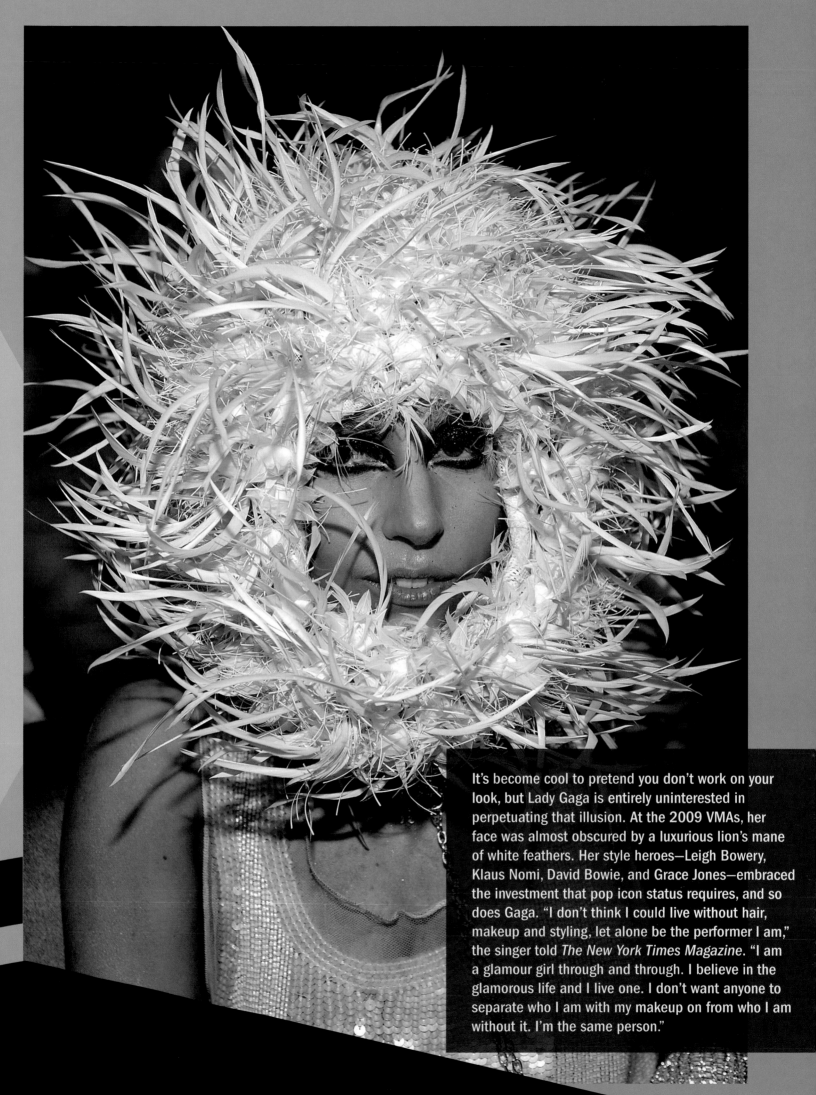

It's become cool to pretend you don't work on your look, but Lady Gaga is entirely uninterested in perpetuating that illusion. At the 2009 VMAs, her face was almost obscured by a luxurious lion's mane of white feathers. Her style heroes—Leigh Bowery, Klaus Nomi, David Bowie, and Grace Jones—embraced the investment that pop icon status requires, and so does Gaga. "I don't think I could live without hair, makeup and styling, let alone be the performer I am," the singer told *The New York Times Magazine*. "I am a glamour girl through and through. I believe in the glamorous life and I live one. I don't want anyone to separate who I am with my makeup on from who I am without it. I'm the same person."

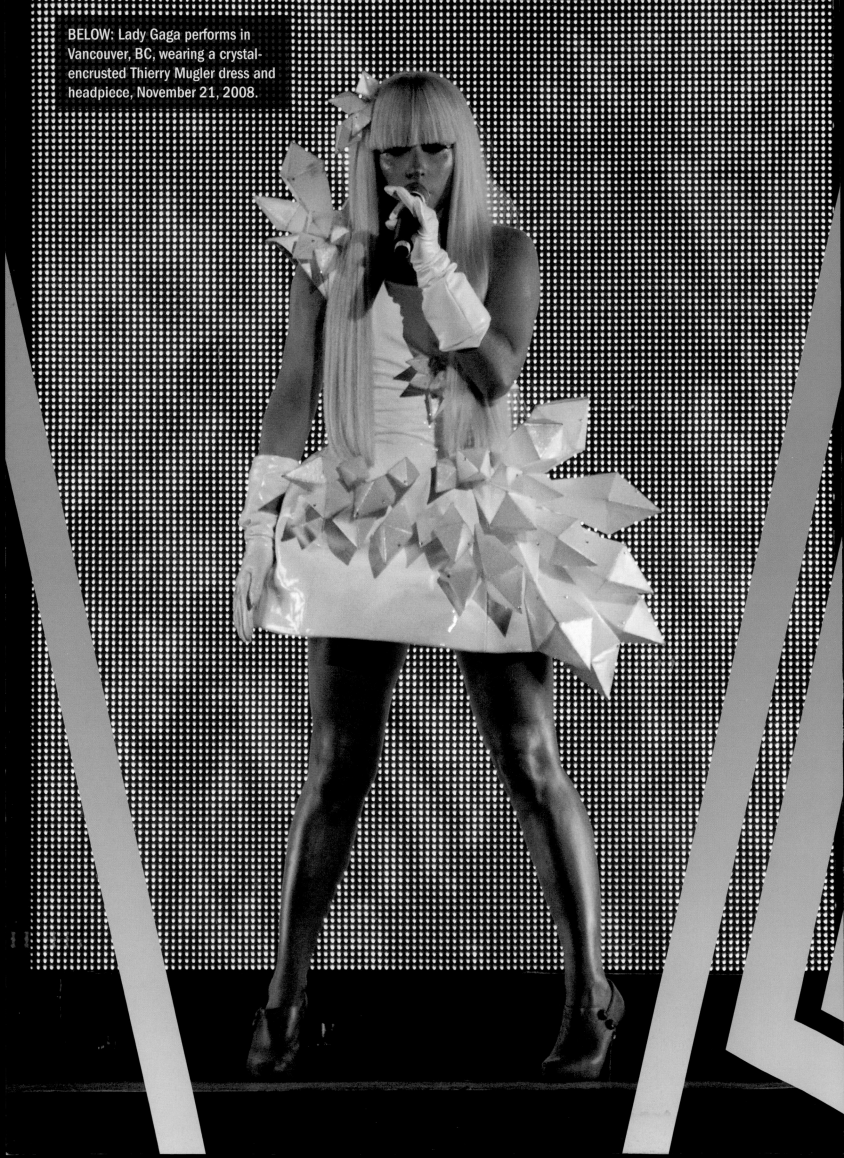

BELOW: Lady Gaga performs in Vancouver, BC, wearing a crystal-encrusted Thierry Mugler dress and headpiece, November 21, 2008.

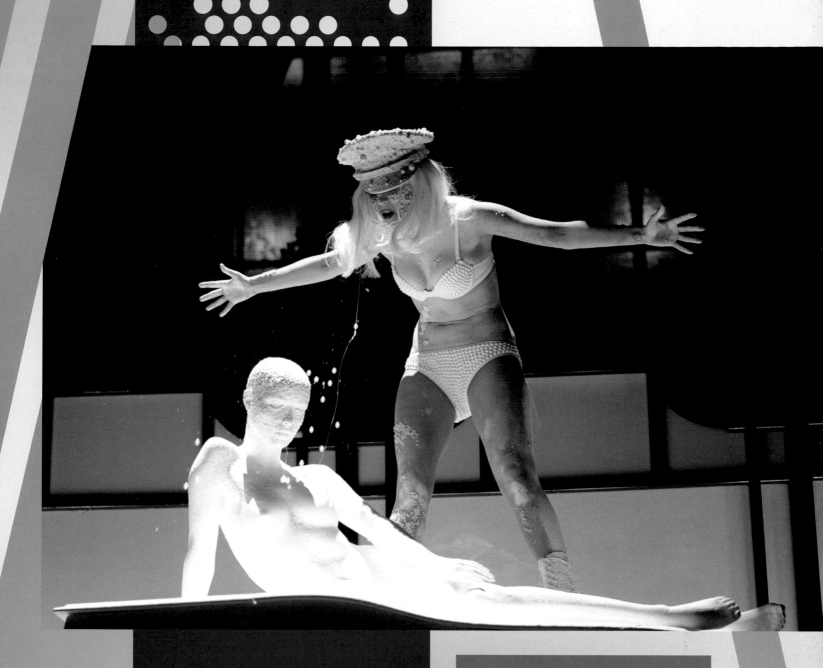

She is so committed to transforming her body into a reflection of her artistic ethos that she bedazzles her skin, nails, and eyelids like some kind of jeweled, living, breathing luxury object. She's worn flakes of metal mesh on her nails, tiny crystals all around her eyes, and pearl-encrusted paint all over her face, neck, and body. It's as if any part of the singer's physical body left unadorned is a threat to the success of her image. Those raindrop-sized crystals suspended around Gaga like a floating chandelier in the "Bad Romance" video aren't just insanely impractical and difficult to navigate, they provide the singer with her own private custom-made atmosphere, and it's only there that Gaga can really be Gaga.

ABOVE: Lady Gaga sheds pearls from her limbs and face while perched atop a white piano at a benefit for amfAR New York; the whole outfit and performance were designed in collaboration with Canadian artist Terence Koh.

AM

LONDE
BITION

"I guess there are a couple of things we have in common," Lady Gaga has said coyly about Madonna, the artist to whom she's most often compared. "We're both Italian-American women, we both started out in the New York underground scene, and we both became famous when we dyed our hair blonde."

As a young teenager, Stefani Germanotta was small, curvy, and brunette, but her posh Manhattan high school was filled with sleek, *Mean Girls* types with sheets of golden blonde hair (Paris Hilton also attended). She dyed her hair blonde for her yearbook photo and then went back to black. After dropping out of NYU to pursue music, then securing and losing the deal with Def Jam, Gaga found herself hanging out on the Lower East Side doing drugs, writing songs, and searching for a sense of clarity about the kind of music she wanted to make. Dark hair matched these dark times. Gaga had been obsessed with electronic dance music and was also interested in classic rock songwriting, but nothing she was working on sounded right

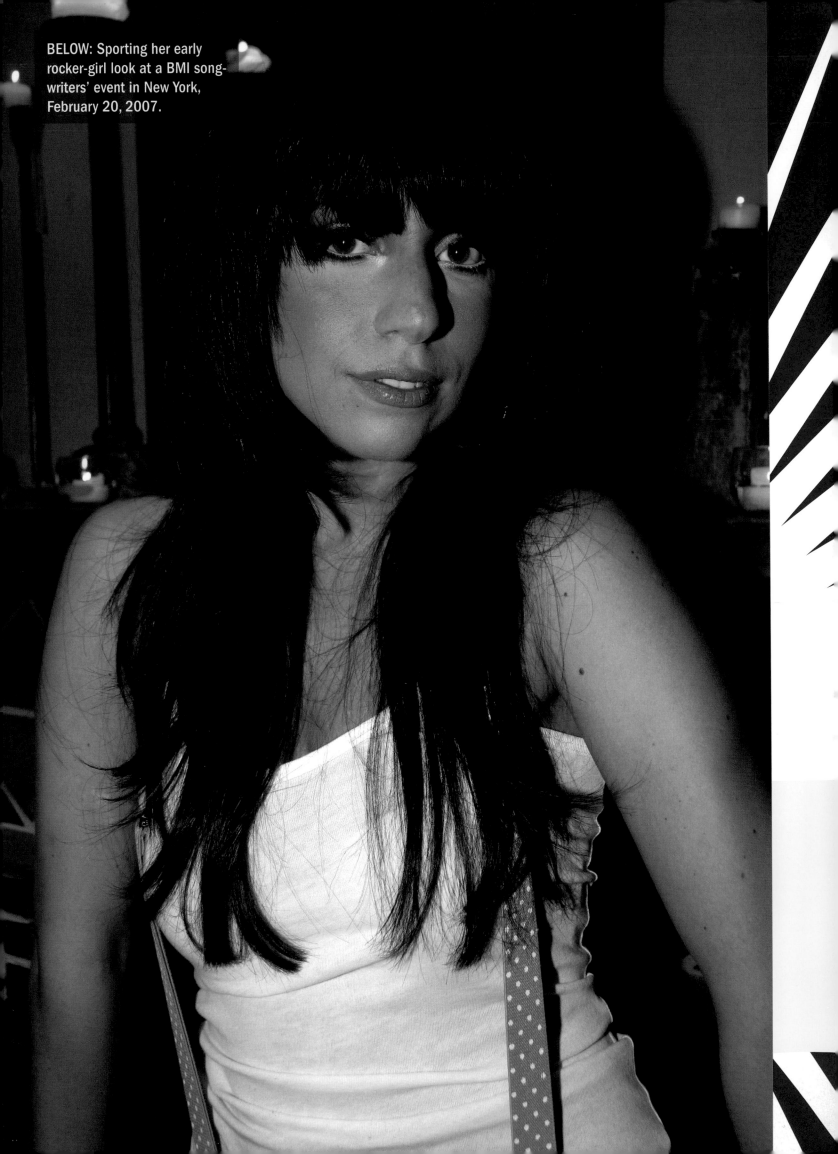

BELOW: Sporting her early rocker-girl look at a BMI song-writers' event in New York, February 20, 2007.

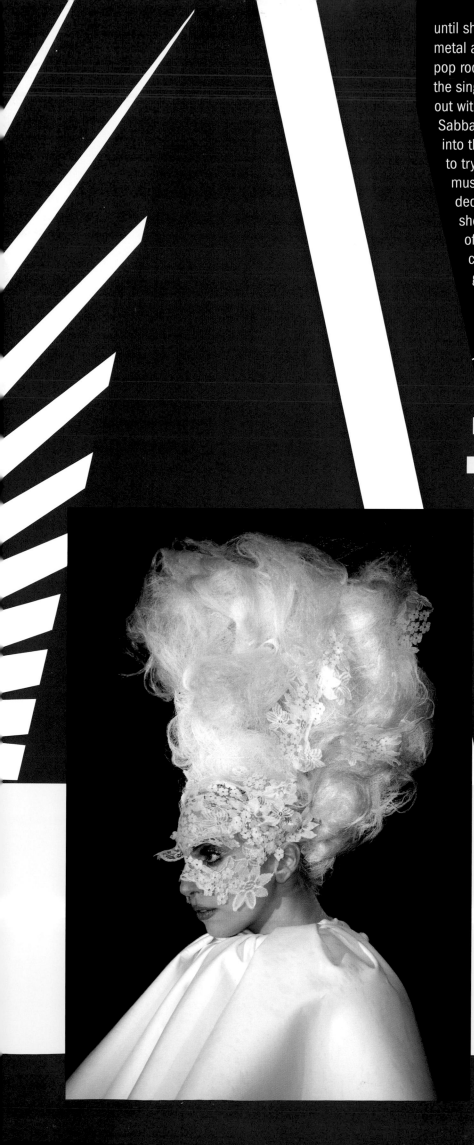

until she rediscovered the hard-edged theatrics of metal and glam rock. "I had been doing folk and then pop rock and hippie rock but, you know, you change," the singer recalled. "I was living downtown, hanging out with this heavy metal crowd who liked Black Sabbath and Iron Maiden and AC/DC and I just got into theatrical pop music. I was bored and I wanted to try something new." Under these influences, her music started to sound like proto–Lady Gaga: decadent, epic, witty, and unabashedly pop. But she still looked like a rocker girl with her smears of black eyeliner and dark serrated shag. Gaga couldn't be Gaga with that hair. And she kept getting mistaken for Amy Winehouse, so she dyed it. "Amy is a badass," the pop star has said. "But I want to be known for my own look."

From that moment forward, Lady Gaga has taken blonde ambition to entirely new heights. She travels with a team of creative collaborators known as the Haus of Gaga, which includes a hairstylist and a magnificent collection of outlandish wigs. A short list of some of the singer's more outrageous hairstyles includes a blonde lion's mane, a cake tray–shaped saucer, luxurious lavender princess waves, a massive woven sun hat, Statue of Liberty–like sunbursts, a sleek blonde mullet, a towering pale pink prom-esque updo, a humongous pouf of cotton candy–colored perm, a gargantuan combination white lace bird's nest and pompadour, porcupine spikes—and of course the infamous bow made of real hair.

LEFT: Lady Gaga complements her gravity-defying pompadour with a mask and headdress by Philip Treacy and a tiered gown by Francesco Scognamiglio at the Brit Awards in London, February 16, 2010.

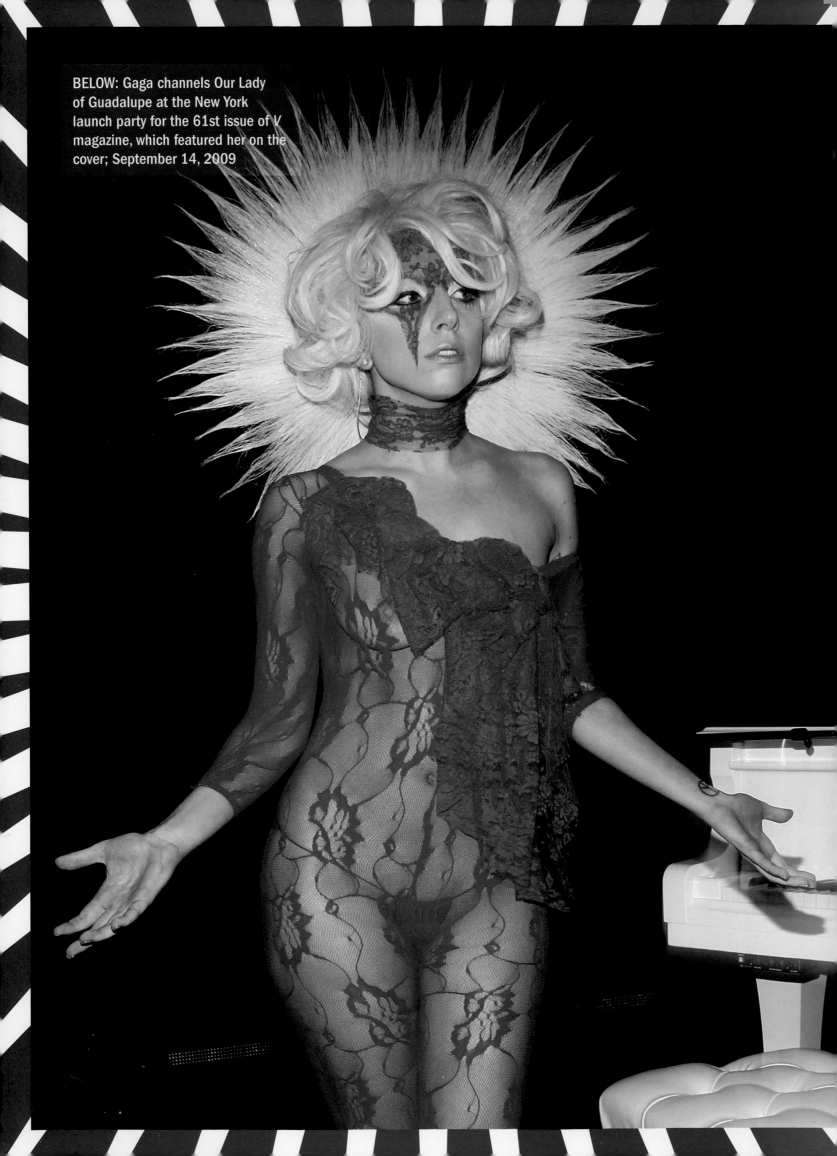

BELOW: Gaga channels Our Lady of Guadalupe at the New York launch party for the 61st issue of *V* magazine, which featured her on the cover; September 14, 2009

Of Lady Gaga's many striking fashion statements, the hair bow may be her most enduring. "One day, I said to my creative team, 'Gaultier did bows, let's do it in a new way,'" she told *New York* magazine. "We were going back and forth with ideas, and then I said"—she snaps her fingers—"hair-bow. We all fucking died, we died. It never cost a penny, and it looked so brilliant." Attached slightly off-kilter on the side of her head, the bow conveys a sense of wit and innocence that's completely beguiling, and it's become Gaga's signature look in all sizes. A slew of different online stores sell the bows, YouTube is rife with instructional videos on how to make your own, and it's become the must-have accessory for any fan attending one of Gaga's shows. When the singer appeared on *Oprah* in the fall of 2010, she even brought the queen of daytime television her very own brunette version. Once Oprah wears that thing on TV, Gaga's world domination will be complete.

Lady Gaga's signature hair bow is a surprisingly versatile accessory. The giant oversized version, worn here at the launch of the music video Web site Vevo in December 2009, gives the singer's demure (for Gaga) gray silk gown a coquettish, naughty Disney princess vibe. But when worn with a skintight nude pencil skirt and black bustier, the bow has the opposite effect of classing up an otherwise ostentatiously provocative outfit. Large or small, off-kilter or worn right on top of her head, Gaga's hair bow reflects her entire creative philosophy: Always be different, but always be Gaga.

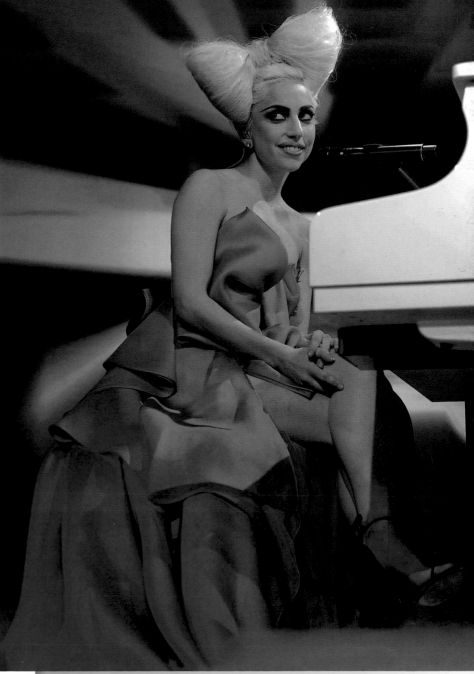

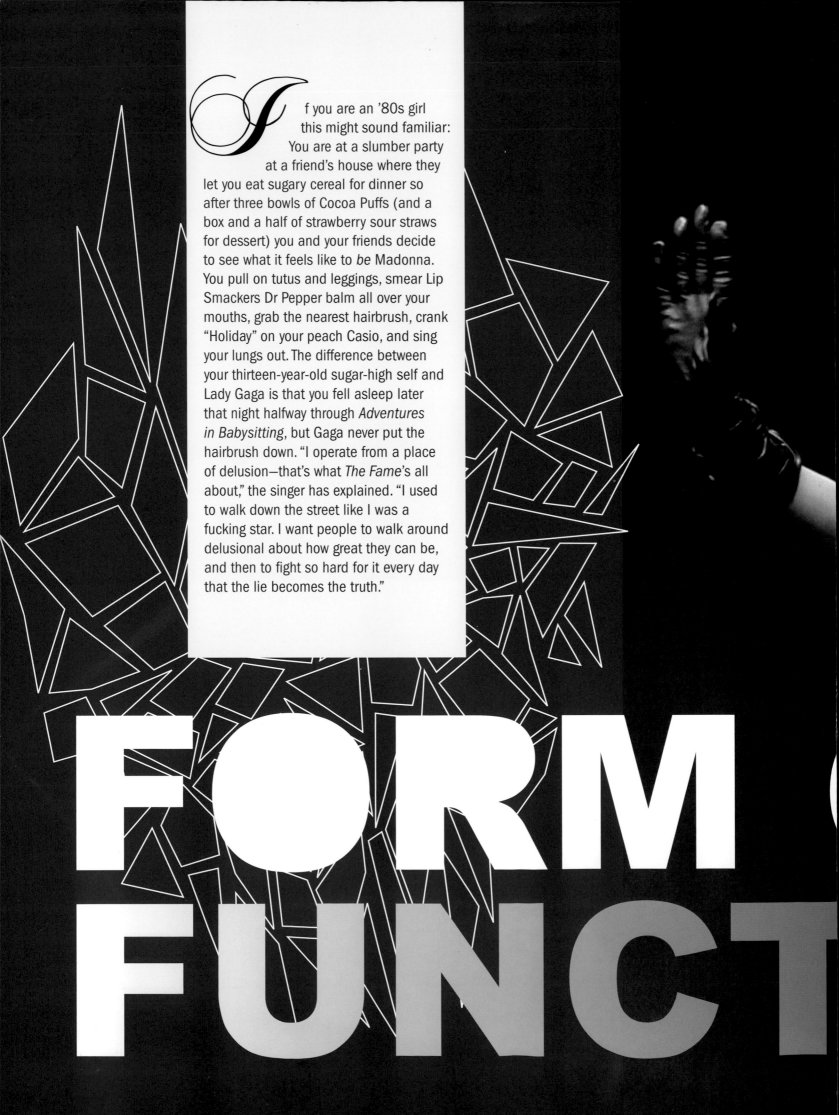

*I*f you are an '80s girl this might sound familiar: You are at a slumber party at a friend's house where they let you eat sugary cereal for dinner so after three bowls of Cocoa Puffs (and a box and a half of strawberry sour straws for dessert) you and your friends decide to see what it feels like to *be* Madonna. You pull on tutus and leggings, smear Lip Smackers Dr Pepper balm all over your mouths, grab the nearest hairbrush, crank "Holiday" on your peach Casio, and sing your lungs out. The difference between your thirteen-year-old sugar-high self and Lady Gaga is that you fell asleep later that night halfway through *Adventures in Babysitting*, but Gaga never put the hairbrush down. "I operate from a place of delusion—that's what *The Fame*'s all about," the singer has explained. "I used to walk down the street like I was a fucking star. I want people to walk around delusional about how great they can be, and then to fight so hard for it every day that the lie becomes the truth."

FORM
FUNCT

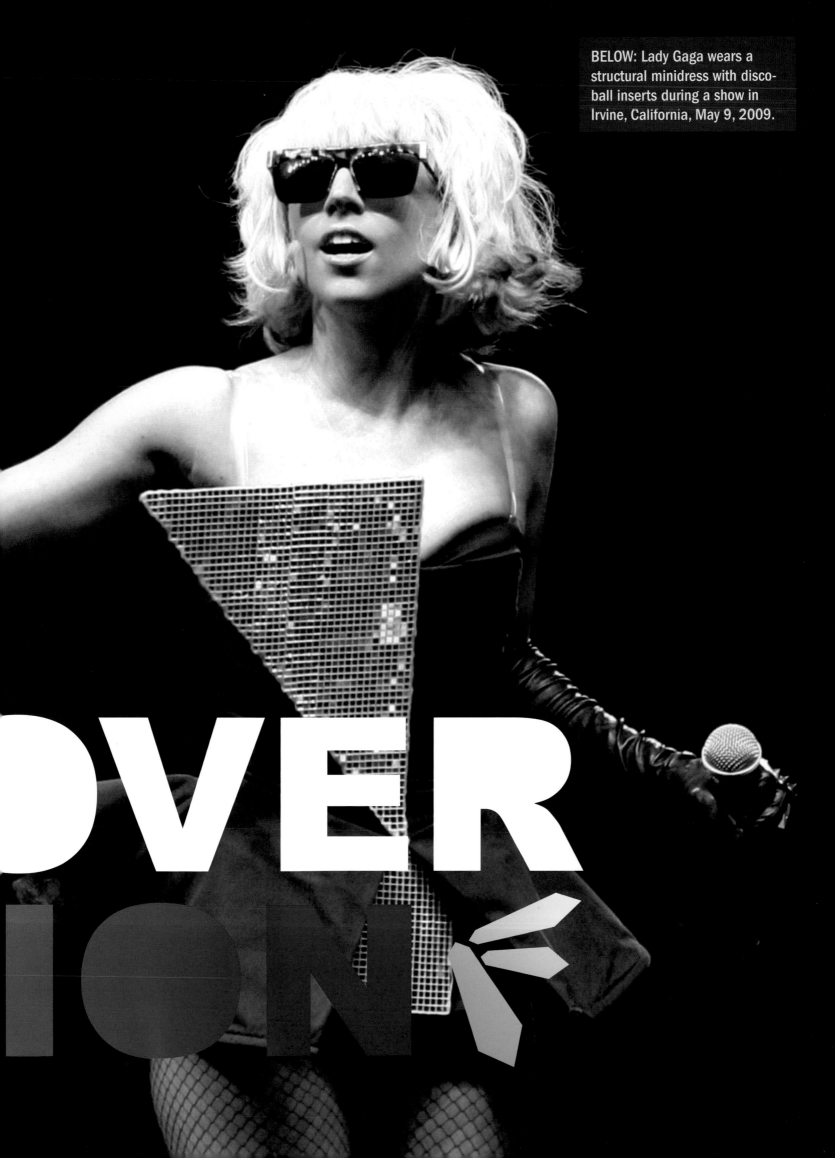

BELOW: Lady Gaga wears a structural minidress with disco-ball inserts during a show in Irvine, California, May 9, 2009.

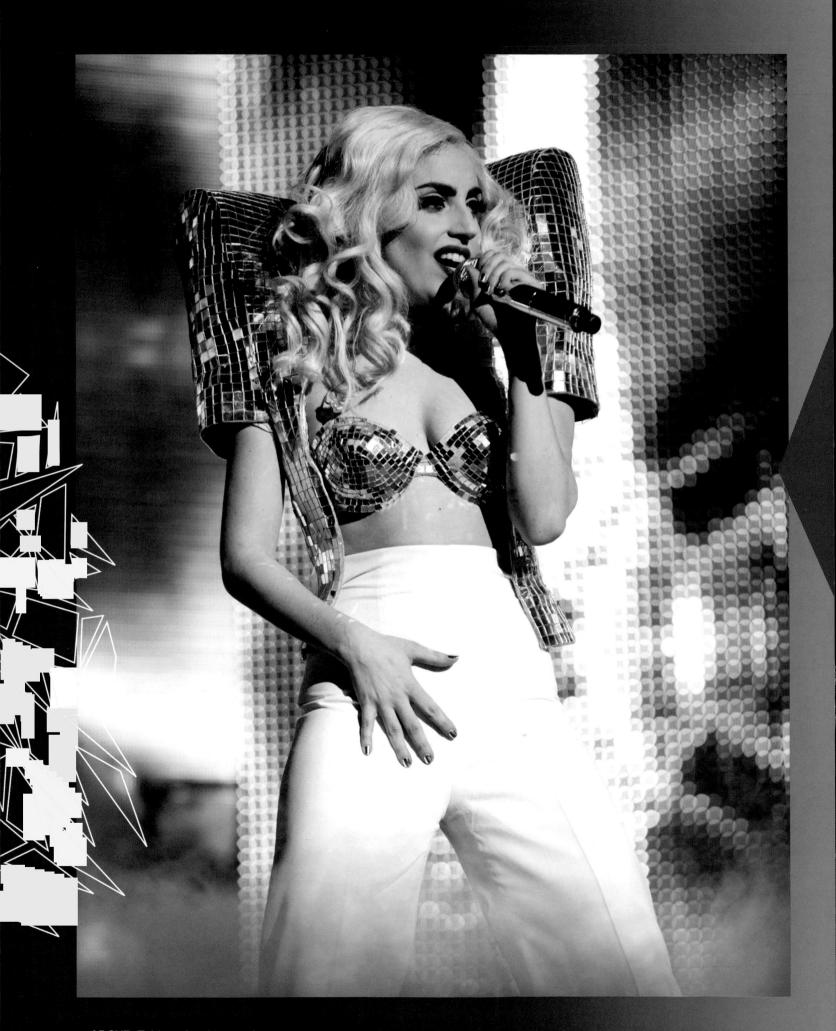

ABOVE: Taking shoulder pads to a new
extreme, Lady Gaga brings the Monster
Ball tour to Radio City Music Hall in New
York, January 20, 2010.

Here, Lady Gaga performs beneath a sculpture of herself in Alexander McQueen's "armadillo" shoes, wearing a hair-sculpture of her own. "I absolutely think about the performance art aspect while I'm writing, and I think about how I can visually translate a pop song to the world in a way that's new and interesting and fun," the singer told *Shockhound*. "I did theater for a while, and they'd tell me 'This is a musical, but you're too pop.' And I'd go into record labels, and they'd tell me 'You're too theatrical.' So I just thought, 'Well, why don't I do both? And why don't I do it *my way*?' And without even realizing what I was doing, it became performance art."

If Lady Gaga sometimes comes off as a precocious child whose parents left her home alone with the cast of *Fame* and the black Amex and said "Have a good time, dear," that's because, in a way, that's exactly the world she's built for herself. Within the bubble created by her family, her creative partners, and the people who work for her, no idea is too extreme, no creative thought is unworthy of expression there's no such thing as pretentiousness, and every origami-like suit, every custom corset, every triangular belt/breastplate, every pair of cigarette wraparound sunglasses is created with real thought and ambition. When the singer first started thinking about fame, "I think I was in my mother's womb," she has said. "But it's not about fame, you see. It's about *The Fame.* It's about a life of glamour. I believe in a glamorous life."

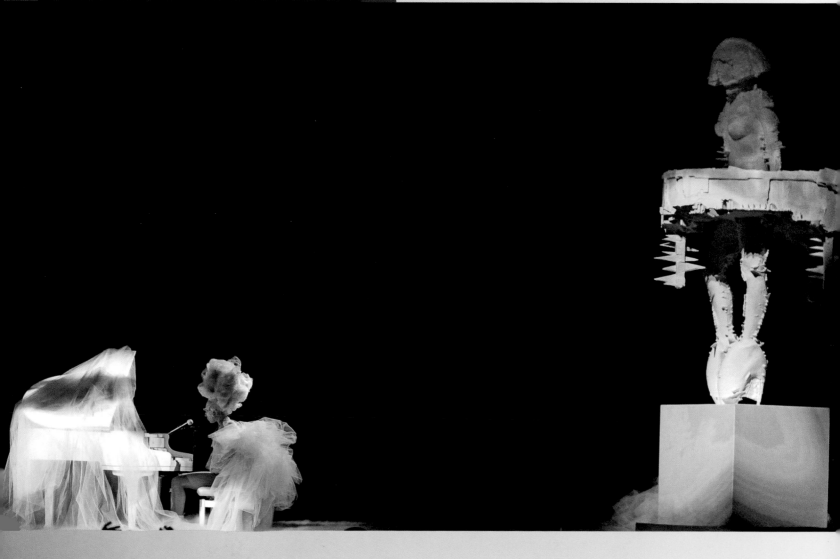

The downside of this is that the world has to endure a near constant stream of precious art student-y monologues from Lady Gaga about her commitment to making "museum-worthy" art out of pop music. But the upside is that, in many cases, Gaga succeeds. There is no creative medium that she doesn't explore as part of her pop identity. She's both an actress and screenwriter in her videos for "Paparazzi" and "Telephone." She's an attentive businesswoman, overseeing and participating in every aspect of her career from her tour schedule to her manicure color. And, with the help of the Haus of Gaga, Lady Gaga is often a walking piece of sculpture.

The singer has worn dresses made almost entirely of yellow flowers or broken teacup pieces or mini mirrors. She's stretched the boundaries of her own shape in a Betty Boop–worthy little black dress with *Jetsons* hips and a triangular silver codpiece, and then in a series of Thierry Mugler pieces that look like crystal gardens. On stage at the Brit Awards in the winter of 2010 she performed in the shadow of an actual sculpture of herself rendered by Nick Knight.

But it's really Gaga's three-piece collaboration with Georgio Armani Privé at the 2010 Grammy Awards that most completely transformed her five-foot-one-inch body into a walking work of sculptural art. It was hard to imagine how Armani's signature restraint would

OPPOSITE: Lady Gaga rocks two versions of Thierry Mugler's crystal-encrusted minidress: the white at an American Music Awards afterparty in 2008, and the black at the O2 arena in London in 2009.

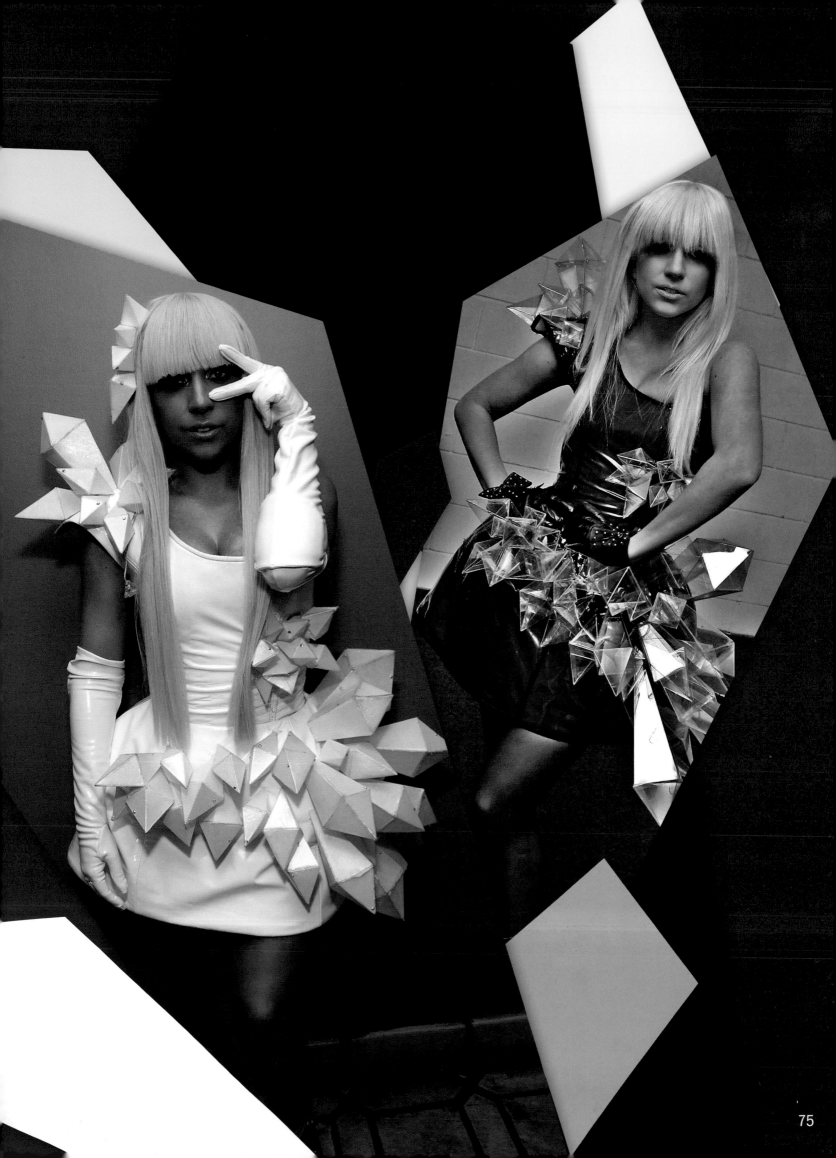

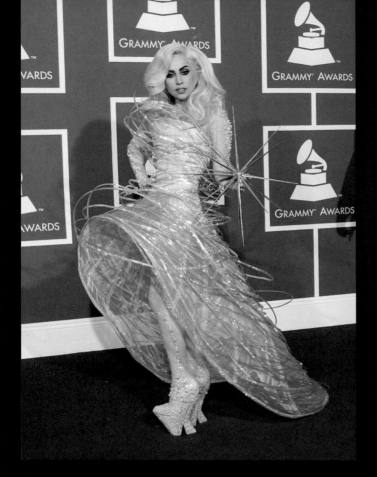

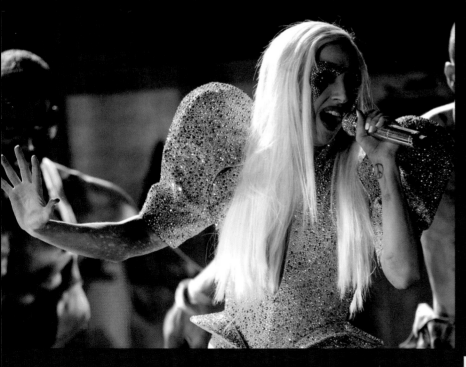

Lady Gaga wore all Armani Privé at the Grammys ceremony on January 31, 2010. ABOVE: A swirling red-carpet gown and Ziggy Stardust-esque heels. BELOW: Giant shoulders and hip-fins made this glitter-encrusted leotard a standout on stage.

merge with Gaga's signature flamboyance, but according to the designer, the union felt natural. "We hear Lady Gaga's music everywhere we go," he has said. "It is like the soundtrack of our times. In addition to her formidable songwriting skills, she is a modern fashion phenomenon." In a series of crystal-themed structures that looked more like alien armor than actual clothing, Gaga held her own pop sculpture show on national television. She walked the red carpet in a strapless pastel dress that looked like it was made of frozen silly string, holding a metal spiked star. For her onstage performance of "Poker Face" and "Speechless" she wore a pistachio green crystal-encrusted leotard with bulbous shoulders as tall as her ears. And sitting in the audience after her performance, the singer wore the sartorial version of the Chrysler building, a cropped silver blazer that ascended from her shoulders and neck into a several-foot-high collection of asymmetrical spikes. Watching Gaga conduct interviews was hilarious: The hosts seemed justifiably concerned about getting too close to her, like they might lose an eye.

During the 30th Anniversary MOCA gala, when Gaga debuted "Speechless" in a performance art piece, a reporter asked her what art meant to her. Gaga's friend and noted photographer David LaChapelle answered for her: "She would die without art!" The singer reiterated her mantra about believing the fantasy until it becomes real: "For me, art is a lie, and the artists are there to create lies we kill when we make it true. . . . Art is life, life is art." And whatever she's wearing has to be all of the above.

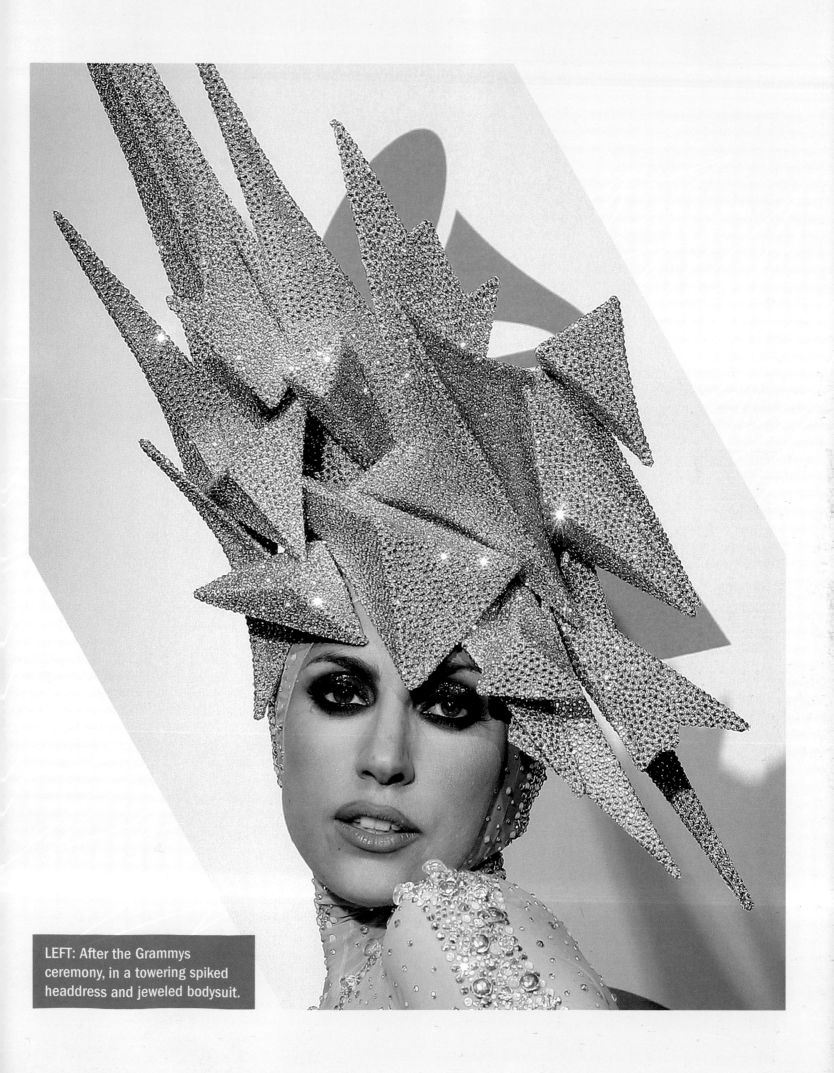

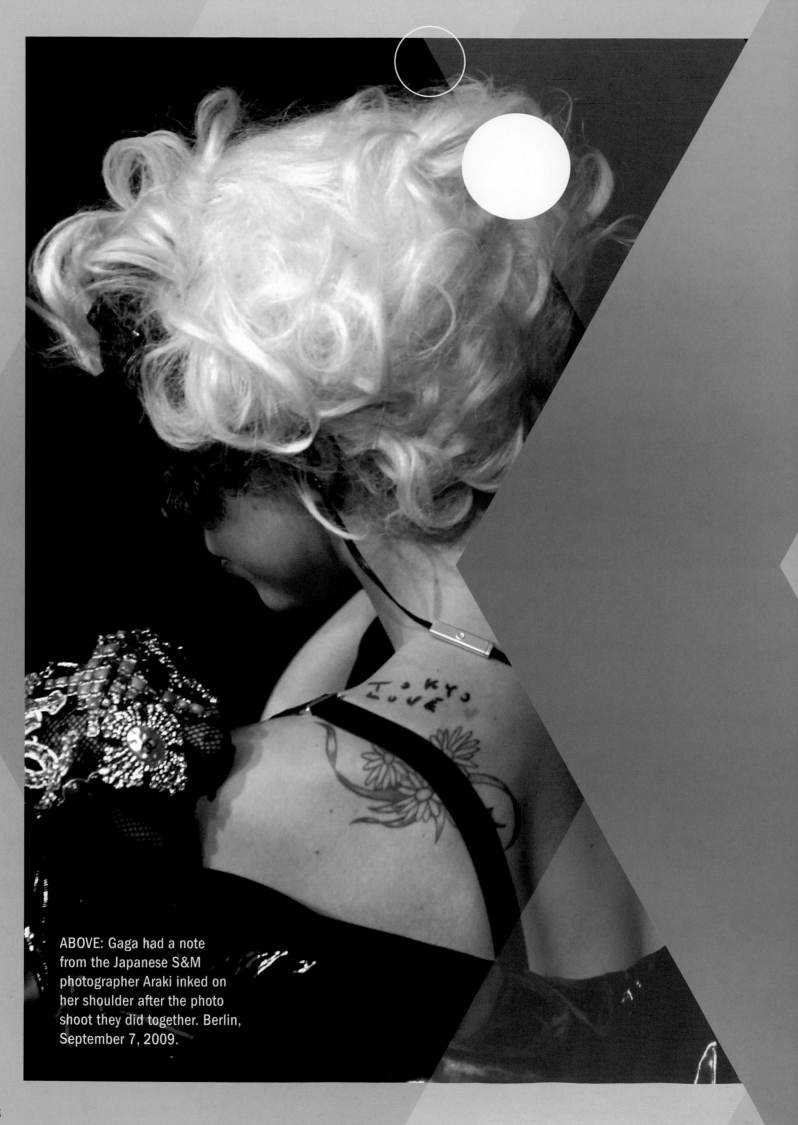

ABOVE: Gaga had a note from the Japanese S&M photographer Araki inked on her shoulder after the photo shoot they did together. Berlin, September 7, 2009.

INK IS SKIN DEEP

When Lady Gaga was still just a pop star in training, in 2008, she went to celebrity tattoo artist Kat Von D to have her very first tattoo, a treble clef tramp stamp on the back of her left hip, covered with something more tasteful. In the YouTube video (because why not document every waking moment?), they appear to be working in the backyard of the tattoo artist's LA studio. They don't really know each other, but they're chatting away in that bubbly faux-familiar vernacular girls reserve for hairdressers and bikini waxers. Von D loves Gaga's electric blue spandex pants. Gaga loves Von D's "elegant" work. As Von D dabs a swirling flowered pattern onto Gaga's inky, bleeding back, Gaga tells the story behind her first tattoo. "I'm so excited you're redoing my treble clef!" Gaga tells Von D with a giggle. "I got [it] when I was seventeen. I remember, I got a fake ID and I went to a tattoo parlor in New York. [My parents], like, had a freaking heart attack." Then she gives us the history of a few of her pieces. It's almost as if she's narrating her own *Behind the Music* episode and each tattoo represents a different pivotal moment in her past—but because she's talking about the tattoos, and not herself directly, she's able to tell the story of her life with a wistful honesty we don't usually see. Gaga is always talking about how there is no separation between her public persona and her private self, but her tattoos are a reminder that there is a real person under the latex and body jewels.

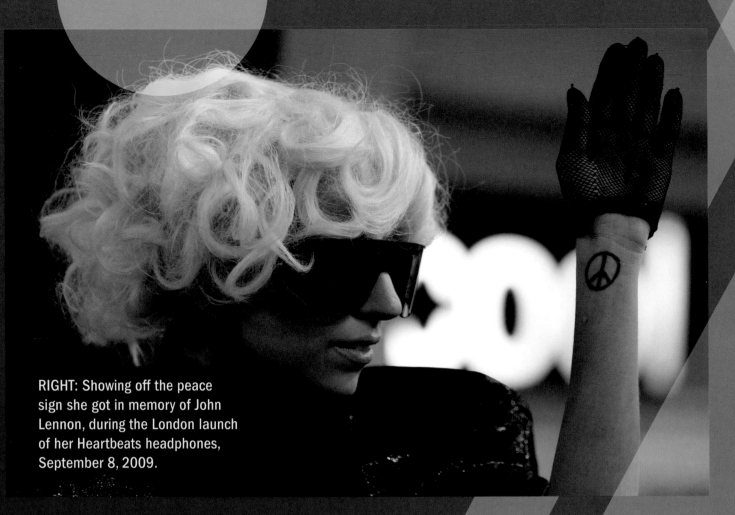

RIGHT: Showing off the peace
sign she got in memory of John
Lennon, during the London launch
of her Heartbeats headphones,
September 8, 2009.

John Lennon inspired the peace sign on her left wrist, the singer has said. "I grew up two blocks from the Imagine Memorial and one block away from where he was assassinated. The reason I had it put upside down is I wanted it to remind me that even though I write fun music about sequins and panties and fame and money, that I make sure to always keep in mind the important things."

The quote on her inner left arm is from *Letters to a Young Poet* by German poet Rainer Maria Rilke, Gaga's favorite philosopher. In English, it reads: "Confess to yourself in the deepest hour of the night whether you would have to die if you were forbidden to write. Dig deep into your heart, where the answer spreads its roots in your being, and ask yourself solemnly, Must I write?"

The day after Gaga won her two Grammys, she got another tattoo as a tribute to her fans, which reads "Little Monsters." "Look what I did last night. 'Little Monsters' forever, on the arm that holds my mic," she tweeted.

Inspired by Japanese S&M photographer Araki, with whom she shot a feature for *Vogue Homme Japan*, she had "Tokyo Love" tattooed on her shoulder in his handwriting. More recently, to commemorate her father's successful heart valve replacement surgery, she had the word "Dad" inked inside a heart on her other shoulder. She included video of the process as the closing shot on her Monster Ball tour. "I told him I was going to get it and he got all teary-eyed," the singer has said. "He said, 'Well, you're running out of real estate, so don't get it too big.'"

Lady Gaga's tattoos work like a physical map of her psyche, reflecting the major moments in her evolution from aspiring starlet to global superstar. But the quote from German poet Rainer Maria Rilke, which encourages the resolute questioning of one's commitment to art, is the one that really synthesizes Gaga's life philosophy. "Must I write?" the quote asks—and for Gaga, always, the answer is yes. "I really scare myself, the nerve that I have," the singer has said of her drive. "I really put all my eggs in one giant basket. I never wanted a backup career, because this is my *life*."

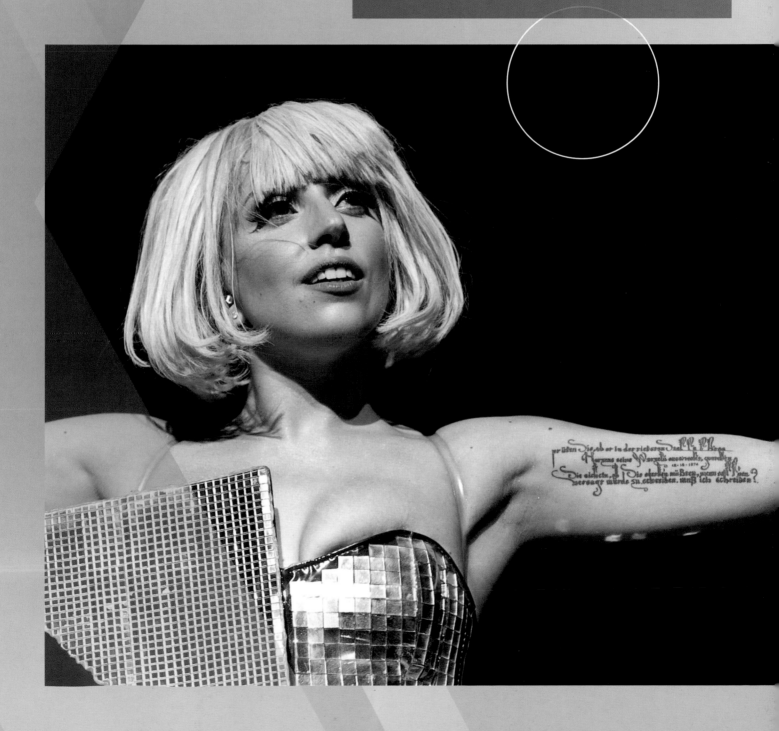

AMERICA
GIRL

*L*ady Gaga likes to cook for her man. Back when the singer was still in her grimy glam metal phase, playing Iron Maiden covers on stage in ten-dollar bikini tops on Lower East Side stages, she dated Luc Carl, a New York–based Tommy Lee look-alike who lists his occupation as "rocker" on his MySpace page. It was a passionate, tempestuous relationship, and Gaga has said Carl was her first true love. One of Gaga's favorite ways of expressing her affection was to cook dinner for him half naked. "He used to say 'Baby, you're so sexy!'" she told *Rolling Stone*. "And I'd be like, 'Have some meatballs.'"

Before she was a world-dominating pop princess, Lady Gaga was just Stefani, a good little Italian girl from a nice Catholic family. She grew up in a house where men were men and women were women. Joseph Germanotta is a Jersey-born, Springsteen-worshiping, musician turned telecom executive. And Cynthia Germanotta is a supportive and proudly well-put together wife and mother. To this day, the entire family remains super close. (Gaga's younger sister Natali Germanotta, a stunning brunette ringer for her sister, has a cameo in the pop star's "Telephone" video.) Gaga wrote the ballad "Speechless" about her father in an attempt to talk him into having necessary open-heart surgery. Even Gaga's perpetual state of pantslessness appears to be, in part, in honor of a family member. "My grandmother is basically blind, but she can make out the lighter parts, like my skin and hair. She says, 'I can see you, because you have no pants on.' So I'll continue to wear no pants, even on television, so that my grandma can see me."

CAN
ENT

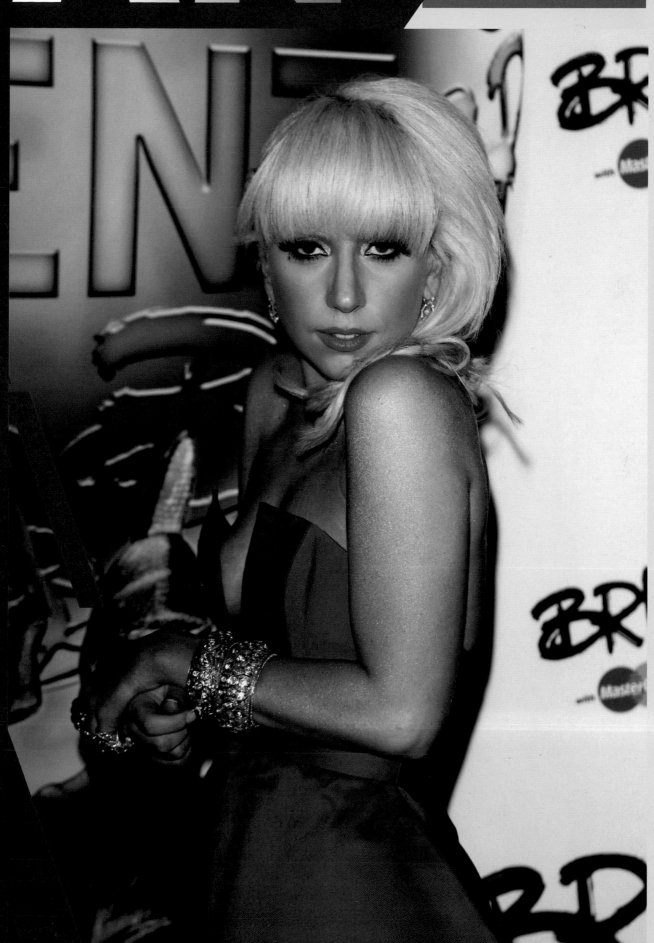

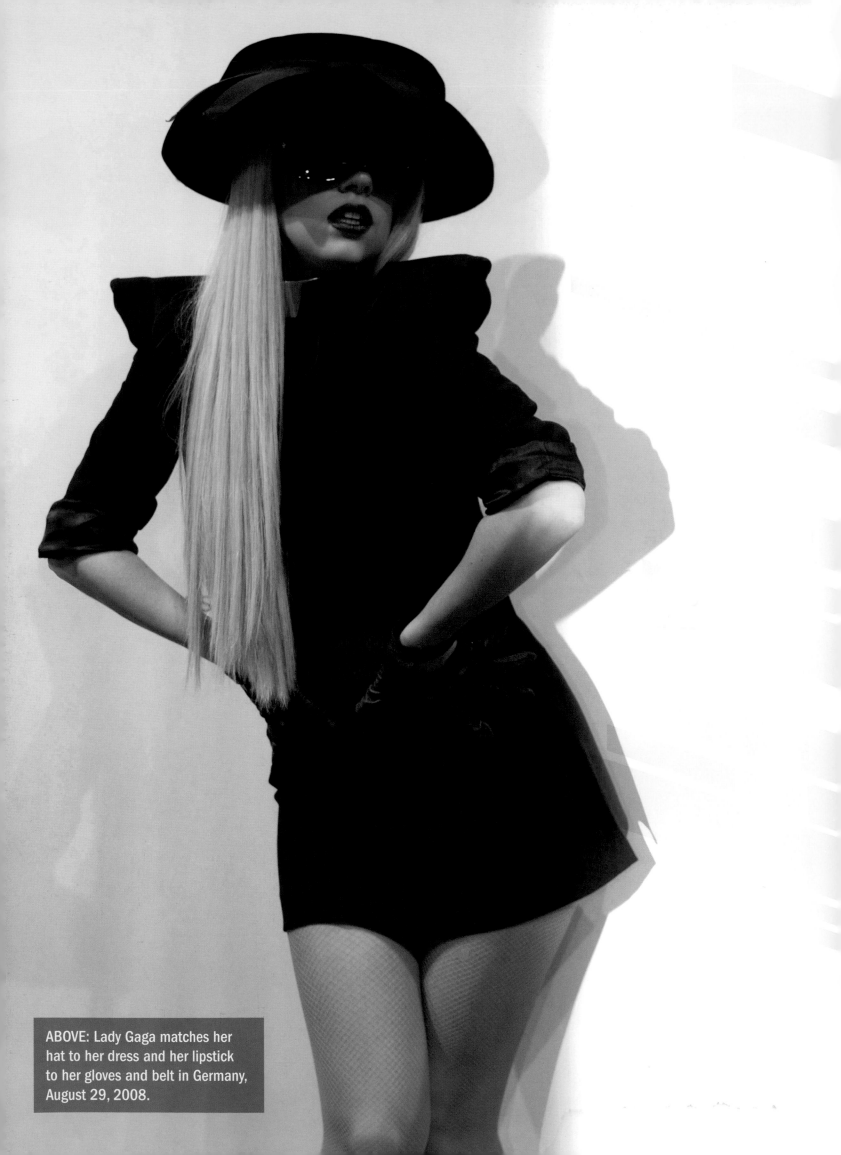

ABOVE: Lady Gaga matches her hat to her dress and her lipstick to her gloves and belt in Germany, August 29, 2008.

This sense of family-oriented traditionalism is a huge influence on Gaga's sense of style. Her video for the single "Eh Eh (Nothing Else I Can Say)" is an unabashed homage to 1950s America and the singer's Italian heritage. The boys all wear muscle shirts and porkpie hats, and the girls all have hair poufs, brightly painted fake fingernails, and caked-on blue eyeshadow. Amid images of giant bottles of olive oil and signs for Italian food, Gaga poses like Sophia Loren on a white Vespa in a gleaming white suit, gossips with her girlfriends over red wine at a neighborhood restaurant with checkered tablecloths, rolls around flirtatiously in demure white lingerie under a flower-print bedspread, and irons her man's shirts after cooking him dinner (spaghetti and meatballs, of course).

BELOW: Hangin' tough in a biker hat, shades, and a jean jacket with the sleeves cut off—note the Bowie pins. Fort Lauderdale, Florida, April 8, 2009.

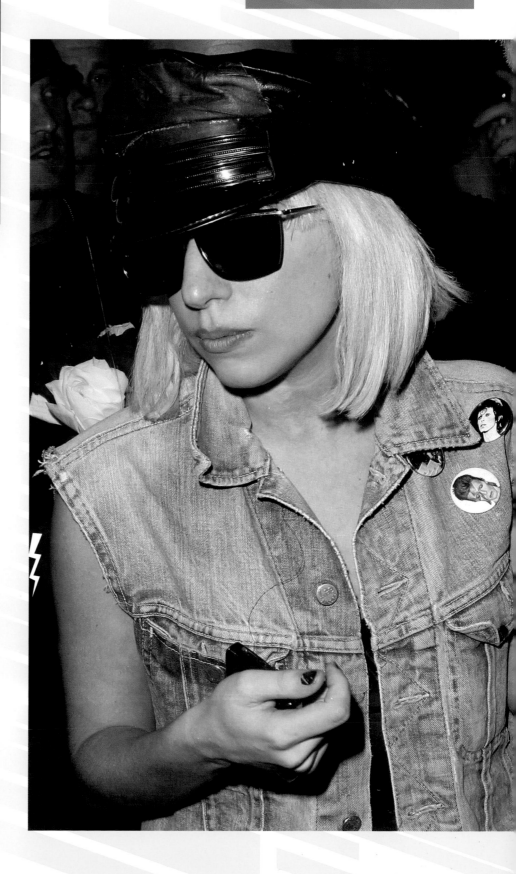

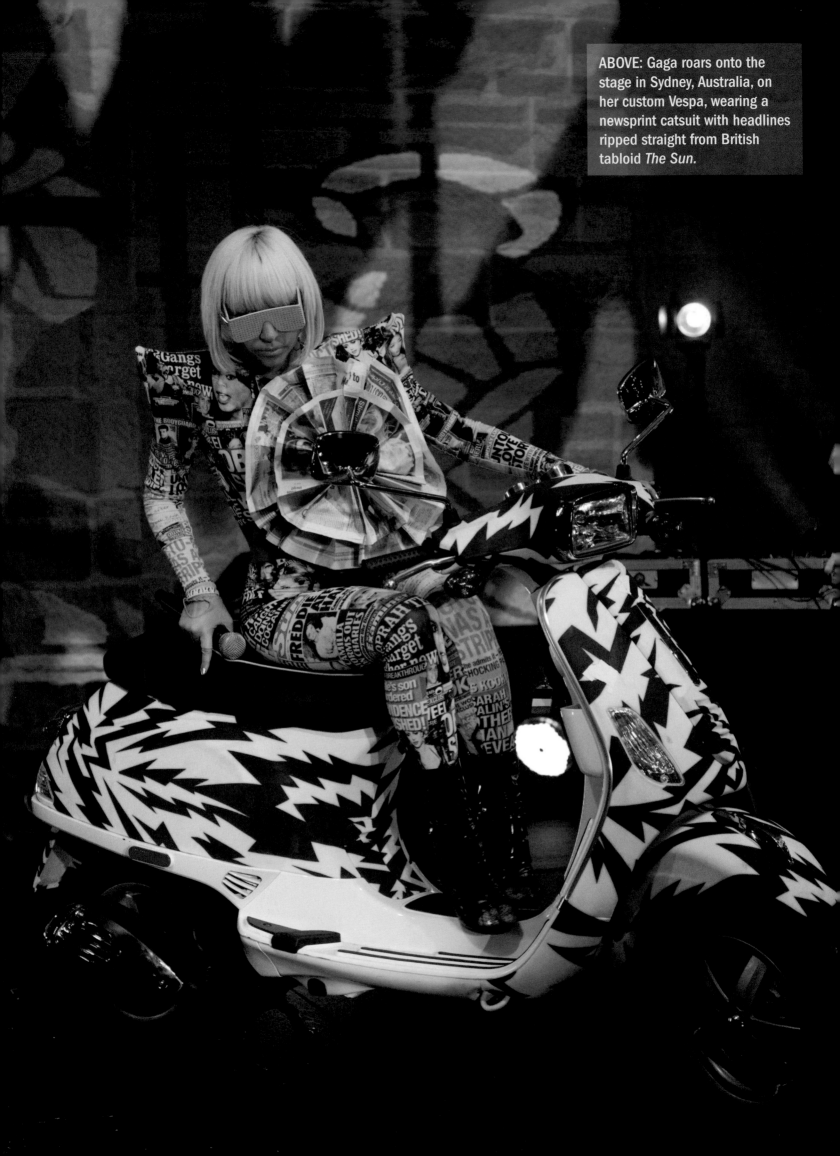

ABOVE: Gaga roars onto the stage in Sydney, Australia, on her custom Vespa, wearing a newsprint catsuit with headlines ripped straight from British tabloid *The Sun.*

She's now a fashion inspiration to legions of fans around the world, but Lady Gaga grew up worshiping at the altar of her own style icons. She loved androgynous weirdo fashion plates like David Bowie and Klaus Nomi, but she also admired more conventional, mainstream beauties like Marilyn Monroe. As an Italian-American girl who grew up in the showbiz capital of the world, the iconography of the classic American blonde is one that's very close to Gaga's heart. She toys with traditional male/female roles by channeling the great Hollywood screen goddesses of the 1950s alongside her own more eccentric looks. A simple black pantsuit with a plunging neckline and scarlet-painted lips—paired with giant shoulder pads—is a Gaga-esque homage to an era when men were men and women were women.

She takes on her inner Rizzo as well, strutting around town in black leather jackets and biker hats, and she opened the Fame Ball shows by riding in on an embellished Vespa. Her video for "Telephone" showcases the darker side of Americana as well. The narrative picks up right where "Paparazzi" left off: Gaga is in jail for poisoning her boyfriend, and she's got to improvise to stay glam. Wearing an oversized studded motorcycle jacket with her hair in Diet Coke–can rollers, roots showing, she comes off like the ultimate greaser's girl, all bold black eyebrows and bad attitude.

Every once in a while Gaga will stun the photogs by showing up for an event dressed not in a hat made of her own hair or a Muppet carcass but in a sleek black cocktail dress, miles of loose blonde curls, and a classic red lip. "I believe in certain institutions," the singer has said of her traditional side. "Cooking, serving dinner, taking care of my family . . . I consider myself quite the lady."

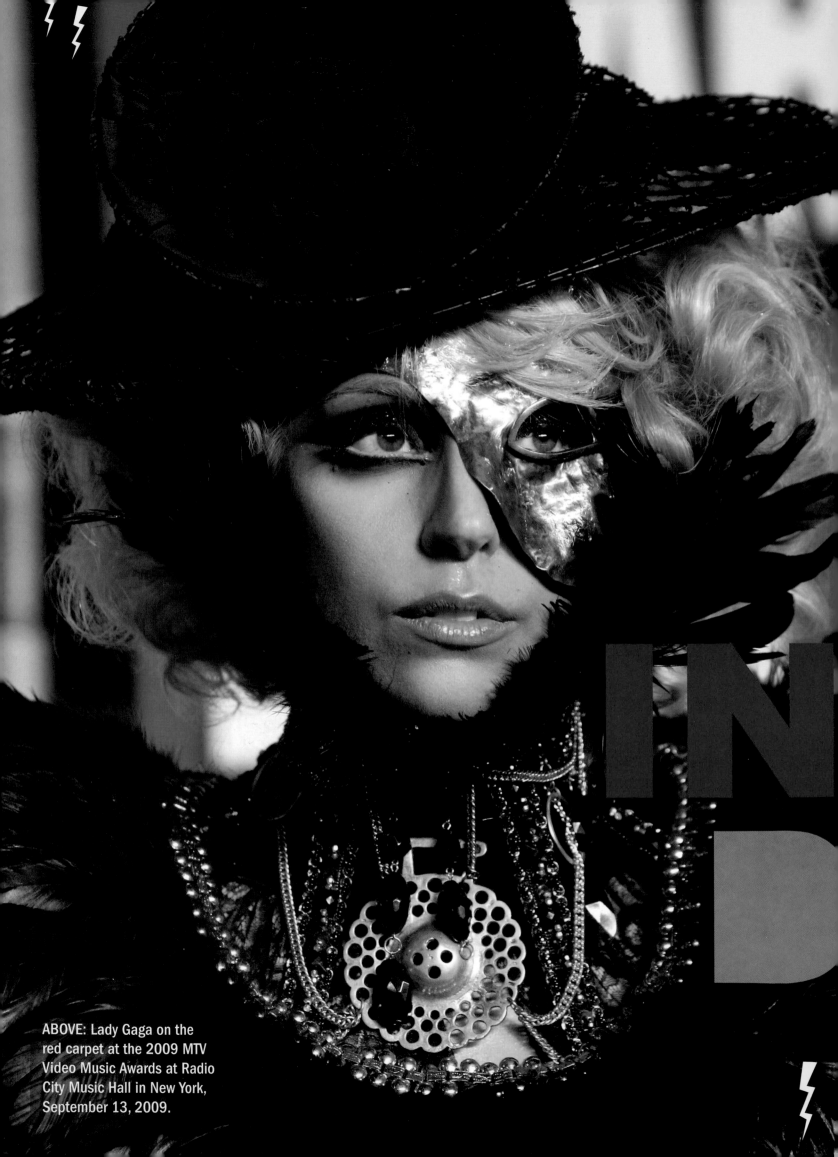

ABOVE: Lady Gaga on the red carpet at the 2009 MTV Video Music Awards at Radio City Music Hall in New York, September 13, 2009.

*E*minem showed up at the 2009 MTV Video Music Awards to present the award for Best New Artist, but he didn't seem that psyched to be there. Pale and weirdly underdressed in white hoodie and shapeless leather jacket, one of the most exciting hip-hop artists of his generation looked like a bored dad at a ballet recital as he announced the nominees (including 3OH!3, Drake, Kid Cudi, and Asher Roth), opened the envelope, and said Lady Gaga's name. The camera panned to Gaga as she approached the stage decked out in the third of six outfits she would wear that night: an Alexander McQueen see-through red lace sack dress with matching face mask and crown. As she approached the stage, Eminem seemed to perk up a bit. With a combination of amusement and derision he leaned in to give the star an obligatory hug and in the process nearly poked his eye out on one of the spires of the pop star's humongous thorn crown.

The intricate red lace stocking Gaga wore over her head that night was just one of a huge variety of masks, veils, eye patches, and appliqués she wears to cover her face. Some are showy and statement making: an embroidered veil with a twisted black bead crown, a black matte gimp mask, a mirrored Rubik's Cube–like half helmet. Others are subtle by Gaga standards: an almost tasteful cluster of rhinestone teardrop orbs affixed around her eyes, a single inky Ziggy Stardust–esque lightning bolt painted across her cheek.

THE
DARK

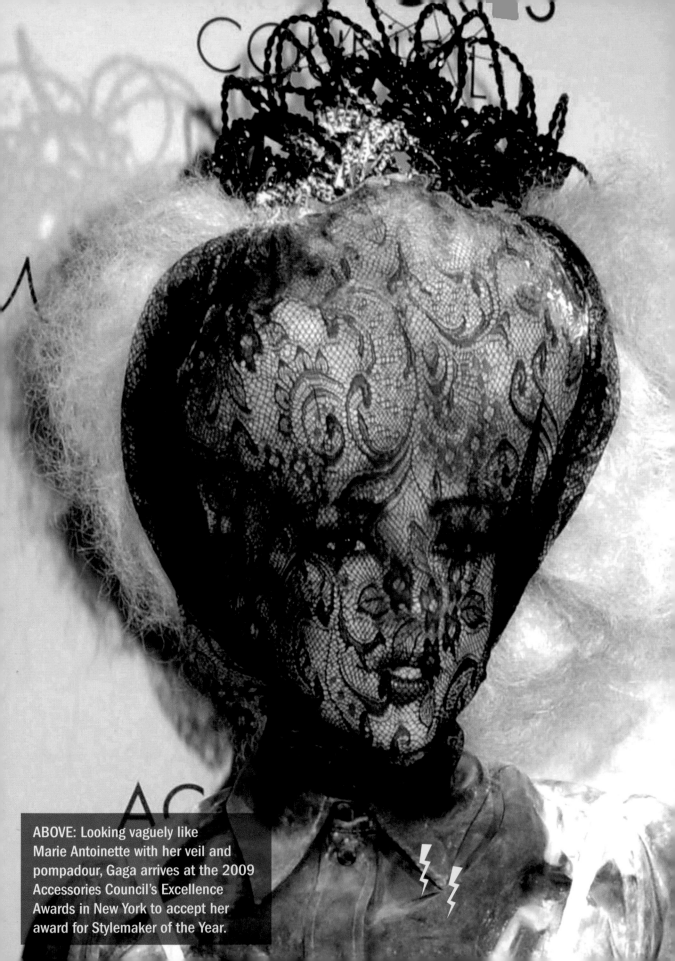

ABOVE: Looking vaguely like Marie Antoinette with her veil and pompadour, Gaga arrives at the 2009 Accessories Council's Excellence Awards in New York to accept her award for Stylemaker of the Year.

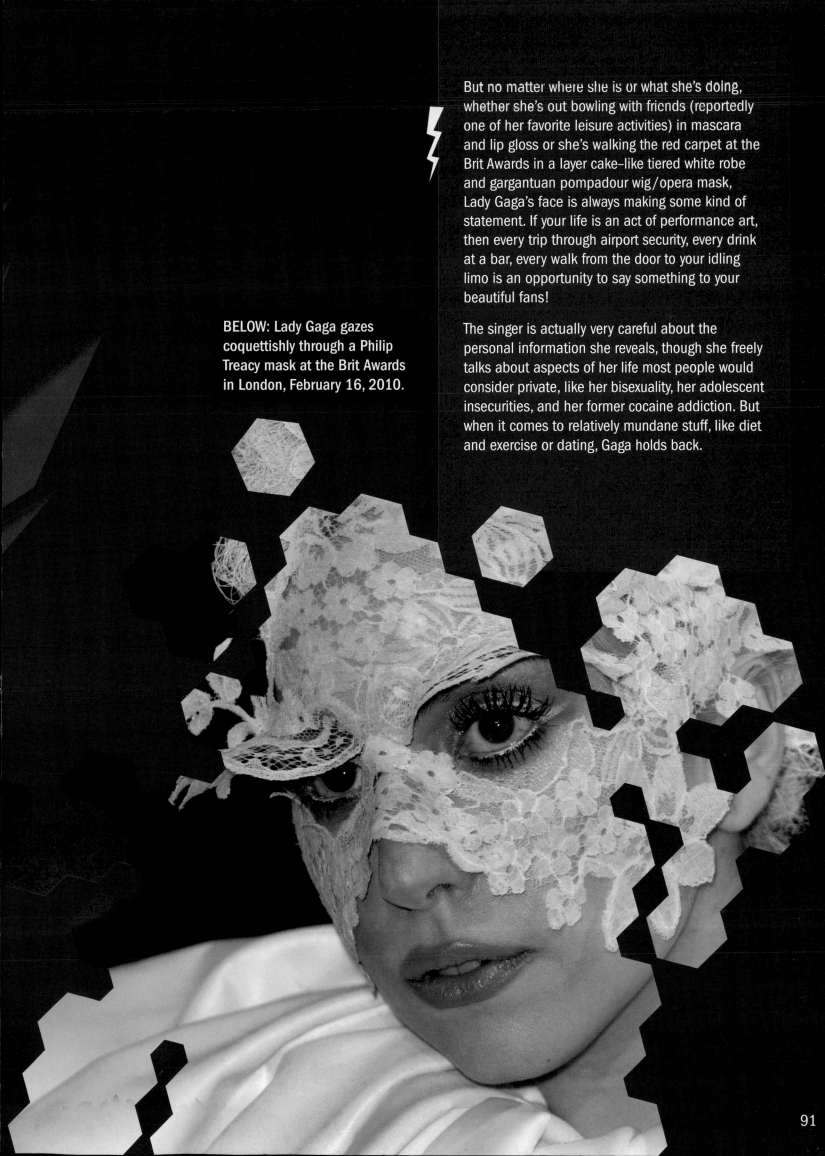

But no matter where she is or what she's doing, whether she's out bowling with friends (reportedly one of her favorite leisure activities) in mascara and lip gloss or she's walking the red carpet at the Brit Awards in a layer cake–like tiered white robe and gargantuan pompadour wig/opera mask, Lady Gaga's face is always making some kind of statement. If your life is an act of performance art, then every trip through airport security, every drink at a bar, every walk from the door to your idling limo is an opportunity to say something to your beautiful fans!

The singer is actually very careful about the personal information she reveals, though she freely talks about aspects of her life most people would consider private, like her bisexuality, her adolescent insecurities, and her former cocaine addiction. But when it comes to relatively mundane stuff, like diet and exercise or dating, Gaga holds back.

BELOW: Lady Gaga gazes coquettishly through a Philip Treacy mask at the Brit Awards in London, February 16, 2010.

One of Lady Gaga's most striking face coverings is a simple latex panel that covers all but the mouth and is attached to a full-body latex catsuit with tiny pointy ears. On stage and in the "Bad Romance" video, Gaga and her dancers prowl around (with remarkable grace considering several versions don't even have eye slits) in these shiny body masks. They are as indistinguishable and interchangeable as if they were genetically engineered. Get it? Fame is faceless! No, but seriously. These blank latex slates do provide an interesting perspective on the relationship between famous people and their fans, or Gaga's "little monsters." Without a face, without an actual identity around to compete with the audience's vision of the artist, nothing distracts her from perfectly reflecting her little monsters, and nothing distracts the little monsters from worshiping her. It's the most efficient exchange imaginable between pop artist and pop audience.

BELOW: Gazing through a ladylike veil at a party in Berlin, September 7, 2009.

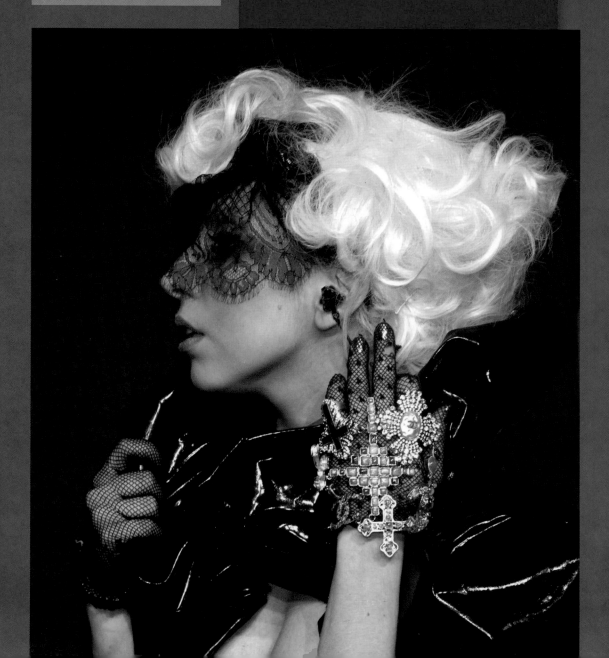

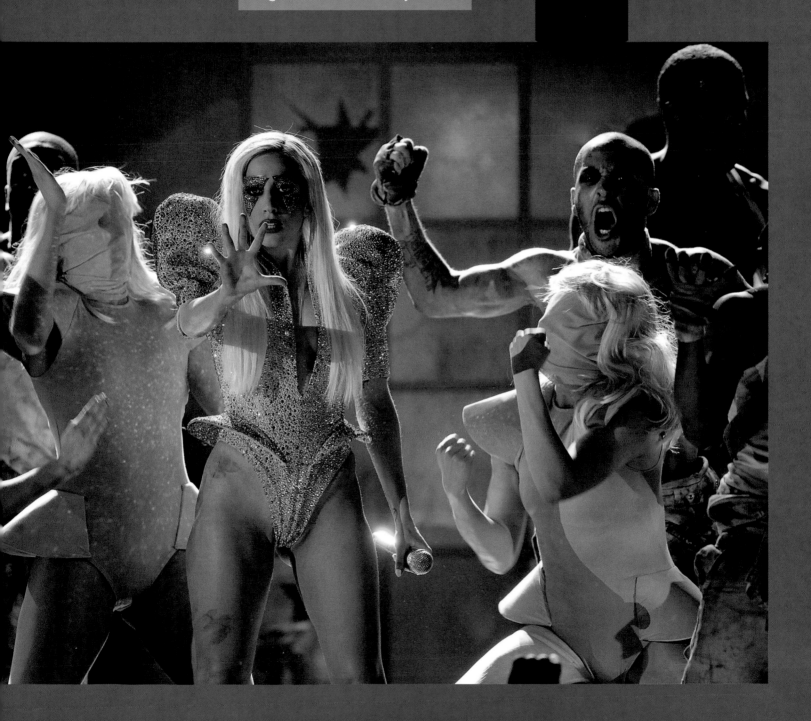

BELOW: Gaga's faceless dancers echo the "Bad Romance" video on stage at the 2009 Grammy Awards.

That moment at the VMAs wasn't only awkward for Eminem. Everybody watching—in the audience and at home—squirmed a little as Gaga made her way to the stage. A natural first reaction to her outfit is confusion (what type of biochemical is that outfit even made out of?). Then comes revulsion (she looks really weird). Then the sense of practical concern (she's totally going to trip). Then amusement, as she returns Eminem's hug with stiff, stately elegance). Then, as the singer leans in to speak, we realize she has a problem. She's got to thank "God and the gays" (as she often does when accepting an award) but there's just no way she can even move her lips enough to form words while wearing that thing. That's when she takes off the mask, and there's a sort of collective shift forward in the seats of everyone watching, as if it's Michael Jackson up there debuting a new face. We know what she looked like half an hour ago on stage, but what does she look like under there right now? In this moment Gaga's mask is the opposite of those militantly anonymous vinyl face sheaths. Instead of presenting the masked celebrity as a sleek, empty mirror, she becomes a maniacally compelling extraterrestrial creature that we never tire of seeing revealed, then re-revealed again and again. Lady Gaga is comfortable with either incarnation of herself; what she can't handle is to be without any mask at all.

LEFT: In an Alexander McQueen red lace concoction complete with spiked crown, Lady Gaga accepts her award for Best New Artist at the 2009 MTV Video Music Awards.

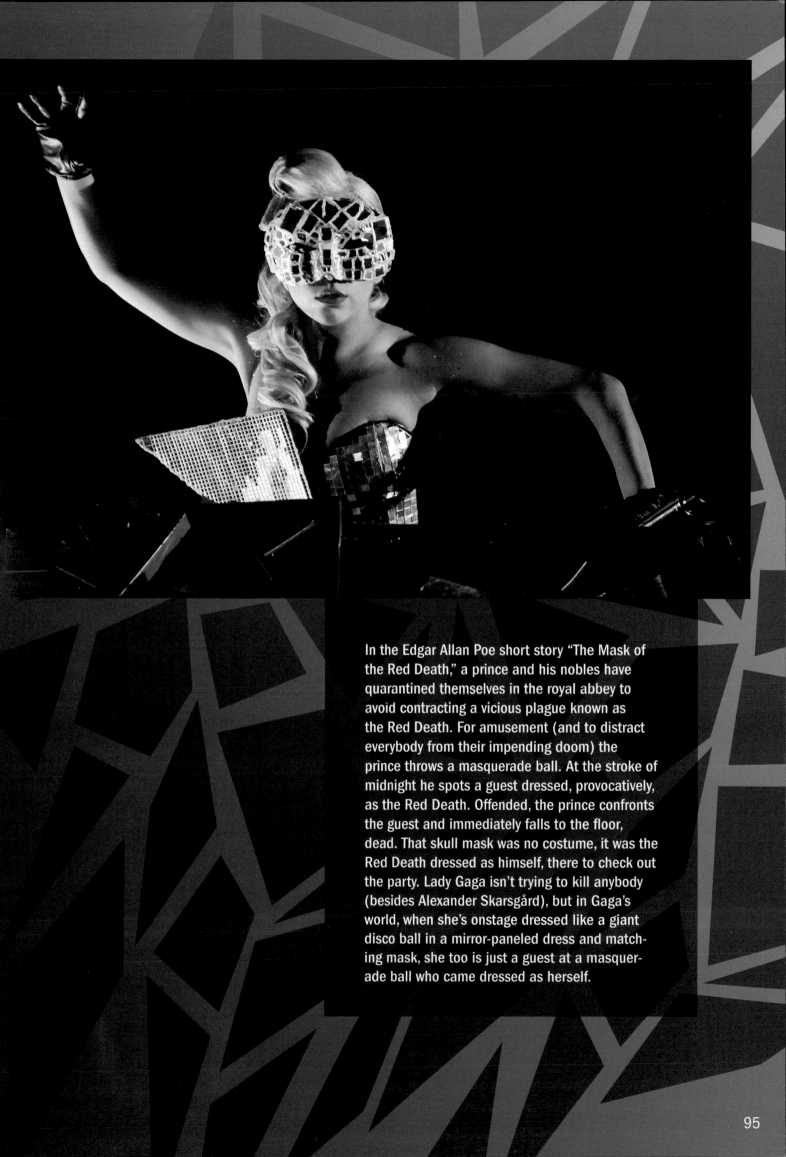

In the Edgar Allan Poe short story "The Mask of the Red Death," a prince and his nobles have quarantined themselves in the royal abbey to avoid contracting a vicious plague known as the Red Death. For amusement (and to distract everybody from their impending doom) the prince throws a masquerade ball. At the stroke of midnight he spots a guest dressed, provocatively, as the Red Death. Offended, the prince confronts the guest and immediately falls to the floor, dead. That skull mask was no costume, it was the Red Death dressed as himself, there to check out the party. Lady Gaga isn't trying to kill anybody (besides Alexander Skarsgård), but in Gaga's world, when she's onstage dressed like a giant disco ball in a mirror-paneled dress and matching mask, she too is just a guest at a masquerade ball who came dressed as herself.

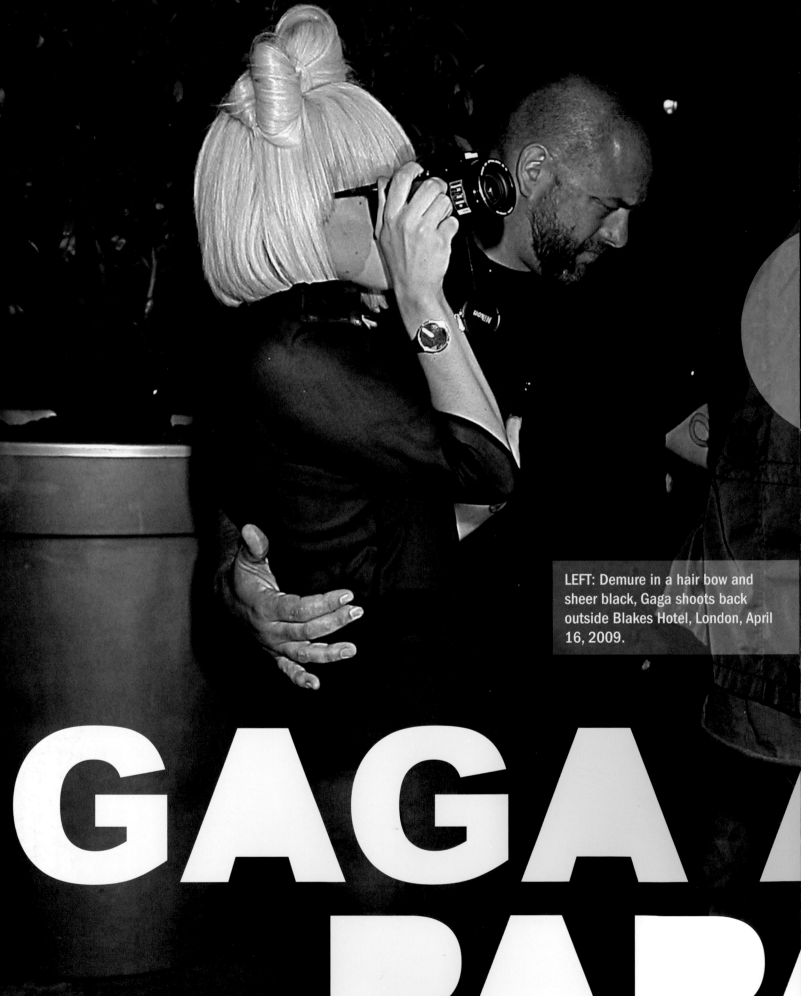

LEFT: Demure in a hair bow and sheer black, Gaga shoots back outside Blakes Hotel, London, April 16, 2009.

GAGA

PAPA

he list of famous artists Lady Gaga has been compared to is long and varied. And she's responded to each with a mixture of coy diplomacy and uncommon graciousness. When Gaga was likened to Christina Aguilera, the "Dirrty" singer said that she wasn't sure if Gaga was a boy or a girl, yet Gaga's response was the epitome of grace: "If anything I should send her flowers because a lot of people didn't know who I was until that happened." When Gaga was dismissed as another Madonna imitator, she said she was flattered, then appeared in a mock brawl with the Material Girl on *Saturday Night Live*. Lady Gaga doesn't mind being compared to other pop icons: In fact, she welcomes it, because her entire creative identity is a self-described synthesis of every pop cultural influence she's absorbed since birth. The singer devoured countless books about Andy Warhol and David Bowie, catalogued and then deconstructed paparazzi shots of Madonna, replayed clips of Marilyn Monroe until they were burned into her memory, and took detailed mental notes on grainy videos of Grace Jones. Even

now that she's famous in her own right, the singer spends hours a day alone with her computer, trolling the Internet for pop cultural inspiration and chronicling her thoughts in a series of ideas files on her desktop.

Lady Gaga is a star, but she's also the ultimate fan. And of the many stars she worships, there is one iconic blonde to whom Gaga wants to be compared: Princess Diana. The singer was only eleven when Diana died but grew up in awe of her and regularly brings her up in interviews. Gaga even included a direct lyrical reference to Diana in the song "Dance in the Dark," where Gaga sings, "Diana you're still in our hearts / Never let you fall apart / Together we'll dance in the dark."

Like that of many fans of Princess Diana, Lady Gaga's obsession has much to do with the symbolism of Diana's death. From her strained relationship with Queen Elizabeth, to the distaste she had for royal life, to her sincere commitment to charity work, to her affair with her

riding instructor and her husband's affair with Camilla Parker-Bowles, there was no moment in Diana's life that the public did not feel entitled to witness. That included, as it turns out, her death. She was killed in a car wreck in Paris after the driver lost control while being chased by paparazzi and crashed into a tunnel entrance. The photographers continued taking photos of the wreckage as it lay there smoldering.

The symbolism was undeniable: the most famous woman in the world literally driven to her death by the lust to get one more blurry shot of her. The world was stunned. Lady Gaga was inspired. Twelve years later, when the singer was planning her first live performance at the MTV Video Music Awards, Diana was on her mind. After consulting with the Haus of Gaga, the singer decided to turn "Paparazzi" into a performance art piece that referenced Diana's death by fame. "Yeah," the singer confirmed to *V* magazine after the VMA performance. "Diana was the most iconic martyr of fame. She died because of it."

If you stage a gruesome mock death at the hands of fame on national television, you might forgive people for interpreting that as an act of protest, as a statement against fame. But that's not how Lady Gaga meant it. She loves celebrity culture. "I used to read tabloids like textbooks, with a scholarly approach," she has said. And she even loves the paparazzi, who function as her unpaid documentarians, ensuring that every new idea she expresses on stage or on the streets will immediately be beamed onto the handheld devices of millions of people around the world. She provides them in turn with an endless flow of new looks to keep up with the twenty-four-hour celebrity news cycle. And to show just how much she appreciates them, Gaga regularly turns the camera lens on them. With a black point-and-shoot that matches her motorcycle jacket and a delicate shoulder-mounted video camera, Gaga is herself a member of the paparazzi, eager to document them documenting her.

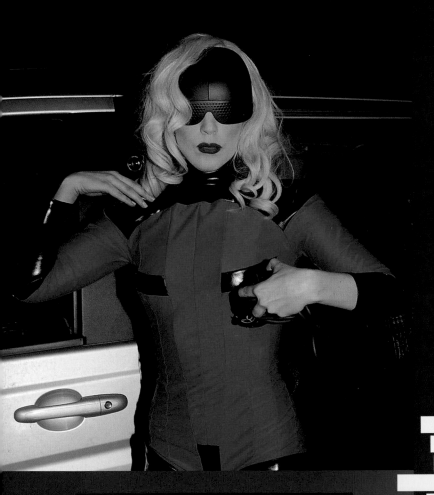

ABOVE: Lady Gaga hits the town in London with a plastic mask covering the top half of her face and a tiny video camera on her shoulder, February 27, 2010.

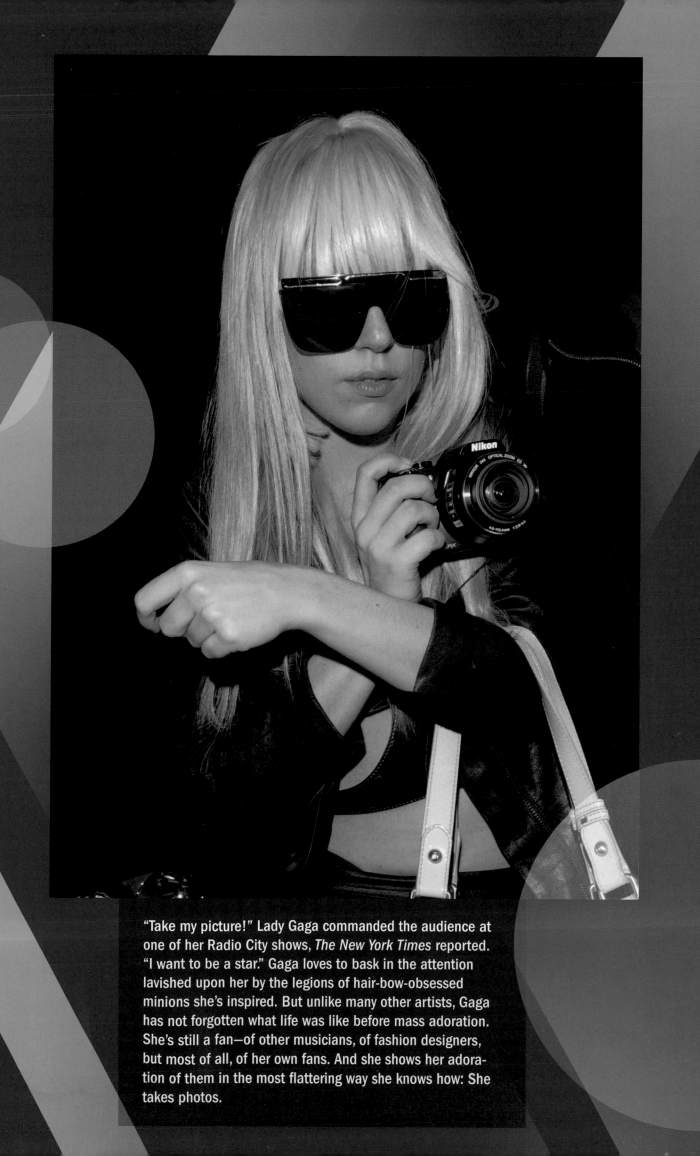

"Take my picture!" Lady Gaga commanded the audience at one of her Radio City shows, *The New York Times* reported. "I want to be a star." Gaga loves to bask in the attention lavished upon her by the legions of hair-bow-obsessed minions she's inspired. But unlike many other artists, Gaga has not forgotten what life was like before mass adoration. She's still a fan—of other musicians, of fashion designers, but most of all, of her own fans. And she shows her adoration of them in the most flattering way she knows how: She takes photos.

HURTS SO GOOD

*O*ver the summer of 2009, British police announced they were looking for witnesses to a brutal assault in Liverpool. A group of six twenty-something girls allegedly kicked and punched an innocent man who was on a date with his girlfriend, leaving him with a broken ankle. Eager to find anyone who might have seen what happened, the cops described the lead assailant as a Lady Gaga look-alike. It's unclear whether the girl was deliberately dressed as Gaga or just another young, cute blonde in a weird outfit. It *is* clear that this would never happen to Miley Cyrus. Miley Cyrus look-alikes don't go around beating the crap out of people. Britney Spears look-alikes? Maybe, after that whole attacking-photographers-with-an-umbrella breakdown . . . but before that? No way. Gaga is different. Gaga is dangerous. And if you stick around too long, you might get hurt.

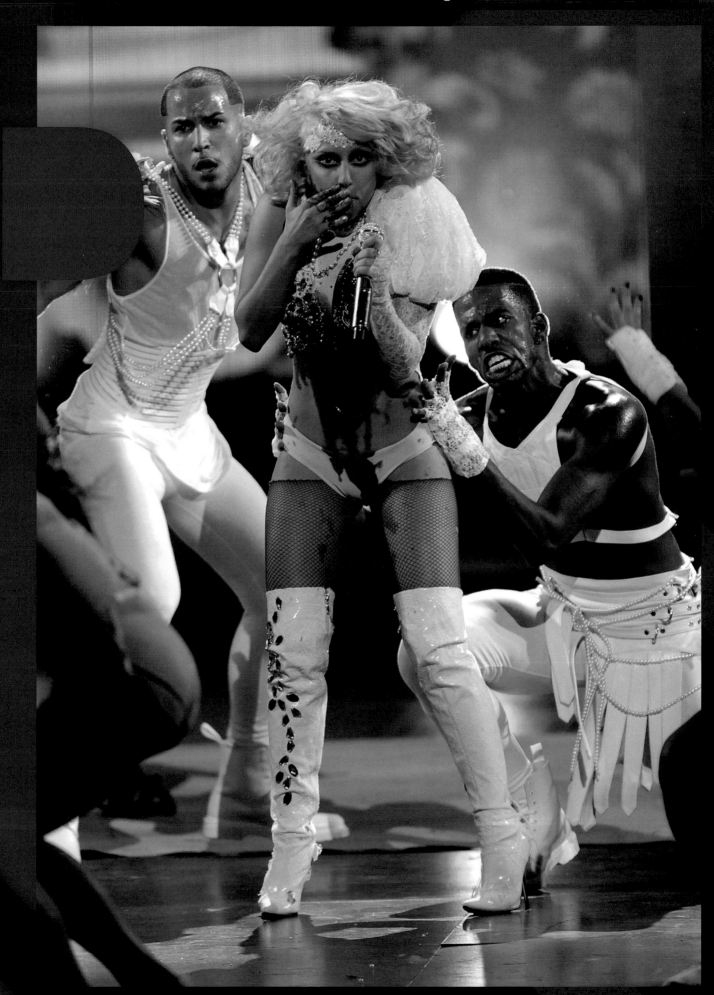

BELOW: Lady Gaga laps up the attention as fake blood streams down her stomach and thighs at the 2009 VMAs.

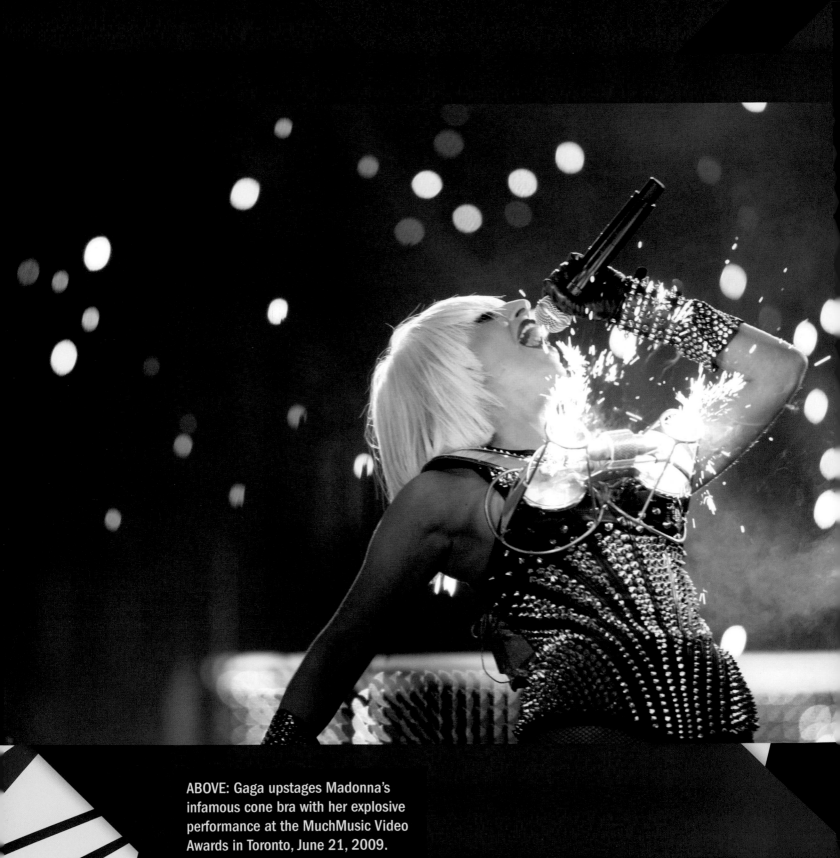

ABOVE: Gaga upstages Madonna's infamous cone bra with her explosive performance at the MuchMusic Video Awards in Toronto, June 21, 2009.

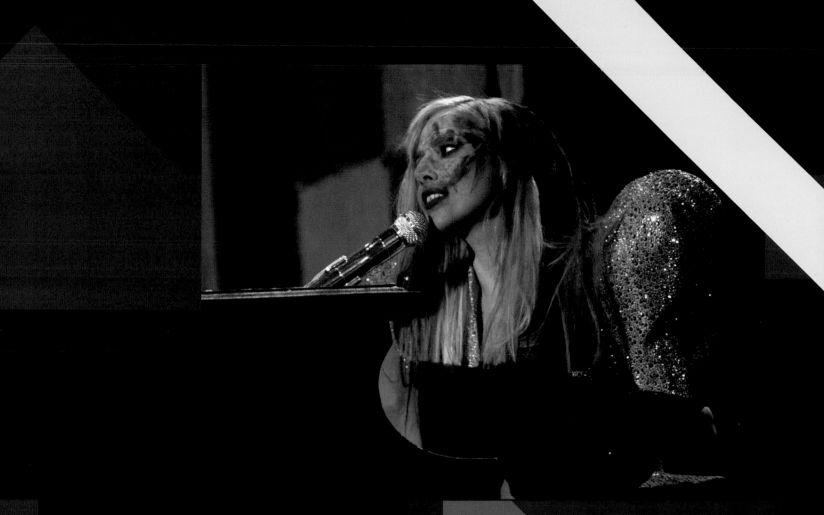

Onstage, in her videos, and on the street, Lady Gaga regularly wears outfits that look charred, torched, stabbed, ravaged, and otherwise massacred. At the MuchMusic Awards in Toronto in 2009, she gave what seemed like a relatively scdatc (for Gaga) performance, wearing a studded black corset and matching panties. But as the song came to a close, Gaga's dancers circled around her, hiding her from the camera, and when she reemerged her boobs were on fire. The two cones spit and crackled like giant sparklers while Gaga bent back, mouth open in a mock roar, chest heaving from the exertion. Immolation is also a theme in the "Bad Romance" video, which concludes with Gaga, draped in a giant polar bear fur train, setting fire to her lover's bed while he's still in it. In the last frame, Gaga is reunited with her sparking bra while she lounges, hair singed and smoking, next to the ash-covered skeleton of her lover. That's nothing compared to the "Paparazzi" video, in which the star hits her

For Lady Gaga, fame is like war. You suit up (monumental shoulder pads instead of fatigues), arm yourself (sparkler bra or giant mountable rifle instead of a regular old machine gun), and you march into battle (in white vinyl thigh-high boots instead of combat boots). Like a soldier, Gaga is fully aware that she might not make it out of all this alive. On stage she's been torched, bloodied, bruised, crippled, drowned, poisoned, and hung, but she's always lived to fight another day. For now . . .

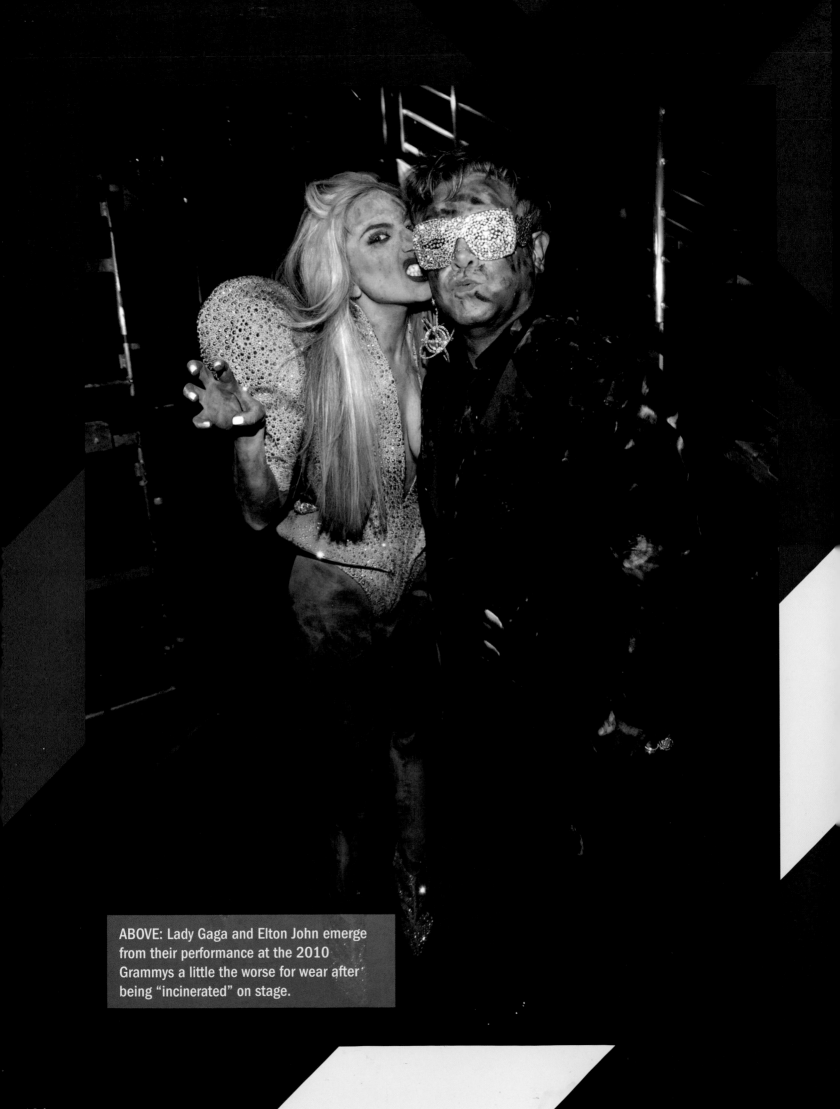

ABOVE: Lady Gaga and Elton John emerge from their performance at the 2010 Grammys a little the worse for wear after being "incinerated" on stage.

boyfriend in the eye with a Champagne bottle and he shoves her off the balcony: Afterward, she's confined to a wheelchair, then platinum crutches. When she's finally healed, she gets revenge by poisoning him (while wearing a bright yellow Minnie Mouse catsuit). At the 2010 Grammys, Gaga's performance of "Poker Face" ended with her dancers throwing her into a flame-spewing incinerator marked "Rejected." She emerged a minute later sitting at a dual piano opposite Elton John, both their faces smeared with greasepaint and ashes, and launched into a medley of "Speechless" and "Your Song."

In Gaga's world (which is really our world, if you buy the whole pop-stars-reflect-our-social-ideals argument), fame is so deliciously appealing that people will do anything to get it. They'll kill for it, and as she demonstrated in her ultimate act of onstage violence, they'll die for it as well. At the 2009 MTV Video Music Awards, the singer performed a version of "Paparazzi" that had her transform from a serene virginal queen in a white lace crown to a crazy-eyed banshee more desperate for attention with every throb of the bass line. "MTV said, what do you want to do?" the singer told *Q.* "I said, I want to bleed to death for four minutes, and they're like [face of total confusion]. So I said, the world is looking for a story about me being fallen. So maybe if I just show them what it looks like, they'll stop looking. Here's what I look like while I'm dying. And I bled to death surrounded by flashing lights and was hung like a martyr in all of my blonde glory. Like many others before, Princess Diana, Marilyn Monroe, Anna Nicole Smith." The performance ended exactly as Gaga wanted it to, with blood gushing from her chest as she hung glassy-eyed and gently swaying from the rafters of Radio City Music Hall.

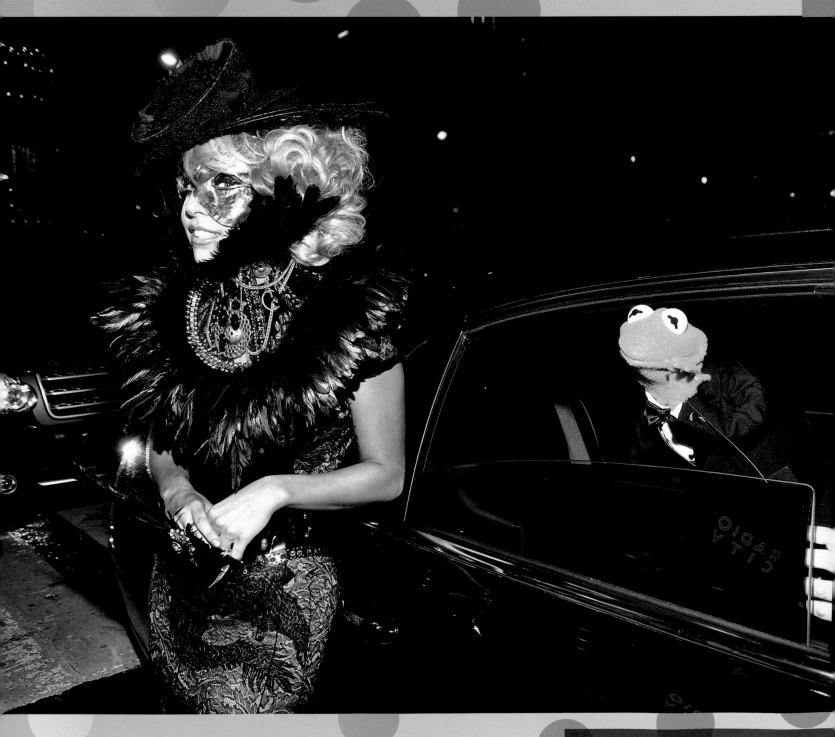

ABOVE: Lady Gaga brings Kermit the Frog as her date to the 2009 MTV Video Music Awards at Radio City Music Hall in New York, September 13, 2009.

SSORY TO THE CRIME

*I*f she wore something that didn't look like a dangerous weapon, Lady Gaga would be a great guest at a cocktail party. If you're into fashion, she can parse the merits of Marc Jacobs's Spring 2010 underwear-as-outerwear show, then share a solemn toast to Alexander "Lee" McQueen (only his friends get to call him that). If you're a modern art person, the singer can talk to you about surrealism or shock art. If you are a film buff, Gaga knows her Fritz Lang and her Clara Bow and her Bette Davis. If you're a rock nerd, she can swap stories about doing drugs and freaking out to Bowie's *Diamond Dogs*. It's as if the singer has designed herself to be seen from every possible angle by eyes that come from every possible background, and her ethos is executed with such maniacal precision that no matter which view you take, it brings you to the same core message.

The totally bizarre accessories Gaga often wears show just how thorough she is about communicating her vision of fame to anyone who catches even a glimpse of her. Imagine you are a hermit. You live in a cabin in the middle of the woods somewhere with no TV, no radio, no Internet. But once a month you head into town to buy supplies (sacks of flour, matches, *Little House on the Prairie* stuff) and while you're paying, you glance over at the magazine rack and see an image of this small supertanned blonde girl wearing a giant glittering crustacean on her face. The

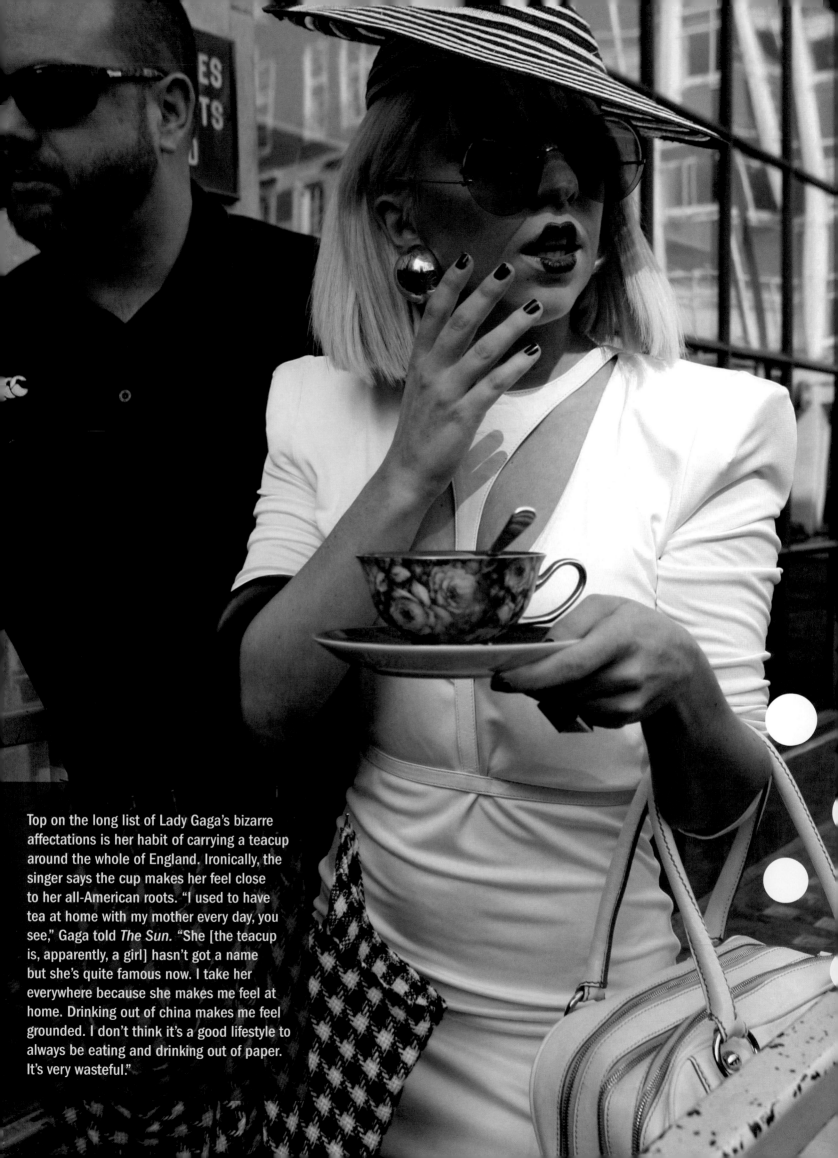

Top on the long list of Lady Gaga's bizarre affectations is her habit of carrying a teacup around the whole of England. Ironically, the singer says the cup makes her feel close to her all-American roots. "I used to have tea at home with my mother every day, you see," Gaga told *The Sun*. "She [the teacup is, apparently, a girl] hasn't got a name but she's quite famous now. I take her everywhere because she makes me feel at home. Drinking out of china makes me feel grounded. I don't think it's a good lifestyle to always be eating and drinking out of paper. It's very wasteful."

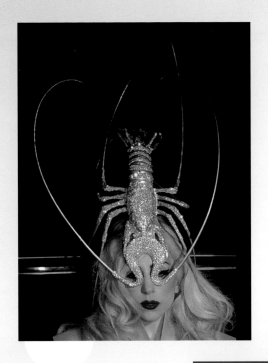

split second it takes your pupils to process that visual information and transport it to your brain is exactly how long it takes Lady Gaga to deliver her message. She is a proud freak, which might inspire you to embrace your inner weirdo. A normal response to a girl dressed in a Philip Treacy lobster mask/hat or a dress made of Muppet heads would be to call a shrink, but Gaga's commitment to her own delusions is so strong that instead she's on *Oprah* talking with throaty sincerity about how the Kermit coat is her way of "making a comment about fur."

Lady Gaga often talks about the power of repetition, of wearing the same thing numerous times, and she lives up to it: appearing perpetually pantsless, wearing her hair bow every day for months, carrying a purple teacup all over London. She regularly tells the same stories in interviews: The Cure was her coke binge soundtrack, in high school she was both delusionally ambitious and a total outcast. And she describes her philosophy about art in a relentlessly consistent way ("Art is a lie, and every day I kill to make it true."). Even the literal sound of her music is based on repetition: 'Pa pa poker face," "Eh eh / nothing else I can say," "Rah rah, ah ah ah / Roma, roma-ma." The look, the sound, the feel, all of it has to be executed with militaristic precision because Lady Gaga is broadcasting on a wide variety of frequencies, and her message can't afford any crossed wires. Though her accessories might look random (the teacup) or even insane (chicken claw bracelet) these decorations are integral to her identity, they work like exclamation points at the end of Gaga's message for the day.

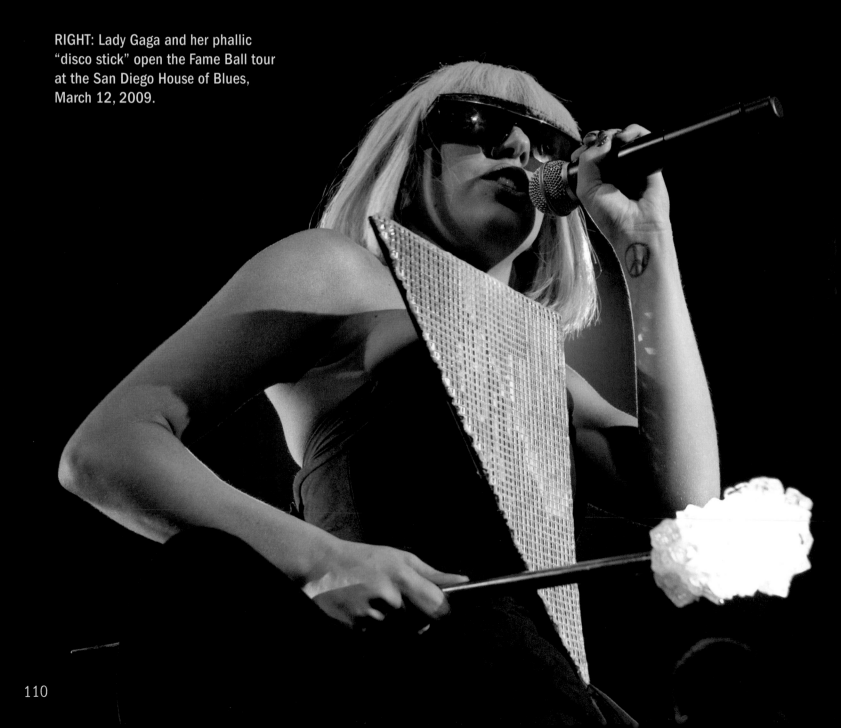

IN SEA
THE

RIGHT: Lady Gaga and her phallic "disco stick" open the Fame Ball tour at the San Diego House of Blues, March 12, 2009.

RCH OF
DISCO
STICK

"I want to wear a dick strapped to my vagina," Lady Gaga reportedly told assorted members of the Haus of Gaga and *Q*'s creative team during a meeting in London to discuss her April 2010 cover shoot. "We all know one of the biggest talking points of the year was that I have a dick, so why not give them what they want? I want to comment on that in a beautiful, artistic way. . . . And I want to call this piece Lady Gaga Dies Hard." The singer's right: People are obsessed with her phantom penis and rumors that she's a hermaphrodite. Other rumors include that she's a transsexual who has had extensive surgery or just a plain old dude living his life in drag. The singer finds this all so hilarious, so exactly part of the absurdity of fame she lives to represent, that she encourages the hell

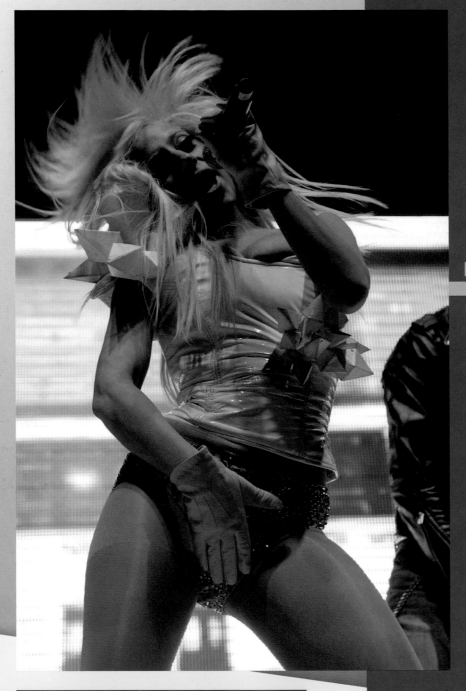

ABOVE: Gaga gets grabby at King's Hall in Belfast, Northern Ireland, February 3, 2009.

out of it. She regularly responds to rumors that she has a penis by batting her eyelashes and saying (on an Australian radio show, among other outlets), "My beautiful vagina is very offended. I'm not offended; my vagina is offended." And when Gaga had the chance to show the world her giant penis, she relished it. "It's a statement about my femininity and makes fun of the hilarity of the media," the star said, again talking about the penis-strapped-to-her-vagina concept for the *Q* shoot. "I want to do something memorable and groundbreaking and the whole world will say, 'What the fuck is happening?'"

Playing with penises—whether it's her boyfriend's or a phallic stage prop or the thick blue dildo she ended up stuffing into her pants for the *Q* cover—is part of Lady Gaga's oeuvre. In deliberate homage to Madonna and Michael Jackson, Gaga regularly incorporates crotch-grabbing into her choreography. In her "Telephone" video, the buzzing cell phone becomes a metaphorical dildo, and her song "LoveGame" is built entirely around the refrain, "I want to take a ride on your disco stick." "It's another of my very thoughtful metaphors for a cock," the singer said when asked about the line. "I was at a nightclub, and I had quite a sexual crush on somebody, and I said to them, 'I want to ride on your disco stick.' The next day, I was in the studio, and I wrote the song in about four minutes. When I play the song live, I have an actual stick—it looks like a giant rock-candy pleasuring tool—that lights up." Subtle she is not.

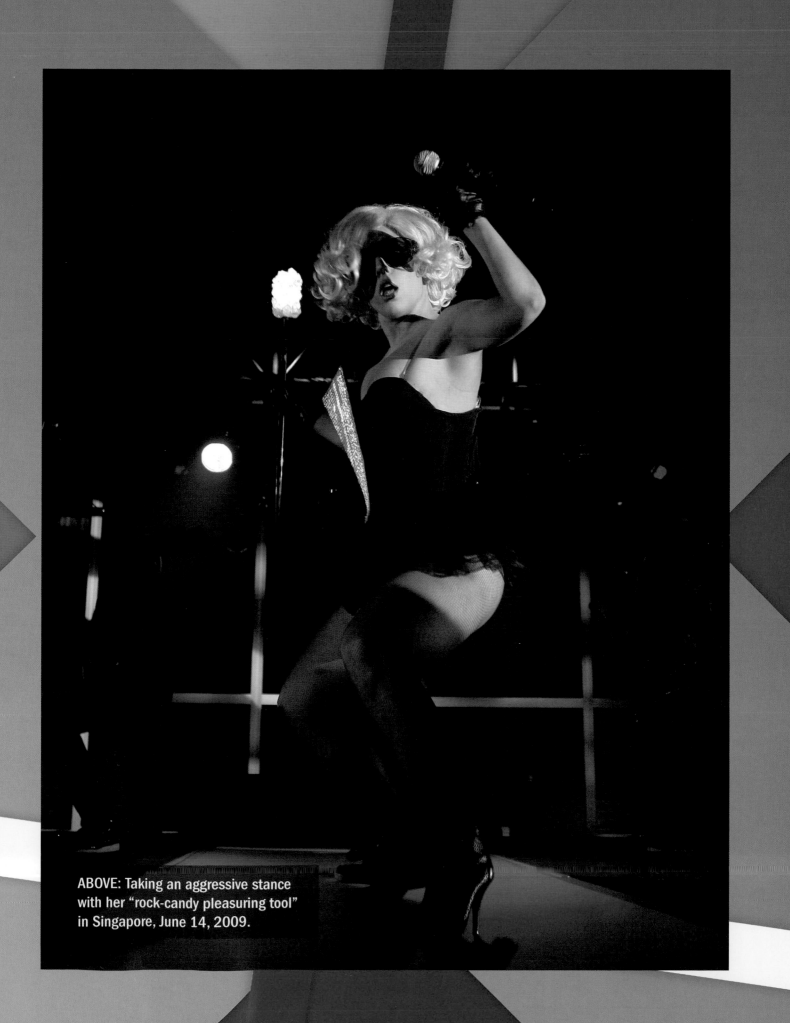

ABOVE: Taking an aggressive stance with her "rock-candy pleasuring tool" in Singapore, June 14, 2009.

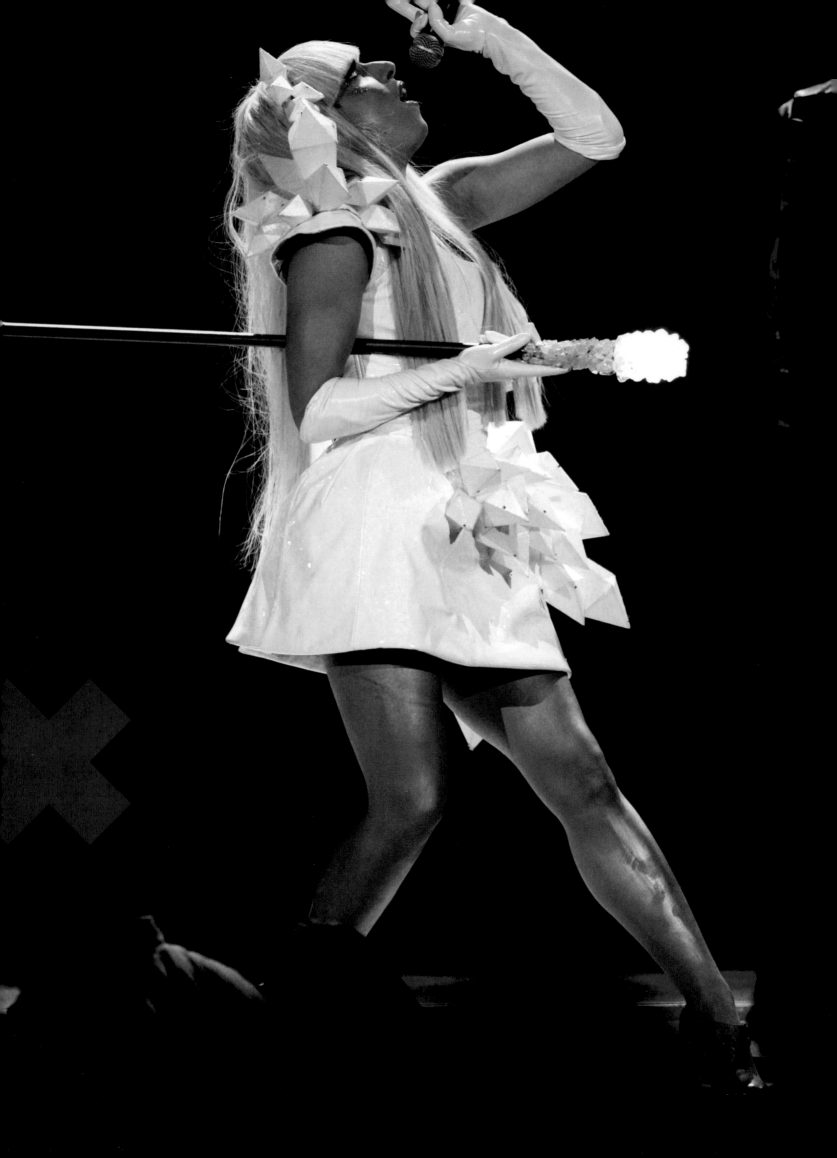

Like everything else in her orbit, Gaga's love of pcniscs, her love of sex, is all part of her love of her work. "Writing a record is like dating a few men at once," the singer told *Blender*. "You take them to the same restaurants to see if they measure up, and at some point you decide who you like best. When you make music or write or create, it's really your job to have mind-blowing, irresponsible, condomless sex with whatever idea it is you're writing about at the time." And if she had to choose between a really fantastic lay and her work, the work wins every time. In fact, she faced that very question with Matthew "Dada" Williams, one of her primary collaborators in the Haus of Gaga. "Dada is quite brilliant and we were crazy lovers, but I stopped it when we discovered what a strong creative connection we had," the singer has said. "I didn't want it just to be about careless love." In Gaga's world, where every swoosh of eyeliner, every wisp of hair, and every adhesive rhinestone is a thought-out gesture, there is no time for casual, no space for carefree, and no such thing as careless.

For Lady Gaga, genitalia are just another accessory. Maybe she has girl parts, maybe she has boy parts, but as long as you're talking about what kind of parts she has, she wins. In the end, everything about Lady Gaga, including her gender, is second to her fame. "I live my life completely serving only my work and my fans," the singer told *The New York Times Magazine*. "And that way, I have to think about not what is best for my vagina but what is best for my fans and for me artistically."

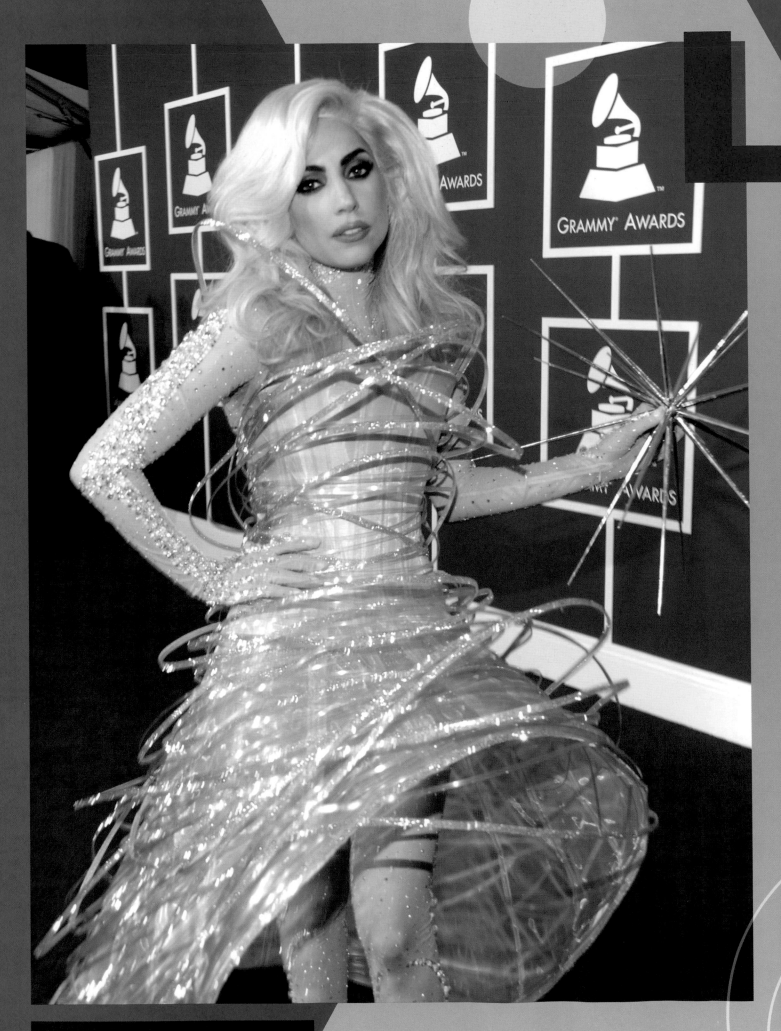

ABOVE: Gaga lands on the red carpet of the 2010 Grammys carrying a giant star prop and orbited by the plastic rings of an Armani Privé gown, January 31, 2010.

LIFE ON MARS

For fifty years pop culture has been obsessed with space. From *The Twilight Zone* to *Planet of the Apes* to *The Rocky Horror Picture Show* and more recently to *Battlestar Galactica*, music, film, and TV has mined the great black abyss for an endless stream of narratives about isolation, human frailty, and hope for a better world. And that unknown world—the place that has all the answers to our woefully human problems, where we can become something better than what we are—is exactly where Lady Gaga claims to be from.

Sometimes she wears outfits that are just spectacularly odd (sparkly Armani green structural leotard, gold vampire grillz), but more often her clothing literally references outer space. She wore massive clanging, orbiting metal rings as a body cage on *Saturday Night Live*, and a smaller version of the same on her head during an appearance at *The Ellen DeGeneres Show* in

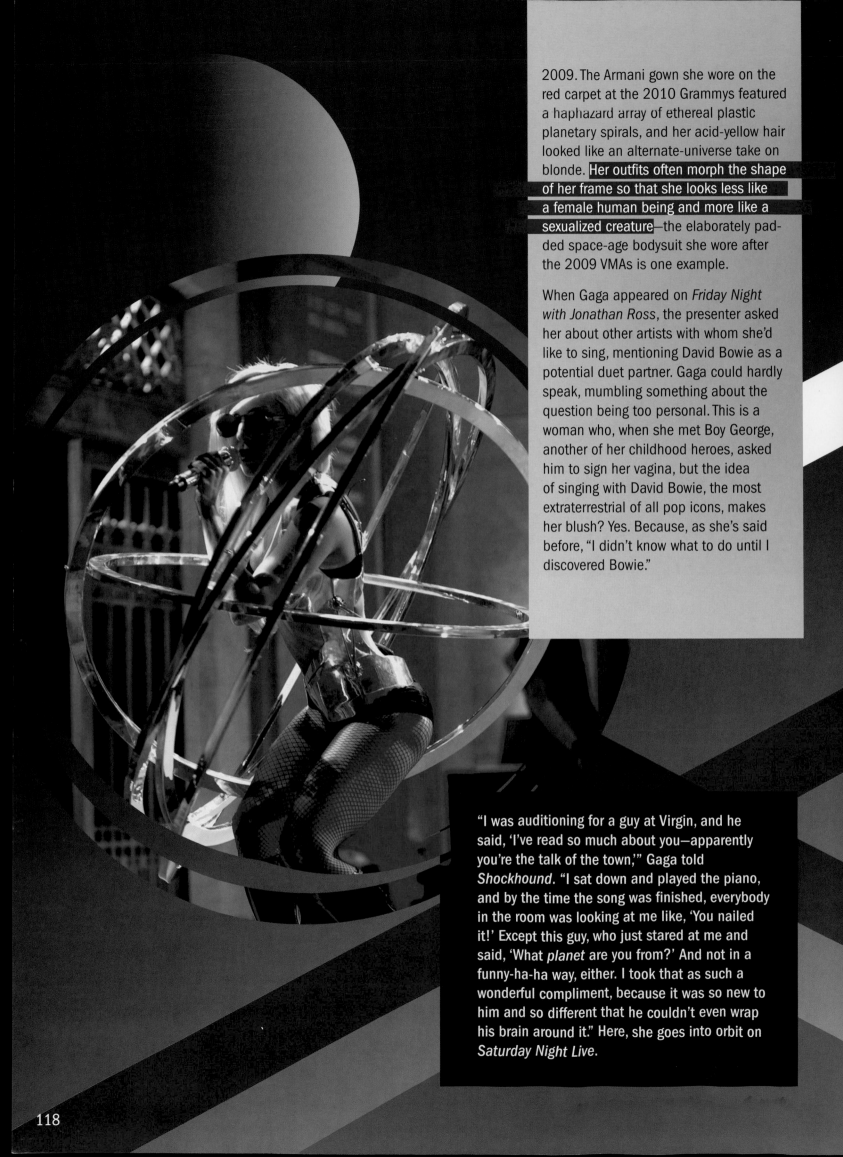

2009. The Armani gown she wore on the red carpet at the 2010 Grammys featured a haphazard array of ethereal plastic planetary spirals, and her acid-yellow hair looked like an alternate-universe take on blonde. Her outfits often morph the shape of her frame so that she looks less like a female human being and more like a sexualized creature—the elaborately padded space-age bodysuit she wore after the 2009 VMAs is one example.

When Gaga appeared on *Friday Night with Jonathan Ross*, the presenter asked her about other artists with whom she'd like to sing, mentioning David Bowie as a potential duet partner. Gaga could hardly speak, mumbling something about the question being too personal. This is a woman who, when she met Boy George, another of her childhood heroes, asked him to sign her vagina, but the idea of singing with David Bowie, the most extraterrestrial of all pop icons, makes her blush? Yes. Because, as she's said before, "I didn't know what to do until I discovered Bowie."

"I was auditioning for a guy at Virgin, and he said, 'I've read so much about you—apparently you're the talk of the town,'" Gaga told *Shockhound*. "I sat down and played the piano, and by the time the song was finished, everybody in the room was looking at me like, 'You nailed it!' Except this guy, who just stared at me and said, 'What *planet* are you from?' And not in a funny-ha-ha way, either. I took that as such a wonderful compliment, because it was so new to him and so different that he couldn't even wrap his brain around it." Here, she goes into orbit on *Saturday Night Live*.

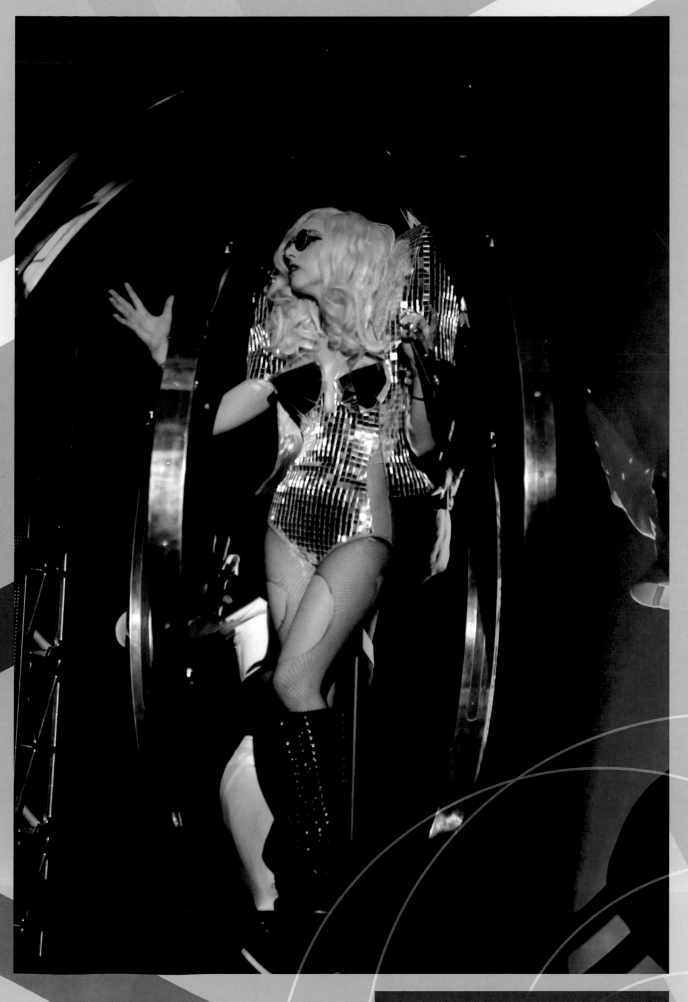

ABOVE: Gaga balances her exaggerated shoulders and breasts while posing on an orbiting set piece during the Monster Ball tour's Los Angeles stop, December 23, 2009.

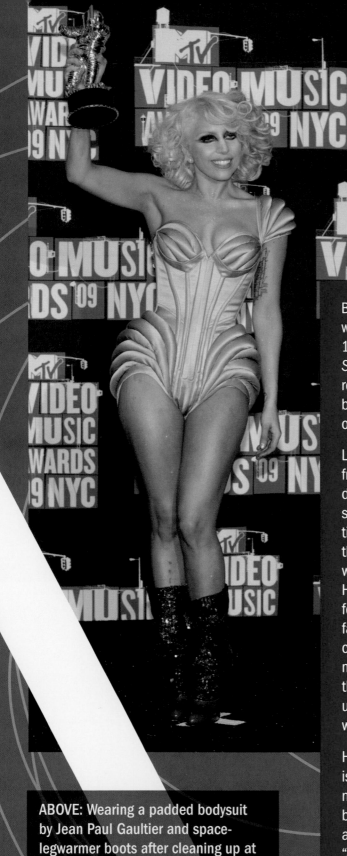

ABOVE: Wearing a padded bodysuit by Jean Paul Gaultier and space-legwarmer boots after cleaning up at the 2009 MTV Video Music Awards.

Bowie needed to build a fantasy world from which to launch his transformation. With the 1972 release of *The Rise and Fall of Ziggy Stardust and the Spiders from Mars* the singer reinvented himself as a flame-haired, platform-booted alien sent to earth to deliver a message of hope and save mankind.

Lady Gaga aspires to build her own world of freedom and salvation on stage every night during the Monster Ball tour. "The design of the show is very, very forward, very, very innovative," the singer told *Rolling Stone.* "I've been thinking about ways to change the way that we watch things. So I've designed a stage with Haus of Gaga that is essentially a frame with forced perspective. So no matter where I go, my fans get the same experience. And the theme of the show is evolution." Every fan, every "little monster" walks into her realm inhibited by their own fears, but they leave unburdened and unleashed, gleeful hair bow–wearing bundles of willful freakishness.

Her Hussein Chalayan–inspired bubble dress is the perfect symbol of this fragile fantasy. It's not about the burlesque thrill of popping the bubbles; it's about escaping to Gaga's world, a place that's strangely serene in its oddness. "A year from now, I could go away, and people might say, 'Gosh, what ever happened to that girl who never wore pants?'" she told *New York* magazine. "But how wonderfully memorable thirty years from now, when they say, 'Do you remember Gaga and her bubbles?' Because, for a minute, everybody in that room will forget every sad, painful thing in their lives, and they'll just live in my bubble world."

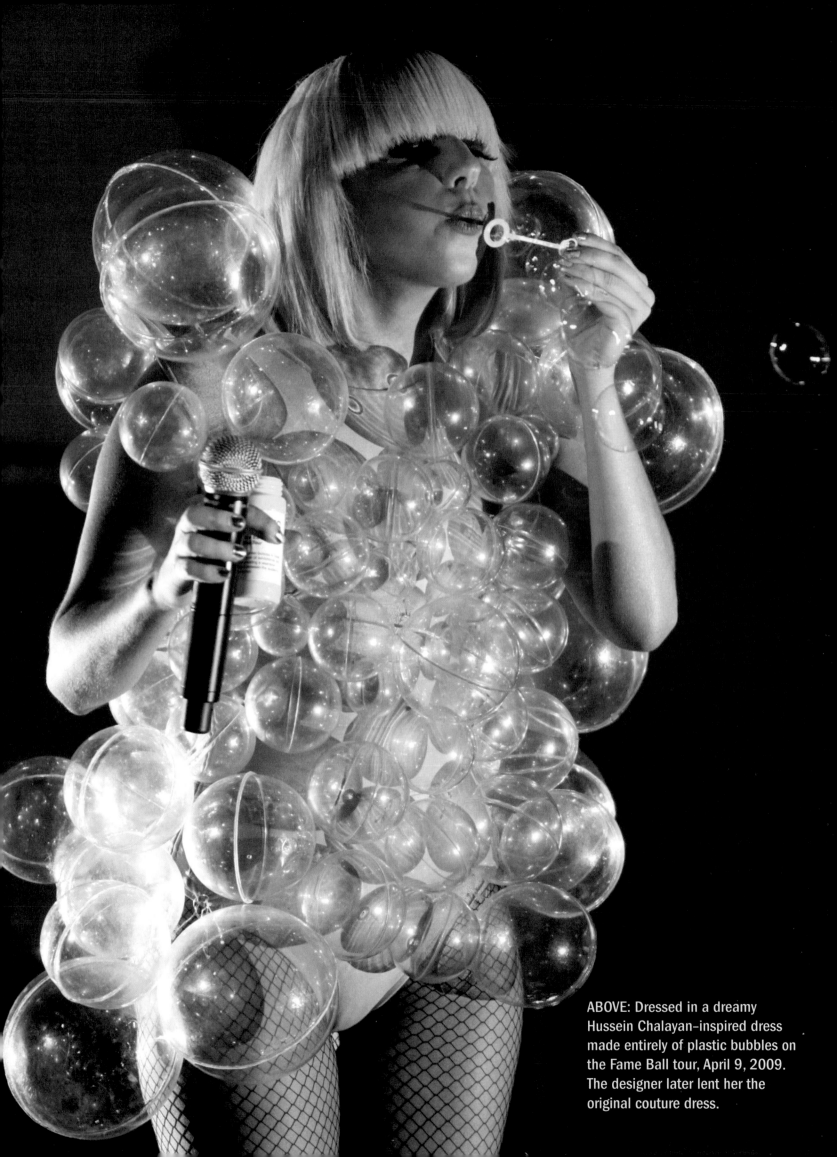

ABOVE: Dressed in a dreamy Hussein Chalayan–inspired dress made entirely of plastic bubbles on the Fame Ball tour, April 9, 2009. The designer later lent her the original couture dress.

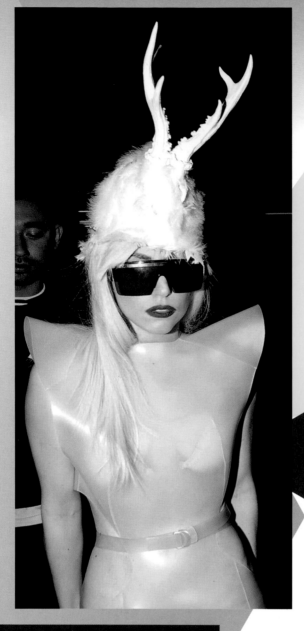

ABOVE: Lady Gaga wears an antler headdress by Mouton Collet with a see-through plastic dress by emerging Scottish designer Rachel Barrett in London, December 5, 2009.

In the modern age, hats are worn casually, as if putting something on your head is a natural expression of easy style: Lindsay Lohan adds a fedora to her leggings-and-heels look, Drew Barrymore wears an ironic trucker hat to a rock show, Nicole Richie wears a paisley silk scarf around her head while at the beach with her kids. And then there are the flocks of aspiring It-boy actors who traipse around Hollywood in black skull caps, the perfect look if you want to seem like you're seeking anonymity while actually drawing the maximum amount of attention to yourself. Hats are the new sunglasses at night, an accessory with roots in practicality that has become the ultimate in frivolity. And as such, it's a Lady Gaga mainstay. Whether she's out for a quiet night at the pub in a military cap or a newsboy or a bowler hat, or she's at an event in a red Flamenco-inspired structure that goes with a mock Zorro outfit or one of her array of turbans, the singer regularly turns to headwear to complete her look.

MAD H

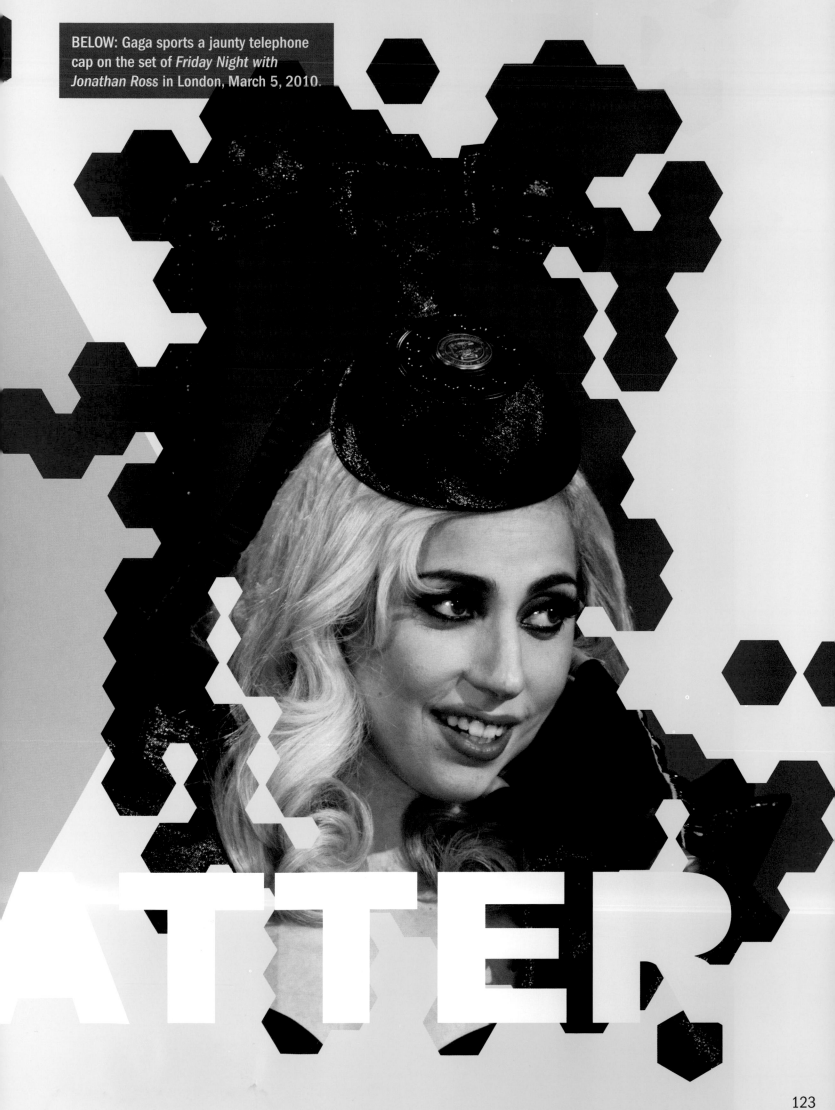

BELOW: Gaga sports a jaunty telephone cap on the set of *Friday Night with Jonathan Ross* in London, March 5, 2010.

ATTER

On stage at the MOCA 30th Anniversary Gala in LA, the singer wore a Frank Gehry–designed multifoot-high hat, ash-colored folds crumpled into a form that looked like a stubbed out cigarette. Walking the red carpet at the 2009 MTV VMAs, the singer dressed like a goth turn-of-the-century heiress in a hat and feathered collar combo designed by Jean Paul Gaultier. She's played the forlorn space-age widow in a small black pincushion hat and veil attached to a giant saucer-like structure with a shimmering black train. She's worn a pale blue draped concoction that made her look like a deranged Maid Marian, a dinner plate mounted on the side of her head, and a white lace needlepoint headdress that reached a foot above her head. Perched on her head we've seen a gargantuan black orchid, slightly askance, which looked capable of causing the tiny star to topple over, as well as the infamous McQueen bloodred lace crown, a giant pleated white headdress that looked like several intersecting beams of otherworldly light meeting at the singer's head in a concentrated burst of white froth, and the black rotary telephone she wore on *Friday Night with Jonathan Ross,* which she pretended to hang up when Ross displeased her. We've also seen Gaga in a variety of antlers—she's put on a comparatively demure set of gleaming white ones, very ladylike and elegant when worn with her transparent latex body armor, and we've seen her walking the streets in a sensational pair of jewel-toned feathered ones, thrusting dramatically into the air and adding about three feet to the star's height.

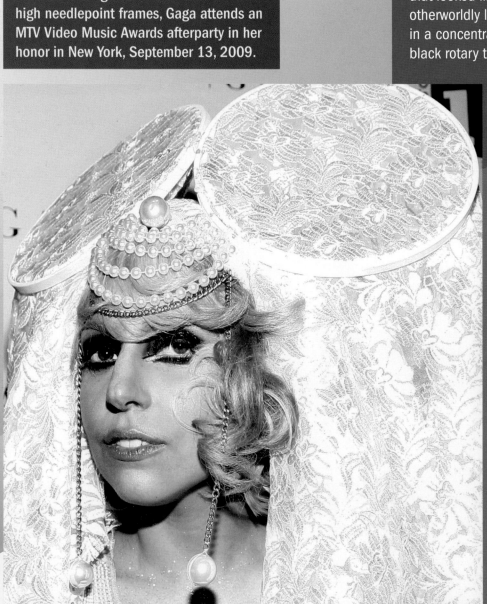

BELOW: Trailing white lace from two foot-high needlepoint frames, Gaga attends an MTV Video Music Awards afterparty in her honor in New York, September 13, 2009.

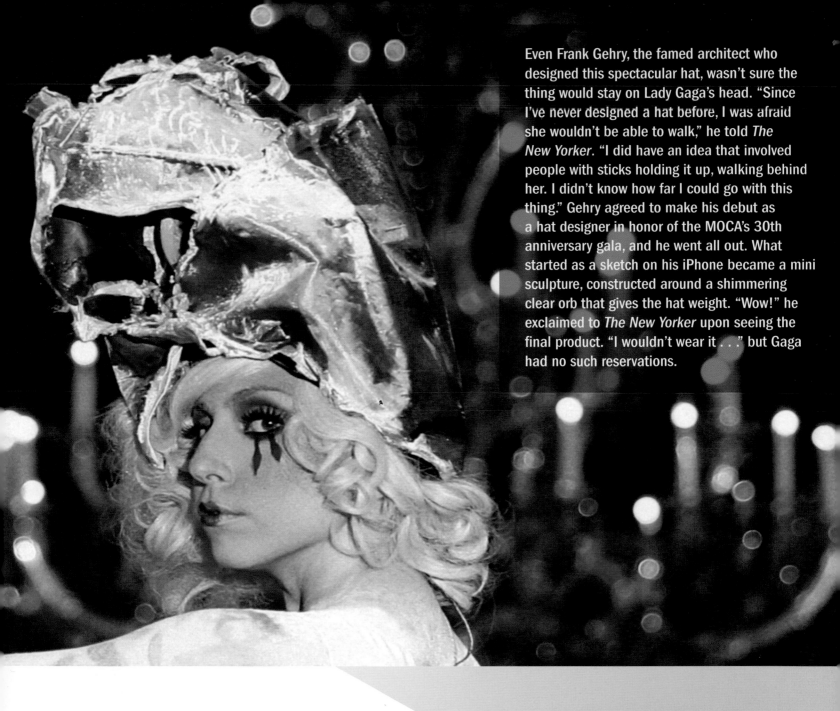

Even Frank Gehry, the famed architect who designed this spectacular hat, wasn't sure the thing would stay on Lady Gaga's head. "Since I've never designed a hat before, I was afraid she wouldn't be able to walk," he told *The New Yorker*. "I did have an idea that involved people with sticks holding it up, walking behind her. I didn't know how far I could go with this thing." Gehry agreed to make his debut as a hat designer in honor of the MOCA's 30th anniversary gala, and he went all out. What started as a sketch on his iPhone became a mini sculpture, constructed around a shimmering clear orb that gives the hat weight. "Wow!" he exclaimed to *The New Yorker* upon seeing the final product. "I wouldn't wear it . . ." but Gaga had no such reservations.

Unlike the collection of starlets and *Teen Beat* boys who wander around airports and Los Angeles hotel bars with hats on their head as part of some pretense at just trying to be real in their real lives, Gaga wears hats the way they are intended to be worn, as statement-making, attention-seeking accessories. She rejects the idea that fame is about reminding the audience of themselves and instead gives us what we really want: something to look at. And she's not planning to alter that philosophy anytime soon. "I'd never give up my wigs and hats for anything," the singer vows.

SHE PLAYED ME

*I*f you want to make Lady Gaga cry, show her a beautiful piano. "We arrived this morning. I was very excited because my room is this gorgeous penthouse with a white baby grand piano in the living room," the singer told *Blender* during a tour stop in Dublin. "When I saw it, I started to cry. I played for a couple of hours, then gave my assistant a heart attack because I wouldn't take a shower. I was like, 'I'm not showering. I'm being brilliant and writing.'" That's what it's like to be the pantsless queen of pop—one piano looks at you the right way and next thing you know you've dropped everything, including personal hygiene, to spend the rest of your life together. Sometimes it's not even a piano that woos you, it's a giant, bedazzled keytar. For Lady Gaga, regardless of whether it's a pristine Steinway or a didgeridoo, her instrument is the ultimate prop in the theatrical extravaganza that is her live show.

Above: Gaga plays a crystal-shaped keytar at the Glastonbury festival in England, June 26, 2009.

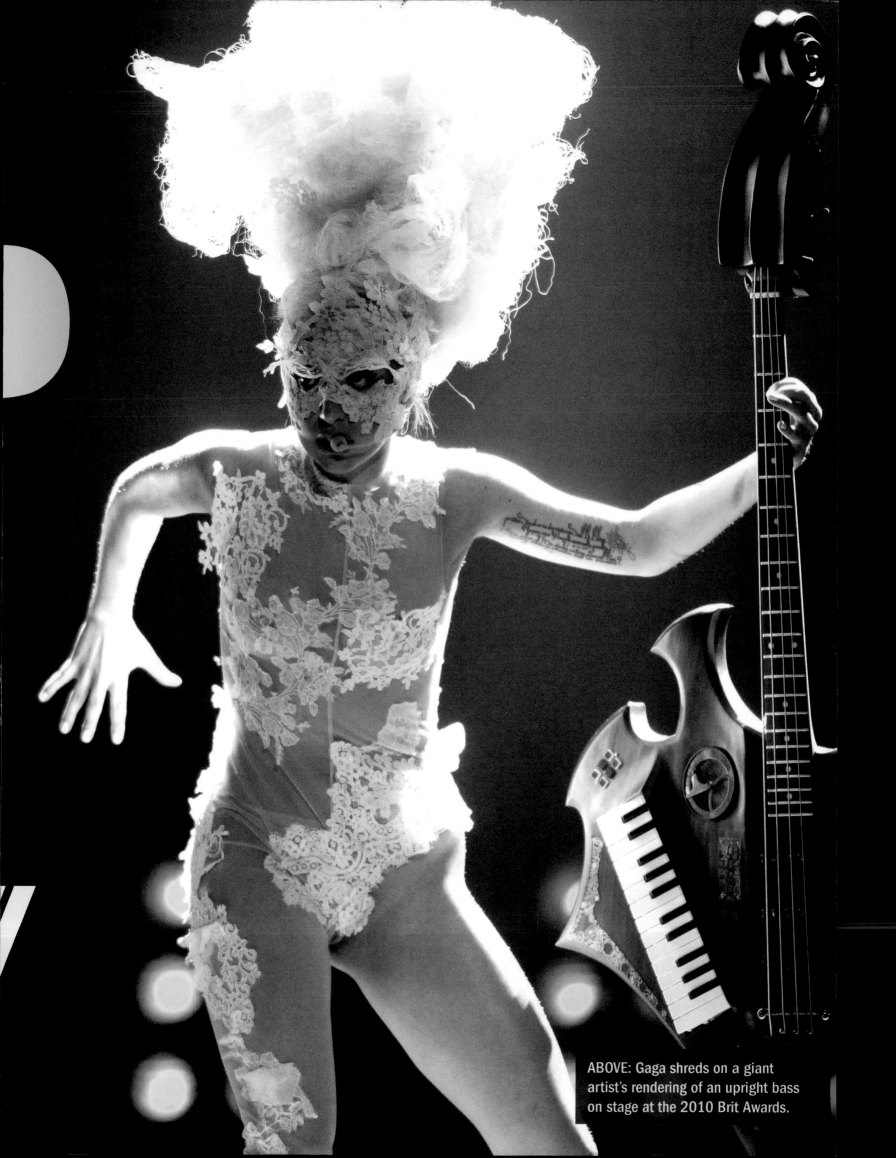

ABOVE: Gaga shreds on a giant artist's rendering of an upright bass on stage at the 2010 Brit Awards.

If each of Gaga's pianos is a new romance, she's been around the block. There was the macabre double-sided piano she played with Elton John at the Grammys, which had bunches of arms poking out of it, their hands desperately grasping at something just out of reach. There was also the Damien Hirst–painted Steinway she played at the MOCA 30th anniversary event, about which the singer kept muttering, in a quiet moment of rehearsal before the show, "holy mother." When she performed on *The X Factor* she played "Bad Romance" on a combo bathtub/piano while sitting on a toilet chair; on *The Ellen DeGeneres Show* she sat at a piano bench made of the backs of several dancers; for her tour, Gaga had a bubble piano made to match her infamous Hussein Chalayan bubble dress. At the VMAs she switched teams for a second and went for the gargantuan crystal-encrusted keytar, which was almost as tall as her, and which she gyrated against in a distinctly not-safe-for-work manner.

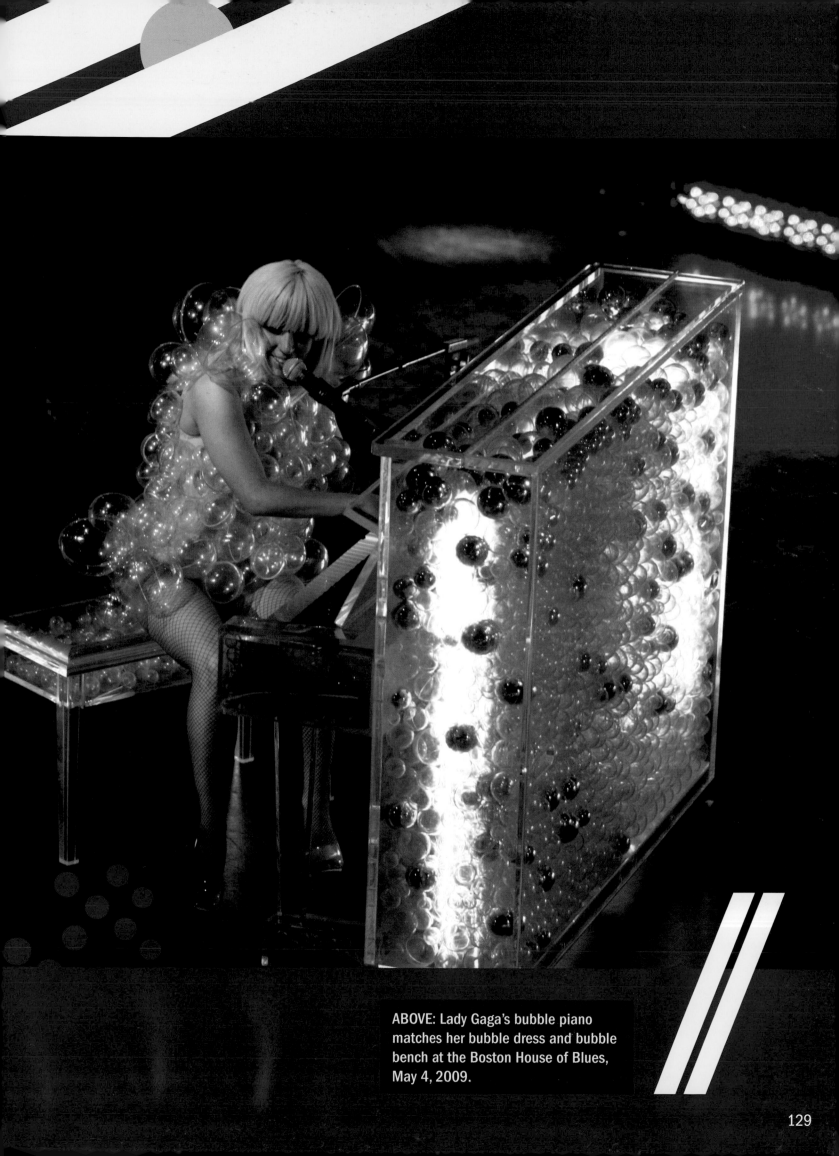

ABOVE: Lady Gaga's bubble piano matches her bubble dress and bubble bench at the Boston House of Blues, May 4, 2009.

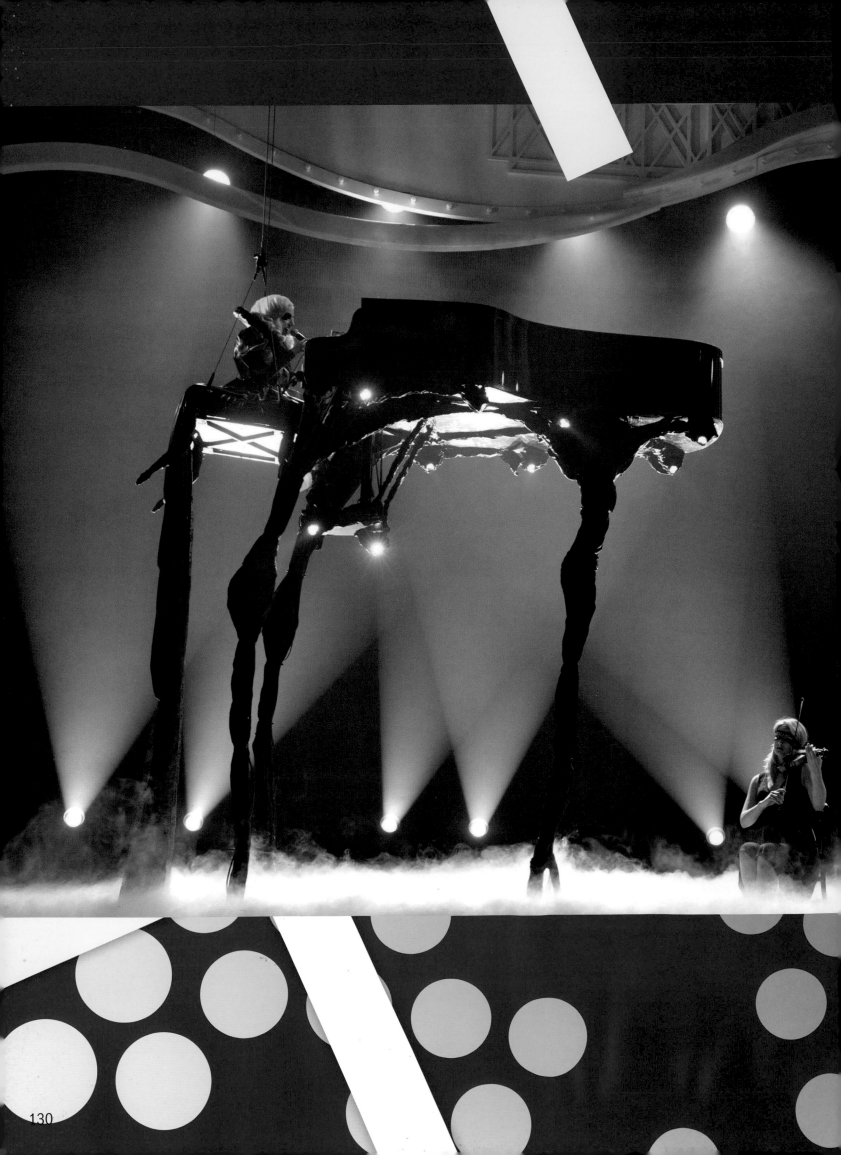

Believe it or not, this was the toned-down version of the performance Lady Gaga had planned. She had a mock suicide planned, but in the end she agreed that might be too much shock for her royal audience. Instead, the singer settled for playing alongside a masked mini orchestra while perched atop a precarious gothic piano with delicate tree-branch legs, wearing a PVC Elizabethan gown, a massive ruff, and an endless PVC-and-lace train. Even great artists make compromises.

Perhaps her most stunning animation of instrument-as-theater took place when Gaga performed "Speechless" for Queen Elizabeth II at the Royal Variety Performance. She played while suspended from a giant swing, her piano lifted up to meet her on spindly Salvador Dali–esque stilts. And that was the less extreme performance the singer had planned for that night: She reportedly originally intended to stage a performance art piece involving a mock suicide. "I have had to tone down my act," Gaga has said of her performance for the royal. "But all of that doesn't matter because I'm a massive fan of the Queen—I was so excited and have even been practicing my curtsy. When I first came up with what I was doing, I said, 'Oh my fucking God, I hope she likes it!'"

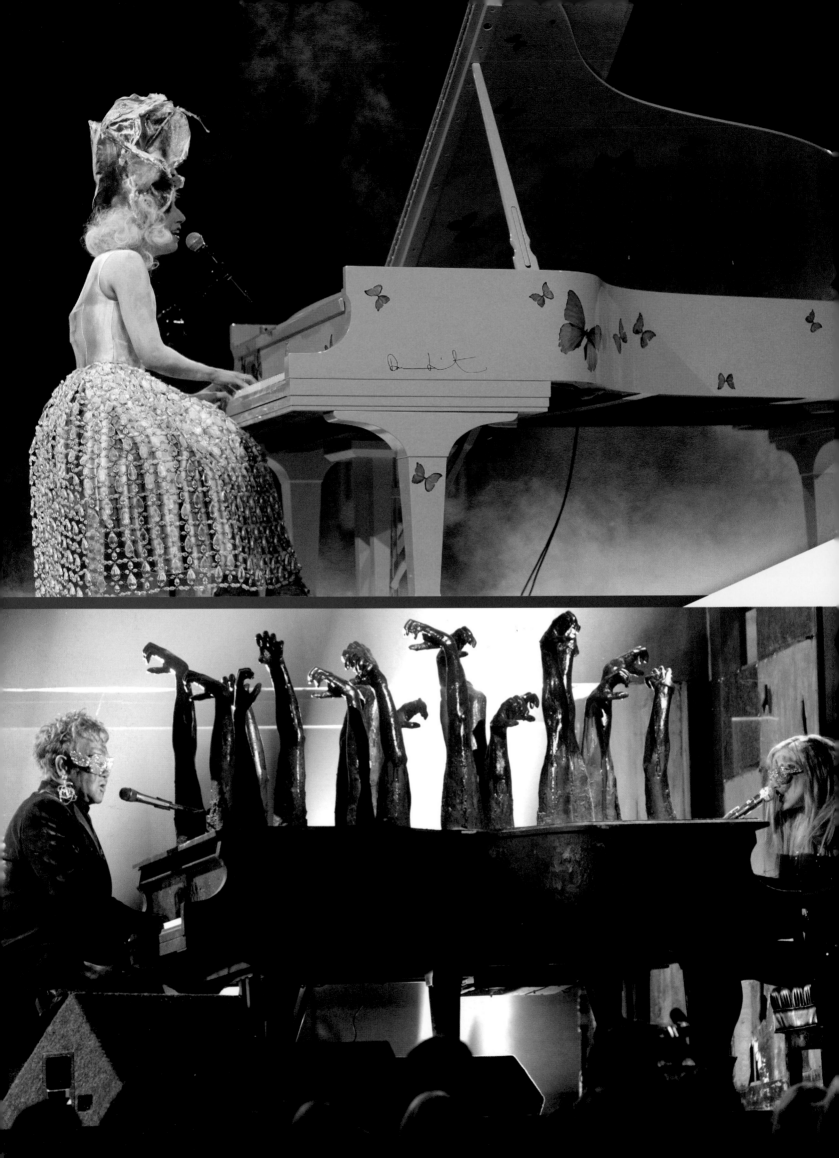

"I always loved rock and pop and theater," the singer has said. "When I discovered Queen and David Bowie is when it really came together for me and I realized I could do all three. I look at those artists as icons in art. It's not just about the music. It's about the performance, the attitude, the look; it's everything. And, that is where I live as an artist and that is what I want to accomplish." There is nothing on Lady Gaga's stage that she hasn't thought about. Everything from the pattern on her dancer's fluorescent Hammer pants to the font on the Haus of Gaga sign to the individual light-up crystals on her "disco stick," she has either designed herself or consulted on. The entire stage has to reflect the aesthetic she's going for that night and her image as a whole.

ABOVE LEFT: Playing the Damien Hirst–designed grand piano at the 30th anniversary gala for the Museum of Contemporary Art in Los Angeles, November 14, 2009. BELOW LEFT: Elton John and Lady Gaga play a dual piano covered in grotesque clutching hands at the 2010 Grammy Awards.

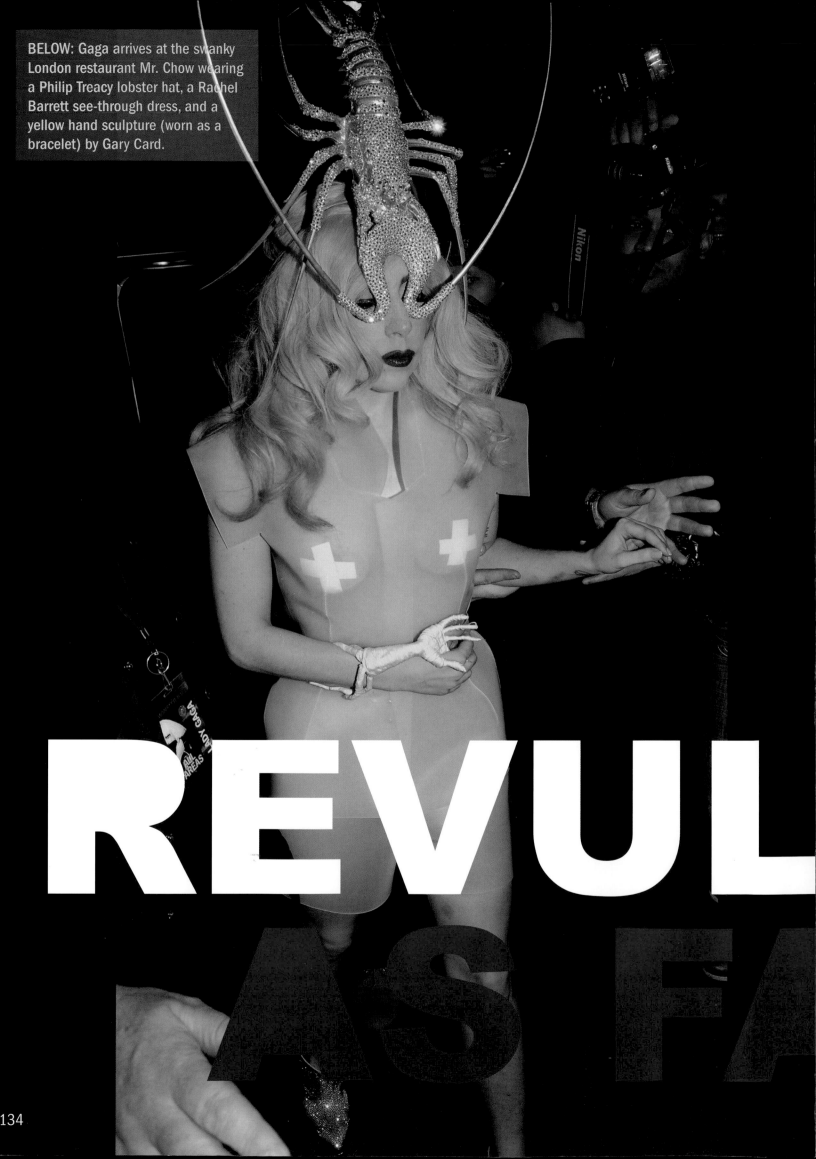

BELOW: Gaga arrives at the swanky London restaurant Mr. Chow wearing a Philip Treacy lobster hat, a Rachel Barrett see-through dress, and a yellow hand sculpture (worn as a bracelet) by Gary Card.

REVUL

"*I* just don't feel that it's all that sexy," Lady Gaga said of her look in *Entertainment Weekly*. "It's weird. And uncomfortable. I look at photos of myself, and I look like such a tranny! It's not what is sexy. It's graphic, and it's art. But that's what's funny: Well, yeah, I take my pants off, but does it matter if your pants are off if you've got eight-inch shoulder pads on, and a hood, and black lipstick and glasses with rocks on them? I don't know. That's sexy to me. But I don't really think anybody's dick is hard, looking at that. I think they're just confused, and maybe a little scared."

For all Lady Gaga's rhapsodic purring about "disco sticks" and bluffing with her muffin and having condomless sex with her art, the singer is in some ways very asexual. When she's getting dressed, the priority is almost never to induce straight-up arousal—you don't see her in a short skirt and a tank top or a fitted cocktail dress, the go-to getups for women on the make. "The last thing a young woman needs is another picture of a sexy pop star writhing in the sand, covered in grease, touching herself," the singer

SION
ASHION

135

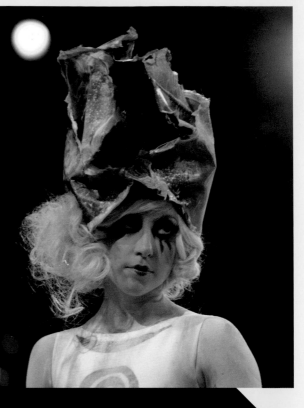

told *Elle*. And even when Gaga is wearing something deliberately provocative, there's always something else going on with her outfit. Maybe she's showing her breasts, but they're only visible beneath a formless blood-colored lace body sock. Or she's wearing a leotard so tight that it reveals the shape of her vagina in a grotesque way. The singer likes to exaggerate or mutate what's traditionally considered sexually provocative to the point of obscenity and revulsion. And this is what designers love about her. "The great thing about Gaga is she always wants to push for the most extreme option," Gary Card, who made the skeletal headgear she and her dancers wore at the AMAs, told the *Los Angeles Times*. "She's brave enough to let herself be a canvas for a designer to go and really express themselves. Nothing is off limits! With Rihanna and Beyoncé there is an end result of desirability and unattainable sexiness, whereas Gaga is a really interesting bridge between the desirable and the grotesque. She's not at all worried about looking ridiculous or hideous; actually, I think she thrives off it."

Of all Lady Gaga's bizarre, disturbing, or just plain weird outfits, the one she wore for her December 2009 performance for Queen Elizabeth II reveals the most about the philosophy behind her tendency toward the grotesque. The singer's outfit consisted of a painted-on lipstick red latex S&M gown, featuring a twenty-foot train and a high, tight collar that looked as if it could actually choke her. With her straight blonde hair slicked back into a wispy trickle of pale yellow and red crystal orbs daubed around her eyes like sideways drops of blood, the singer looked like a satanic version of Elizabeth I. Famous for her refusal to marry, the so-called Virgin Queen considered courtship to be a political tactic. She weighed every decision about sexuality and relationships against what would be good for her country, and she concluded that marriage would only weaken her political power. So she stayed single for life, referring to her English subjects as "all my husbands, my good people." As a result, her people vaulted her to saintlike status.

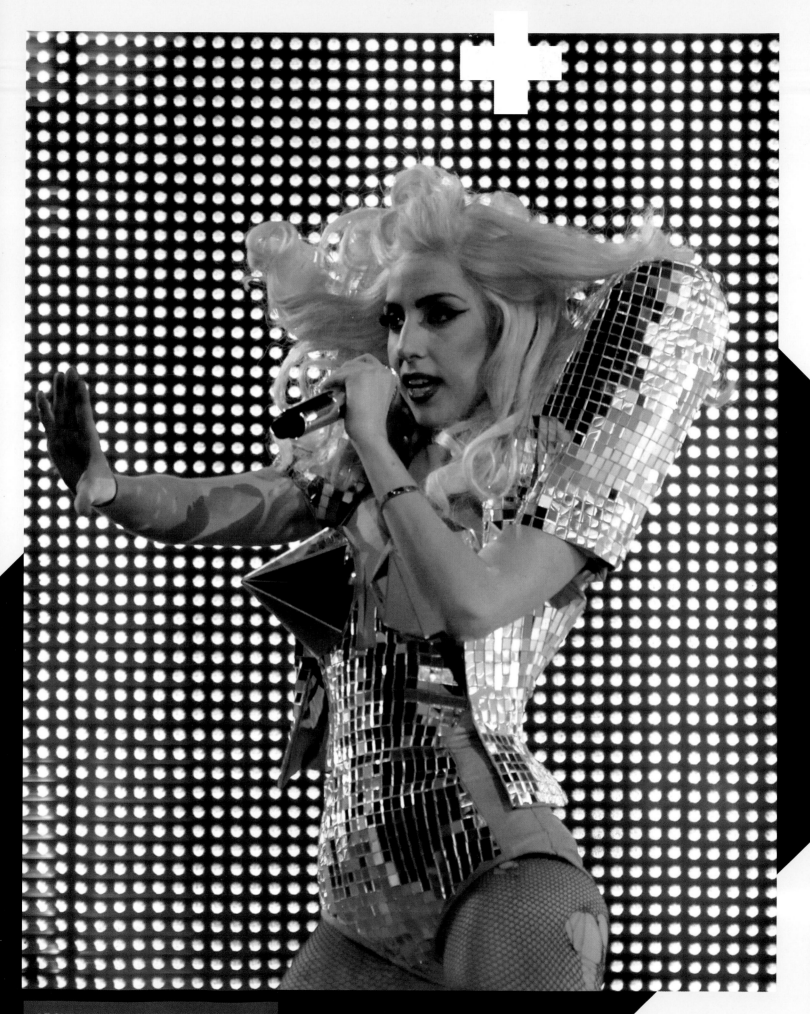

ABOVE: Looking anything but "come-hither" in militant shoulder pads and metallic cone boobs on stage in Los Angeles, December 23, 2009.

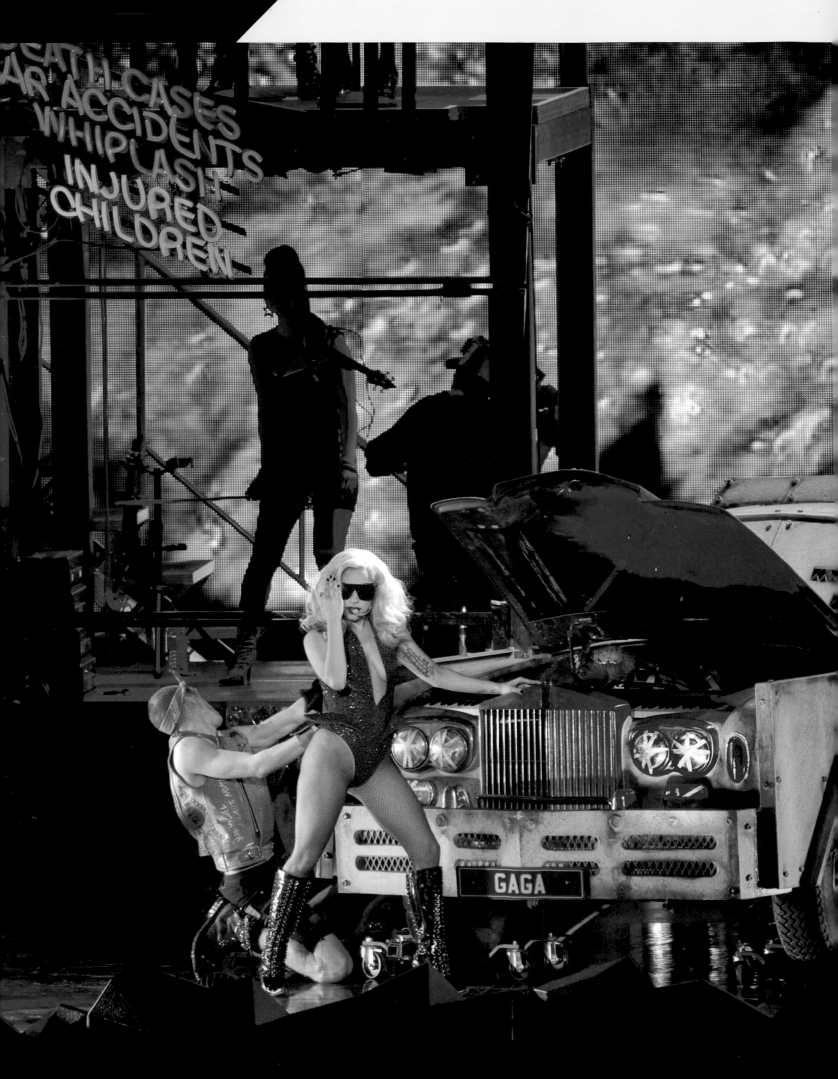

Lady Gaga also talks about "marrying" her art. And she fully expects she'll be one of those artists who never finds companionship outside of her relationship with her little monsters. "I'm not trying to prove to anybody that I'm going to be here for thirty years. You either are or you're not," the singer told *Entertainment Weekly*. "It's either important for you to stop, and buy a condo, and have babies, and marry a rich actor, or not do any of that, and continue to make music and art, and die alone. Which is what I'll probably do." For all her frank sex talk, her manipulation of social values, and her promotion of her own ambiguous sexuality as an aspect of her identity, in the end Lady Gaga is almost demure, virginal, even. Her sexual energy is on display almost constantly, but at the end of the night she goes home alone.

Backstage during her tour with the Pussycat Dolls, *Blender* reported that Nicole Scherzinger gave Gaga a pair of pearl-and-diamond bow-shaped earrings. "She is too freaking nice to be as pretty as she is," Gaga said. "If I was as pretty as her, I wouldn't be that nice." But she's not, thankfully, because conventionally pretty girls are . . . conventional, and Lady Gaga has built a career out of defying convention. She transforms into such a flamboyantly freakish creature that her image becomes profoundly divorced from any kind of traditional standards of beauty. In Gaga's world, the only standard of beauty that matters is your own.

GET THE LOOK

"Once things start to change and your career gets crazy the tendency is to just hire really amazing stylists or artists and they just pull things and they send them to you," Lady Gaga told Yahoo Shine. "I don't like to do that. I mean, fashion's my whole life." With that in mind, the singer still takes time out of her insanely hectic schedule to go out into the streets in whatever city she's in and actually peruse the racks herself, handpicking items she's going to wear out to the clubs, in her hotel room, and even on stage. These are some of her favorite sources.

COUTURE

ALEXANDER MCQUEEN: Arguably Lady Gaga's most important fashion collaborator, the singer has appeared in countless McQueen creations, from the bondage dress so tight she had to be cut out of it, to the infamous armadillo platforms. Contact: www.alexandermcqueen.com. Shop on the designer's Web site or at his flagship store in New York: 417 W. 14th St., New York, NY; 212-645-1797.

THIERRY MUGLER: The French ballet dancer turned visionary designer behind many of Gaga's structural, origami-inspired, colorful fitted dresses. Contact: www.thierrymugler.com. Shop at the designer's online boutique.

HUSSEIN CHALAYAN: The British/Turkish Cypriot designer behind Lady Gaga's infamous bubble dress as well as her massive oversized "Perfecto" moto jacket and filmy resort-stripes slip dress, among other creations. Contact: www.husseinchalayan.com. Shop online at www.ssense.com.

JEREMY SCOTT: Gaga admires the American-born designer for his ability to merge fashion with art. "He does a lot of work with the Keith Haring Foundation," the singer told Yahoo Shine, while trying on a Haring-print moto jacket she then announced "was coming home with me." Contact: www.jeremyscott.com. Shop online at www.openingceremony.us.

BENJAMIN CHO: Gaga counts the New York–based designer and scenester as a friend and collaborator; he designed the fringed corset leotard Gaga wore during her April 2009 appearance on *American Idol*. Shop at the designer's New York store: 427 W. 14th St., New York, NY; 212-966-5376.

YVES ST. LAURENT: "This is an Yves St. Laurent jacket," Gaga purred during a Los Angeles shopping trip with MySpace TV. "Is there anything better than that? I don't think so." Contact: www.ysl.com. Shop at the official online store: www.ysl.com/Yves_Saint_Laurent.

VERSACE: "I am very inspired by Versace," Gaga told Yahoo Shine. The singer regularly appears in Versace sunglasses and the rumor mill regularly churns out reports, as of yet unfounded, that Gaga and Donatella Versace, the singer's blonde, tan, eccentric doppelganger, will collaborate on a line. Contact: www.versace.com. Shop online at: www.net-a-porter.com.

GUCCI: "I love the Italians," the singer told Yahoo Shine. "I love really graphic beautiful lines, very sophisticated and elegant and futuristic. Very Gaga." Contact: www.gucci.com. Shop on the designer's Web site or at one of many Gucci boutiques around the world.

CHANEL: The ultimate in iconic fashion houses. Gaga has said of lead designer Karl Lagerfeld, "*Us Weekly* putting me on a worst-dressed list? I couldn't care less. If Karl Lagerfeld called me an ugly hag, then I'd be upset. Because it's Karl Lagerfeld." Shop at one of many Chanel boutiques around the world or online at www.neimanmarcus.com.

VIKTOR & ROLF: The singer's "Telephone" video featured a chain jumpsuit constructed by the Dutch designers, who specialize in an edgy, subversive look that matches Gaga's fashion oeuvre. Contact: www.viktor-rolf.com. Shop one of the designer's many boutiques around the world, or online at www.thecorner.com.

ASHLEY ISHAM: The Singapore-born, London-residing fashion visionary is responsible for some of Gaga's most elaborate, textured dresses. Contact: www.ashleyisham.com. Shop at the designer's flagship boutique: The Fullerton Hotel, 1 Fullerton Square, #01-04, Singapore 049 178; +(65) 6536 4036.

VIVIENNE WESTWOOD: The iconic British designer was one of the first people in fashion to merge the battered, aggressive appeal of the punk sensibility with high fashion, and as such is one of Gaga's most important fashion progenitors. Contact: www.viviennewestwood.com. Shop online at www.viviennewestwood online.co.uk/acatalog or shop the singer's flagship store: 44 Conduit St., W1S 2YL London.

PATRICIA FIELDS: The ultimate costumer for television and film, Fields's quirky fashion-forward sensibility went mainstream with *Sex and the City* and Gaga takes over where Carrie Bradshaw left off. Contact: www.patriciafield.com. Shop online or at the New York City store: 302 Bowery; 212-966-4066.

LINGERIE

COCO DE MER: Widely considered to be the premier luxury erotic boutique in the world, the store features elegant leather wear, toys, and exquisite lingerie. Shop online or visit one of the store locations listed at www.coco-de-mer.com.

TRASHY LINGERIE: The best spot for cheeky, gleefully cheesy stripper gear, including items Gaga regularly buys like fishnets and stripper shoes. Contact: www.trashy.com. Shop online or visit the store in Los Angeles: 402 N. La Cienega Blvd.; 310-652-4543.

BOUTIQUES

OPENING CEREMONY: This visionary boutique, with locations in Los Angeles, New York, and Japan, is one of the singer's regular shopping spots. It carries an impeccably edited collection of unusual emerging designers and established bold-name labels, which together make up the Gaga look.
Contact: www.openingceremony.us. Shop online or at one of their four locations: New York: 35 Howard Street, New York, NY; 212-219-2688. New York: Ace Hotel, 1190-1192 Broadway, New York, NY; 646-695-5680. Los Angeles: 451 N. La Cienega Blvd., Los Angeles, CA; 310-652-1120. Tokyo: Shibuya Seibu Movida 21-1, Udagawa-Cho, Shibuya-Ku, Tokyo 150-0042, Japan; +81-3-6415-6700.

SEARCH AND DESTROY: Wondering where Gaga got her hands on that fabulous studded leather motorcycle jacket she wears in the "Telephone" video? Now you know. Check out this New York City located outpost of all things rocker and channel your inner Pink Lady.
Shop at the store: 25 Saint Marks Pl., New York, NY; 212-358-1120.

DECADES: A merging of vintage couture and modern consignment shop, this spot is a mecca for fashionistas looking for that elusive one-of-a-kind find.
Contact: www.decadesinc.com. Shop at the store: 8214 ½ Melrose Ave., Los Angeles, CA; 323-655-0223.

TRASH AND VAUDEVILLE: One of the original sources for goth and punk gear in New York City, this spot sells much of the fetish clubwear, vinyl clothing, and bondage pieces that Gaga integrates into her wardrobe.
Contact: www.nycgoth.com. Shop at the store: 4 St Mark's Pl., New York, NY; 212-982-3590.

WHAT GOES AROUND COMES AROUND: Based in Los Angeles and New York, this impeccably curated vintage emporium boasts a fantastic collection of vintage jewelry, a Gaga staple.
Contact: www.whatgoesaroundnyc.com. Shop online or at the two locations: New York: 351 West Broadway; 212-343-1225. Los Angeles: 1520 Cahuenga Blvd., Space 15 Twenty; 323-836-0252.

CATWALK: "This is one of my favorite stores," Gaga told MySpace TV of the Hollywood-based collection of rare designer items. "You get all of the most amazing designers from around the world but it's all vintage."
Contact: www.catwalkdesignervintage.com. Shop the Los Angeles store: 459 N. Fairfax Ave.; 323-951-9255.

ACCESSORIES

PHILIP TREACY: The avant-garde hat and handbag designer behind several of Gaga's most infamous headpieces, including her sparkling lobster hat.
Contact: www.philiptreacy.co.uk. Shop the flagship boutique: 69 Elizabeth Street, London SW1W 9PJ.

STEVIE BOI: The eyewear designer behind the crystal-encrusted shades on the cover of Lady Gaga's debut album, *The Fame*.
Shop at the designer's Web site: www.stevieboi.com.

CHARLIE LE MINDU: One of the visionaries behind Gaga's elaborate architectural headwear and various hybrid wig/hats and wig/masks.
Shop online: www.charlielemindu.com. Pop-up hair salon: Tatty Devine, 236 Brick Lane, London E2 7EB, UK; www.tattydevine.com.

MOUTON COLLET: Jewelry and object design team behind many Gaga accessories including her infamous white antler cap.
Contact: www.moutoncollet.com. Shop online: www.yoox.com

JACK'S EYEWEAR: Unassuming from the outside, this Los Angeles–based sunglasses emporium is jammed to the gills with a dizzying array of frames from established designers, vintage finds, and obscure eyewear artisans.
Shop at the store: 120 S La Brea Ave, Los Angeles, CA; 323-933-1402.

ST. NICHOLAS OF TOLENTINE: Gaga designs or commissions much of the jewelry she wears, but she's also got a great eye for vintage costume jewelry. This parish flea market, open on the weekends and located in Queens, Gaga's place of birth, is a treasure trove of weird, inspiring pieces from the 1920s through the 1980s.
Contact: 80-22 Parsons Blvd., Jamaica, Queens, NY; 718-591-1815.

RICKY'S: Walk into this New York–based products emporium for all things quirky and beauty related, and walk out looking exactly like Gaga in a lavender wig, hair-extension-turned-hair-bow, and bedazzled hot pink nails.
Shop online and find store locations in New York and Miami: www.rickys-nyc.com.

MAKEUP

MAKE UP FOR EVER: The ultimate in professional-quality punk rock products, its eyeliners and mascaras bring out the inner rock girl.
Contact: www.makeupforever.com. Shop online at www.sephora.com.

FACE STOCKHOLM: The essence of serene cool, this Swedish makeup and product brand is one of Gaga's favorites; she told *Marie Claire* she keeps Face Atelier Ultra Foundation PRO in Porcelain in her makeup bag.
Shop online and find global store locations at www.facestockholm.com.

M.A.C.: In addition to being a spokesperson for the brand, Gaga actually uses its products, especially its Fluidline black eyeliner and the signature Viva Glam Gaga lipstick she designed for them. "There was this color I used to wear when I was living in downtown New York called Pink Nouveau," the singer told Britain's the *Daily Mail*. "It was a bright, toxic, neon pink. I was eighteen and a complete unknown, so didn't have much money to buy lots of nice makeup. Pink Nouveau was the one thing that made me feel more famous than I was. So I asked the guys at M.A.C. to make something that was derived from that."
Shop online and find worldwide store locations at www.maccosmetics.com.

UNEARTH INFLUENCE

MUSICIANS

DAVID BOWIE

The Rise and Fall of Ziggy Stardust and the Spiders from Mars (1972)

Let's Dance (1983)

Ziggy Stardust: The Motion Picture (1983 film)

Moonage Daydream: The Life & Times of Ziggy Stardust, book by David Bowie and Mick Rock (Universe, 2005)

MADONNA

Like a Virgin (1984)

Like a Prayer (1989)

Erotica (1992)

Confessions on a Dance Floor (2005)

FREDDIE MERCURY AND QUEEN

Sheer Heart Attack (1974)

A Night at the Opera (1975)

A Day at the Races (1976)

Queen: Greatest Hits I & II (1995)

GRACE JONES

Fame (1978)

Nightclubbing (1981)

KLAUS NOMI

Klaus Nomi (1981)

Simple Man (1982)

The Nomi Song (2004 documentary)

LEIGH BOWERY

Minty: Open Wide (1997)

The Legend of Leigh Bowery (2001 documentary)

Leigh Bowery, by Martin Engler, Rene Zechlin, and Leigh Bowery (Kehrer Verlag, 2009)

Leigh Bowery Looks, by Fergus Greer and Leigh Bowery (Violette Editions, 2006)

BOY GEORGE

Culture Club: Colour by Numbers (1983)

At Worst . . . The Best of Boy George and Culture Club (1993)

Straight, by Boy George and Paul Gormana (Arrow, 2007)

THE CURE

Kiss Me, Kiss Me, Kiss Me (1987)

Disintegration (1989)

Mixed Up (1990)

Wish (1992)

MARC BOLAN AND T. REX

T. Rex—Electric Warrior (1971)

LED ZEPPELIN

Led Zeppelin (1969)

JUDY GARLAND

Judy Garland in Hollywood: Her Greatest Movie Hits (1998)

The Essential Judy Garland (2006)

MICHAEL JACKSON

Off the Wall (1979)

Thriller (1982)

Bad (1987)

Dangerous (1991)

ARTISTS

ANDY WARHOL

Campbell's Soup, 1968

Gold Marilyn Monroe, 1962

Elvis, 1963

The Last Supper, 1986

Chelsea Girls (1966 film)

Bike Boy (1967 film)

Lonesome Cowboys (1968 film)

The Philosophy of Andy Warhol: (From A to B and Back Again), by Andy Warhol (Mariner Books, 1977)

TERENCE KOH

Images at www.saatchi-gallery.co.uk/artists/terence_koh.htm

More projects at www.asianpunkboy.com

SPENCER TUNICK

www.spencertunick.com

DAMIEN HIRST

The Physical Impossibility of Death in the Mind of Someone Living, 1992

For the Love Of God, 2007

The Golden Calf, 2008

For the Love Of God: Making Of The Diamond Skull, by Damien Hirst (Other Criteria, 2008)

FRANCO VEZZOLI

Francesco Vezzoli: A True Hollywood Story, by David Rimanelli, Gianfranco Maraniello, Gregory Burke, and Francesco Vezzoli (The Power Plant, 2009)

"Greed" (2009 short film)

ARAKI

www.arakinobuyoshi.com

Sentimental Journey, by Nobuyoshi Araki (Shinchosha Company, 1991)

Akaki (Portfolio), by Nobuyoshi Araki (teNeues, 2009)

FRANK GEHRY

Guggenheim Museum Bilbao, Bilbao, Spain (1997)

Experience Music Project, Seattle, Washington (2000)

Marqués de Riscal Vineyard Hotel, Elciego, Spain (2006)

Sketches of Frank Gehry (2005 documentary)

FILMMAKERS

BAZ LUHRMANN

Strictly Ballroom (1992)

Romeo + Juliet (1996)

Moulin Rouge! (2001)

FELLINI

Nights of Cabiria (1957)

La dolce vita (1960)

8 ½ (1963)

BURLESQUE

Burlesque: A Living History, by Jane Briggeman (BearManor Media, 2009)

Burlesque and the Art of the Teese/ Fetish and the Art of the Teese, by Dita Von Teese (It Books, 2006)

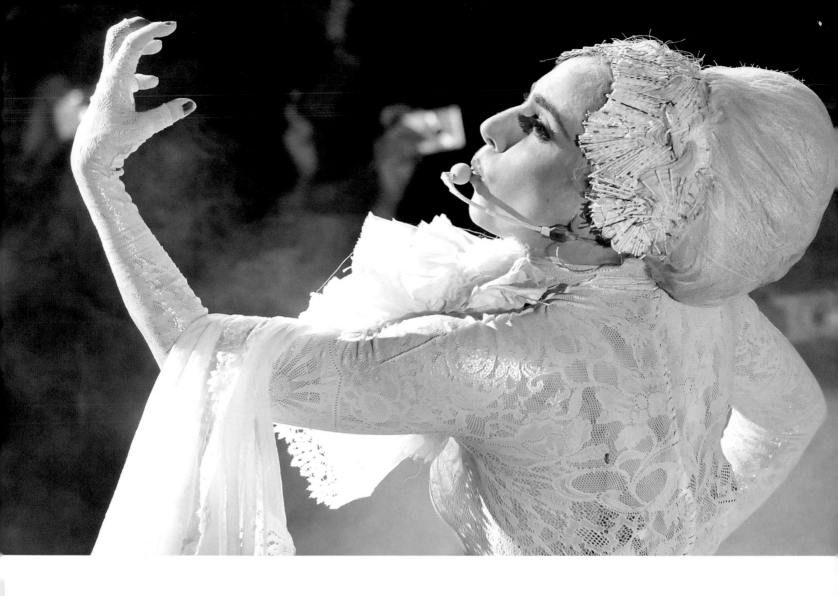

ABOUT THE AUTHOR

LIZZY GOODMAN is a New York–based journalist whose writing on rock 'n' roll, fashion, film, and television appears in *Spin*, *Rolling Stone*, Britain's *New Musical Express*, *Nylon*, *Out*, *Interview*, *Details*, *Elle*, and the *New York Post*. She is currently a regular contributor to *New York* magazine. She was Editor at Large at *Blender*, where she maintained the media face of the brand and remains a regular pop cultural pundit on television and satellite and public radio. She is the author of the biography *Cat Power: A Good Woman* (Three Rivers Press/Random House 2009). Goodman's essays have also appeared in the anthologies *Cringe* (Crown/Random House 2008,) and *Rock and Roll Cage Match* (Three Rivers Press/Random House 2008). The first outfit she remembers picking out herself involved stirrup pants.

ACKNOWLEDGEMENTS

I have this habit of calling books "projects," as if that will make them less work. Call it whatever you want, writing a book, any book, requires a level of life-ruining immersion that should by all rights leave you absolutely friendless in the end. Not me, though. My crazy friends and family have stuck around through a few of my "projects" now and I couldn't be more grateful. So, thank you Mom and Dad for accepting that all your phone calls would go to voicemail while I was working on this and knowing that you should keep calling anyway. Thanks Jake Goodman for showing up in my apartment while I'm working and not leaving and talking to me for hours about Arsenal and what new music you can steal from me. That's always helpful. Thanks to Marc Spitz: You handled my regular freakouts about this book with the usual combo of eye-rolling, indispensible advice, and trademark Spitzian punk rock grace. Huge thanks to my comrade-in-Gaga, Maureen Callahan, who certainly knows what it's like to wake up with "Bad Romance" reverberating in her head. Thanks to Kate Cafaro, who bought me wine and dry shampoo and other fortifying items as I wrote the first chapter in her Austin hotel room. Thanks to Sarah Lewitinn, who I forgot to thank in my first book, even though she's totally responsible for my entire career. Ultra: You are my hero and I love you, thank you. Thank you Matthew Kriteman, who voted for the title "Lady Gaga's Clothes." Big thank you to my editor Kjersti Egerdahl. Thank you to James Fitzgerald, consummate lit geek, green chile fan, and mentor. Thank you for everything, Jim. Also, thank you to Rob Sheffield, Andrea Sheets, Ariel Ashe, Niki Kanodia, Hugo Lindgren, Irina Aleksander, Michael Berens, Leah Greenblatt, and everyone at Bikram LES. And as always, a final thanks goes out to the two figures in my life who are never supportive, don't care about my career, and often seem actively interested in keeping me from writing another word so long as I live: Joni Mitchell and Jerry Orbach, my beloved basset hounds.

IMAGE CREDITS